500 MANGA CHARACTERS

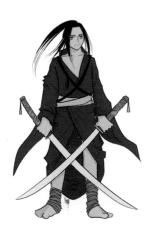

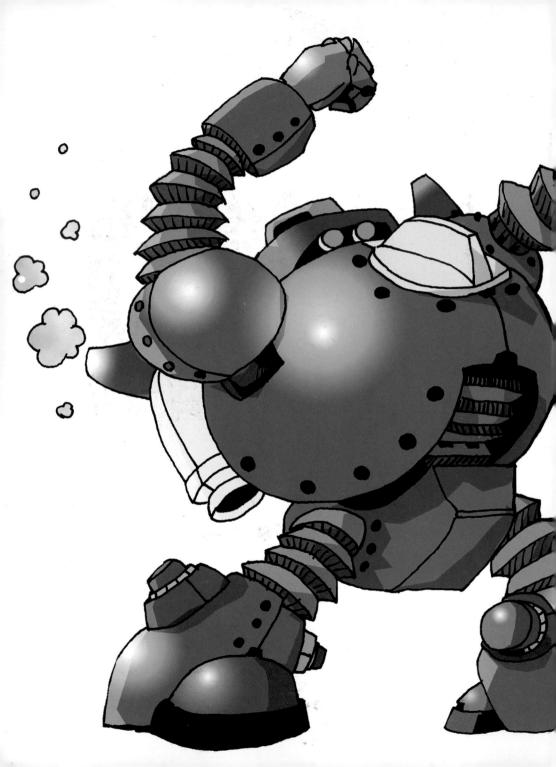

SWEATDROP STUDIOS

500 MANGA CHARACTERS

Copyright © 2007 by The Ilex Press Limited

All rights reserved. No part of this book may be used or reproduced in any manner whatsoever without written permission except in the case of brief quotations embodied in critical articles and reviews. For information, address Collins Design, 10 East 53rd Street, New York, NY 10022.

HarperCollins books may be purchased for educational, business, or sales promotional use. For information, please write: Special Markets Department, HarperCollins Publishers, 10 East 53rd Street, New York, NY 10022.

First Edition

First published in the United States and Canada in 2007 by: Collins Design

An Imprint of HarperCollinsPublishers

10 East 53rd Street

New York, NY 10022

Tel: (212) 207-7000

Fax: (212) 207-7654

collinsdesign@harpercollins.com

www.harpercollins.com

Distributed throughout the United States and Canada by: HarperCollinsPublishers 10 East 53rd Street

New York, NY 10022 Fax: (212) 207-7654

This book was conceived, designed, and produced by ILEX, Lewes, England

Library of Congress Control Number: 2007920323

ISBN: 978-0-06-125652-3 ISBN-10: 0-06-125652-8

Printed and bound in Thailand First Printing 2007

1 2 3 4 5 6 7 / 10 09 08 07 06 05 04

Vipnagorgialla font courtesy of Ray Larabie www.larabiefonts.com

For more information about 500 Manga Characters, see: www.web-linked.com/manfus

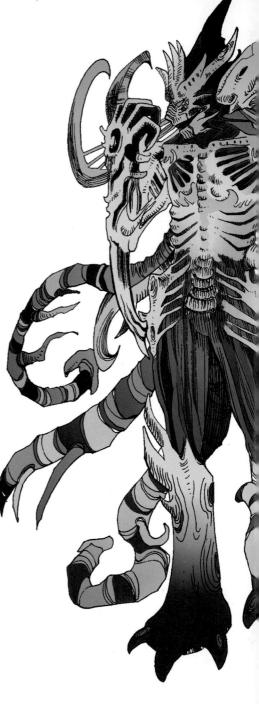

contents

Introduction

- □□□ Introduction
- □□7 How to use the CD

Image gallery

- Teenage female contemporary
- **□42** Teenage female
- traditional Asian
- Teenage male contemporary
- Teenage male traditional Asian
- 138 Fantasy
- I 168 Action
- 198 Sci-fi
- 228 Historical
- 252 Gothic Lolita
- 272 Child male
- 296 Child female
- 320 Adult male
- 350 Adult female
 - Chibi male
- 396 Chibi female
- 412 Villains
- 442 Mecha
- 468 Monsters
- 494 Animals

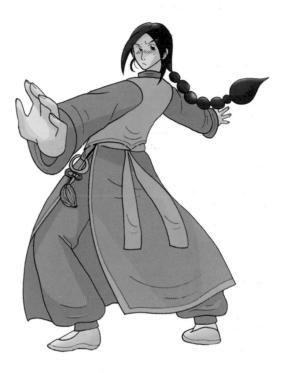

Computer coloring basics

- 510 Hardware
- 512 Software
- 514 Basic tools
- 516 Brush tools
- 518 Blocking in colors
- 520 Light and shade
- **522** Airbrush and beyond
- **524** Artists
- 528 License agreement

introduction

"Manga" is simply the Japanese word for "comics," referring solely to printed comics. The word, however, has become internationally recognized to refer to the art style, subject matter, and method of presentation, and manga-style artists can be found all over the world.

Manga in its present form has existed for over 50 years, but the origins of Japanese sequential art date back to ukiyo-e painting from the 19th century. Hokusai, probably the most famous ukiyo-e artist, is generally credited with coining the term "manga," literally meaning "irresponsible pictures." The development of this style into mass-produced sequential art in the early 20th century, combined with influences from European and American strip-panel comics, evolved the form into what is now commonly accepted as manga. Anime, referring to Japanese animated films and cartoons, is also a big influence on manga artists. Both manga and anime share many visual traits, so it's natural for the two to be associated.

The flexibility within manga is part of its appeal, and there's manga-style artwork to suit all tastes. From the gritty and realistic to the cute and exaggerated, and every step in between, there's always something interesting about every new picture drawn in this uniquely versatile artform. This book offers you a massive selection of 500 manga characters illustrated in a wide range of styles, themes, and poses.

using the cd

Getting Started

All of the images on the CD are stored as .psd documents that can be opened in all leading image-editing programs. They are named according to their category and position in the book. For example, 039 teen male trad 07.psd is image number 39 in the book, and is the seventh image in the Teenage male traditional Asian category. Each of the categories has its own folder on the CD, so you can easily find the files that you are looking for.

Searching Metadata

Another easy way to find the files that you are looking for is to search through the metadata tags. Metadata sounds complicated, but it just means data that describes other data-in this case, keywords that describe the content of the images. This means that you can search through all of the images on the CD to find, say, all of the characters wearing kimonos. Most image-editing and cataloging software will allow you to browse through your images and view the metadata. In Adobe Photoshop an external application called Bridge is used to browse images. Adobe Photoshop Elements on the Macintosh also uses Bridge, but Photoshop Elements on the PC uses the Organizer workspace. Corel Paint Shop Pro uses the Organizer window. They all work in broadly the same way, and we will use Photoshop Elements as an example.

Open Photoshop Elements and go to the Organizer workspace. When it has opened, go to File > Get Photos > From Files and Folders, and navigate to the CD that contains the images. Choose to Import all Tags when prompted to make sure that all of the metadata keywords are loaded into Flements.

As you navigate the folders on the CD, you will see that thumbnails of the images appear in the main window. If you double-click on one of these images it will expand to fill the window and give a list of all the attached keywords describing the image below it.

To search for all images that are tagged with a certain keyword, simply click the icon next to the keyword tag on the right, and the photo list will be restricted to only those images that include the selected keyword. There is a text file containing all of the search keywords on the CD. You can also search by artist name from the same

list to find all of the images drawn by a particular artist.

image gallery

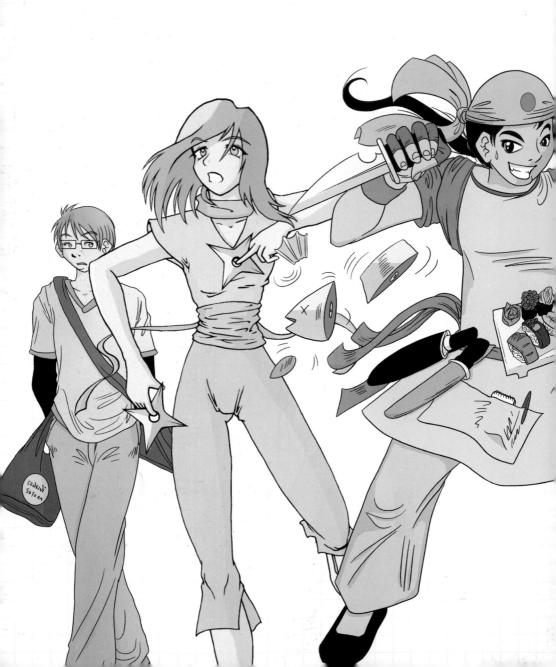

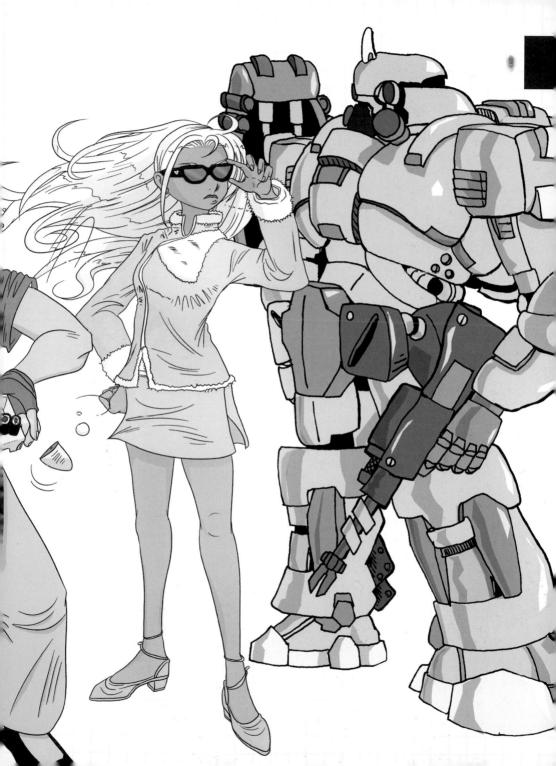

teenage female contemporary

search criteria

food. bag. smart. leg warmers. angry. wink. uniform. walking. standing.

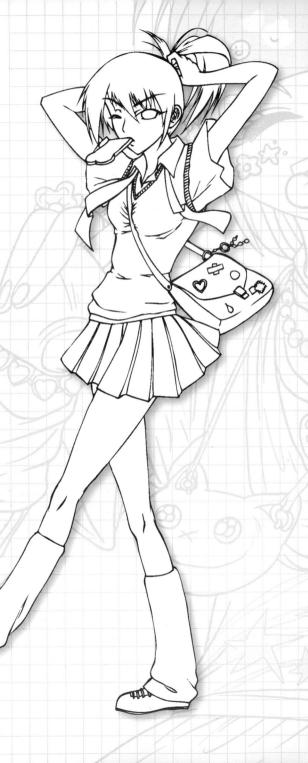

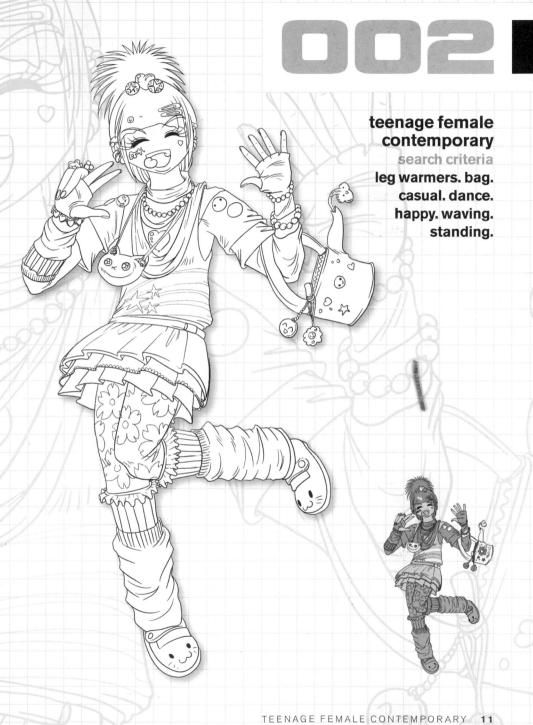

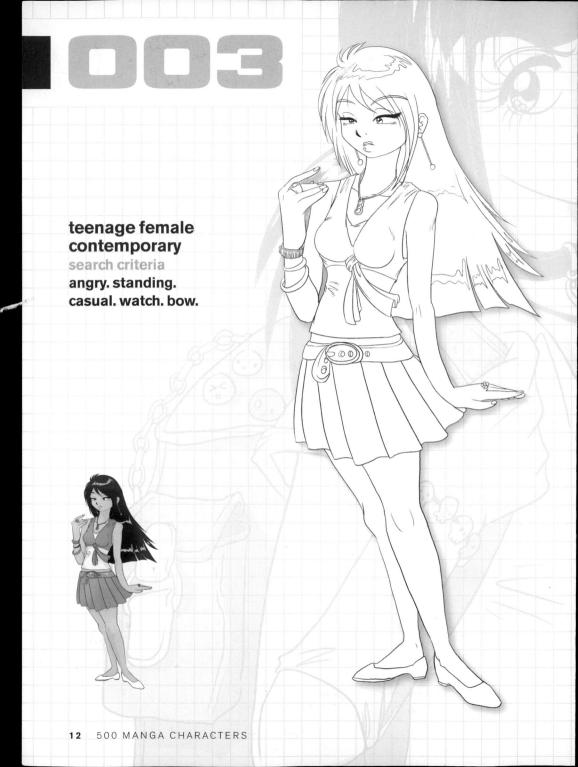

search criteria

bag. skull. casual. sad. standing.

search criteria

leg warmers. flowers. casual. happy. standing. dance.

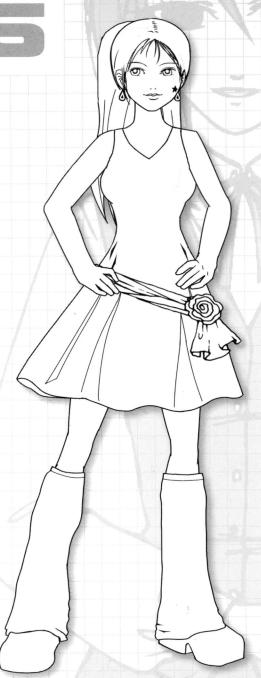

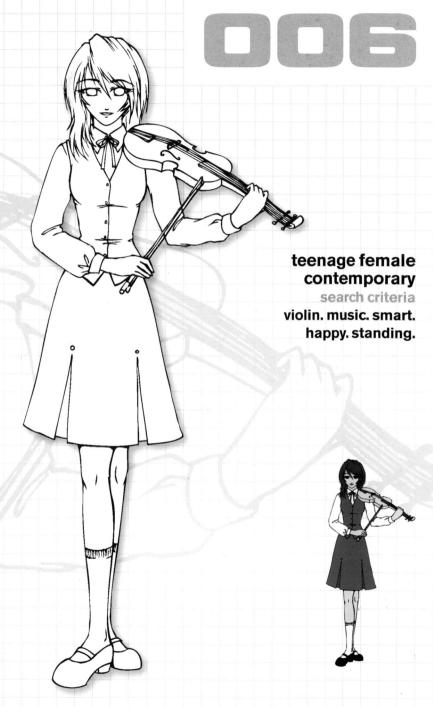

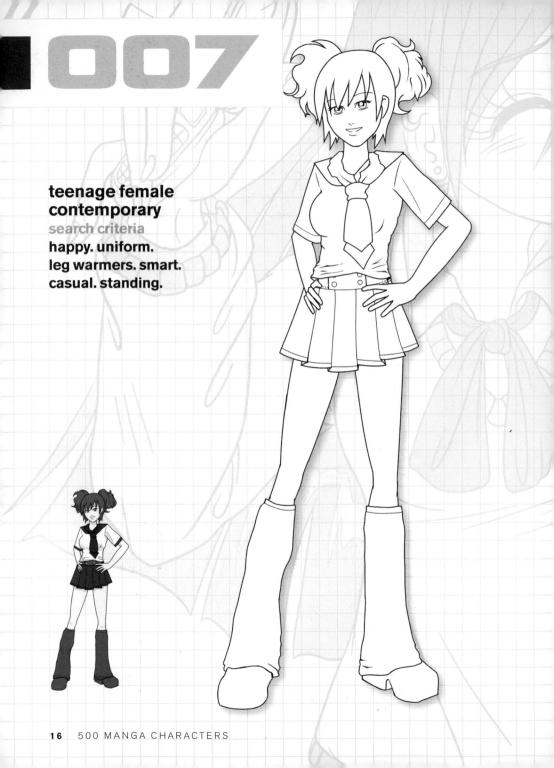

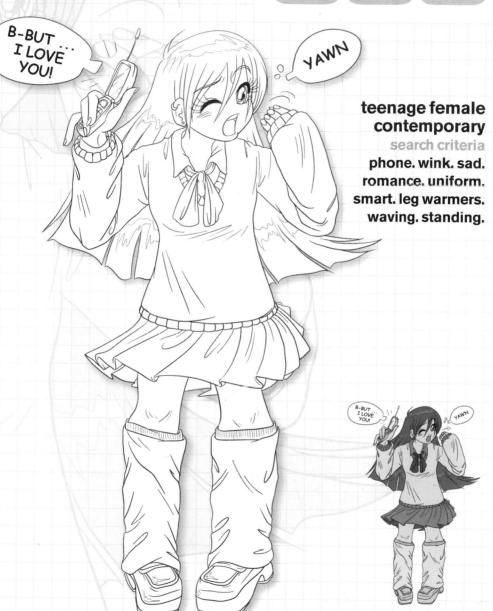

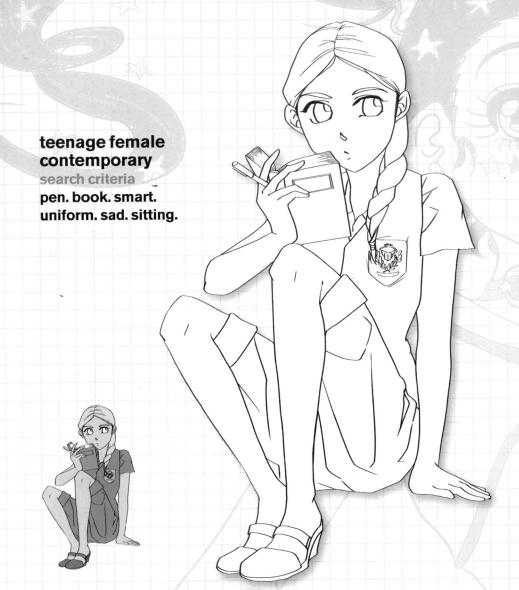

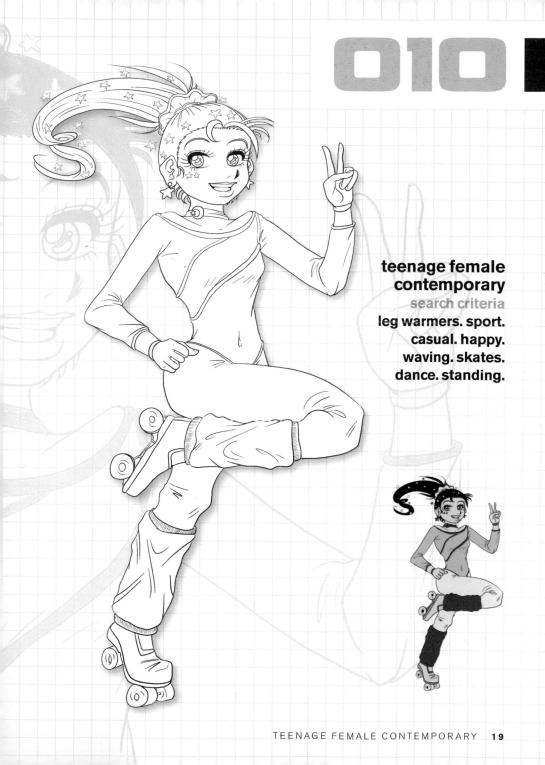

teenage female contemporary

search criteria hat. casual. sport. happy. standing.

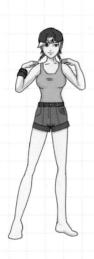

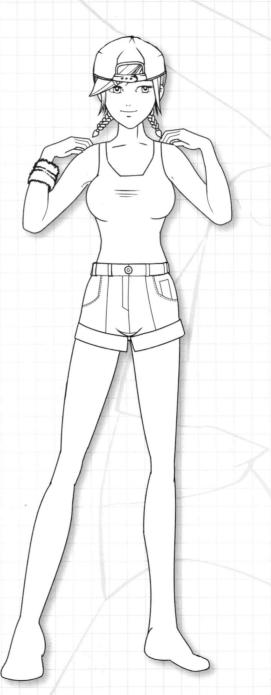

teenage female contemporary search criteria ball. sport. angry. jumping. casual.

search criteria

chibi. paper. glasses. book. casual. sad. walking. standing.

teenage female contemporary

search criteria

chibi. sad. angry. standing. walking. dance. casual.

search criteria

chibi. book. pen. suspenders. casual. sad. standing. walking.

search criteria

chibi. bag. food. leg warmers. happy. uniform. smart. walking. standing.

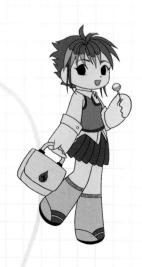

teenage female contemporary

search criteria

bag. phone. toy. cat. watch. casual. sad. walking. standing.

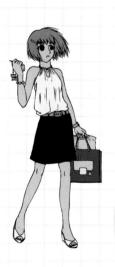

26

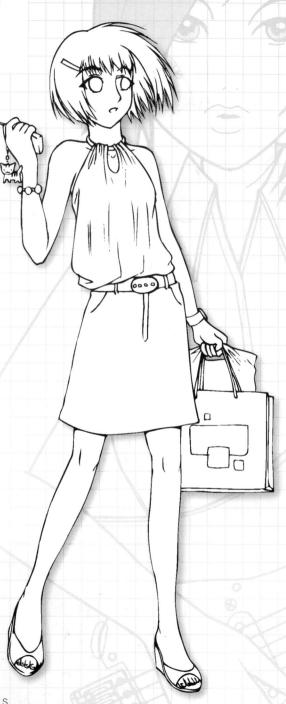

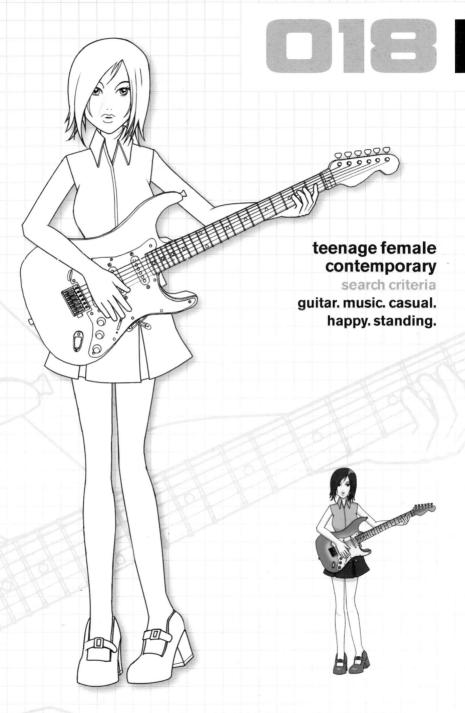

teenage female contemporary

search criteria

food. plate. smart. uniform. happy. standing.

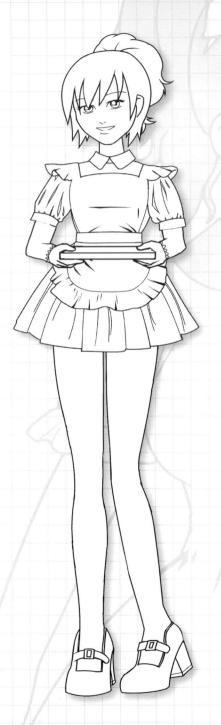

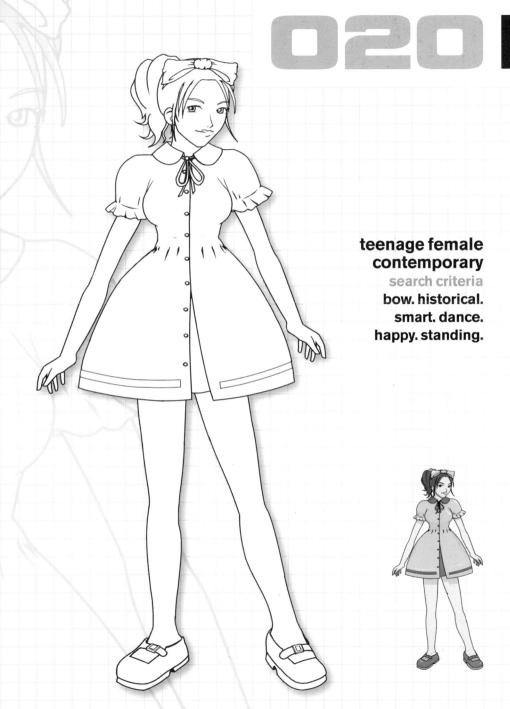

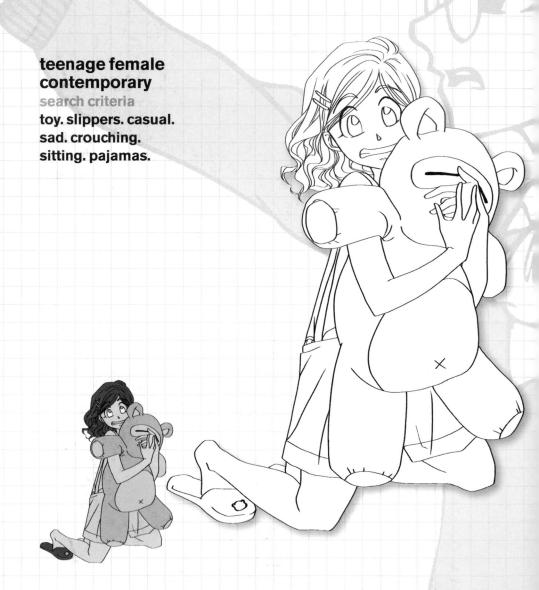

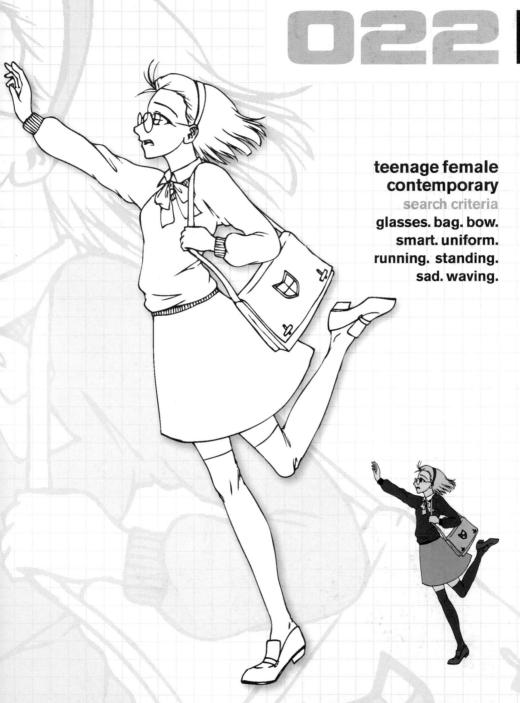

search criteria spade. hat. casual. happy. standing.

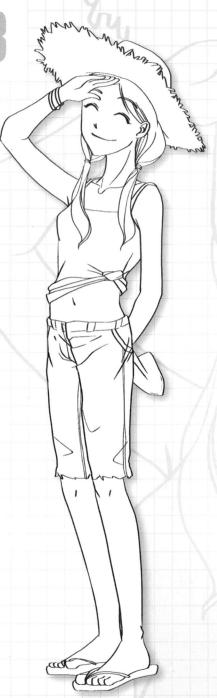

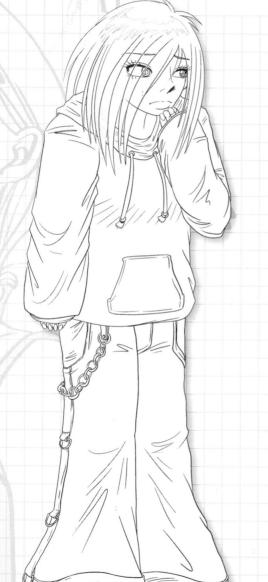

search criteria

chain. casual. sad. standing, hoodie.

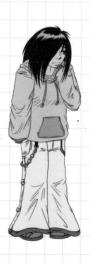

teenage female contemporary search criteria hat. casual. sport. happy. standing. 500 MANGA CHARACTERS

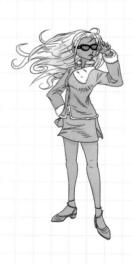

teenage female contemporary

search criteria

happy. walking. standing. casual.

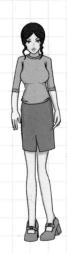

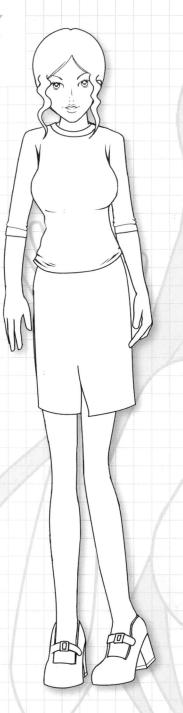

teenage female contemporary

search criteria

happy. waving. standing. casual. swimwear.

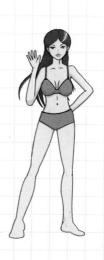

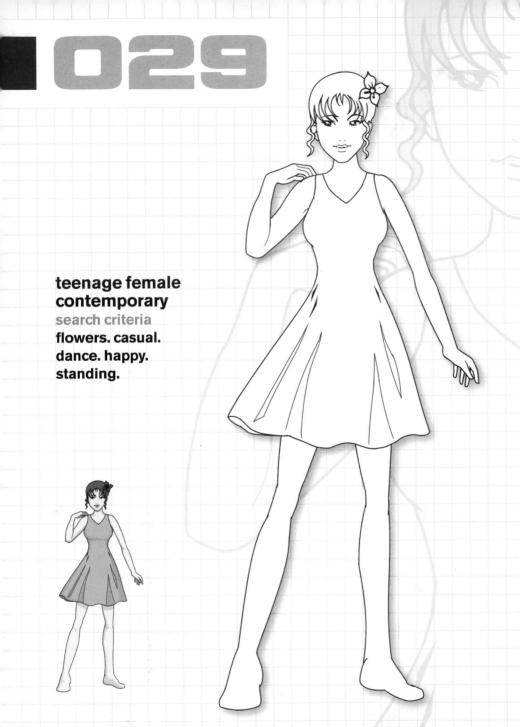

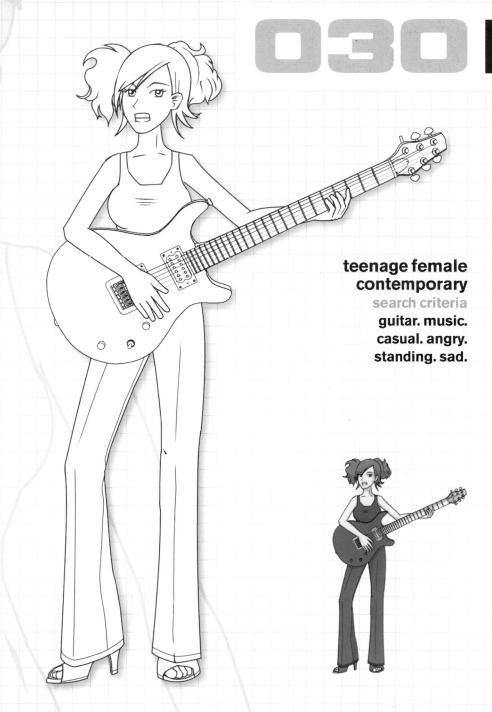

teenage female contemporary

search criteria

skateboard. casual. angry. standing. sport.

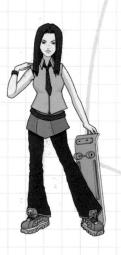

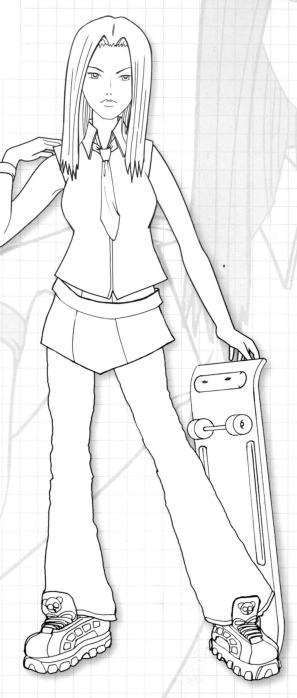

search criteria

happy. standing. walking. casual. hoodie.

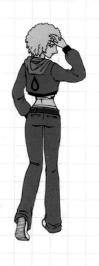

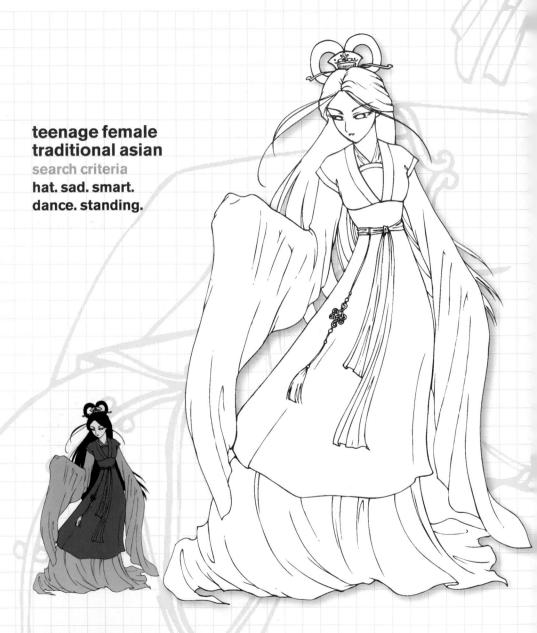

teenage female traditional asian search criteria cheongsam. happy.

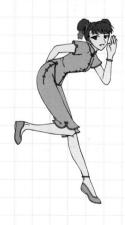

standing. walking. jumping. smart.

teenage female traditional asian

search criteria

bow. cheongsam. smart. happy. jumping. standing. waving.

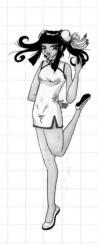

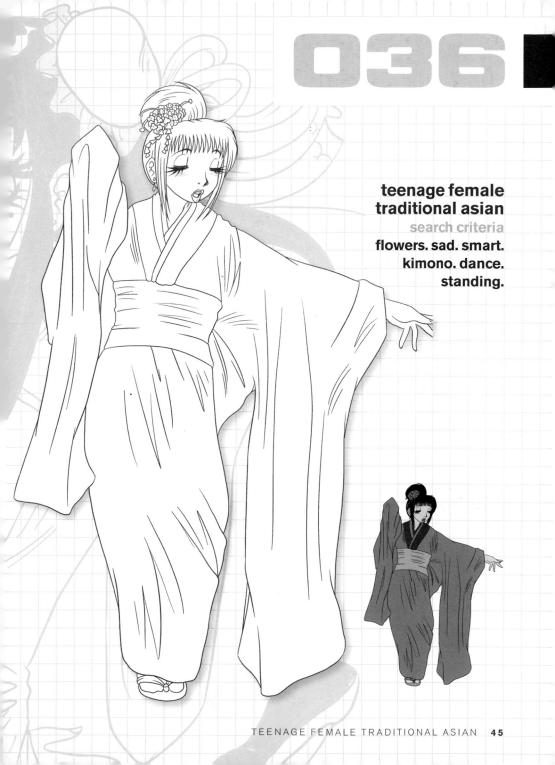

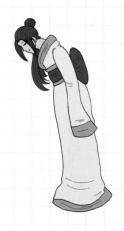

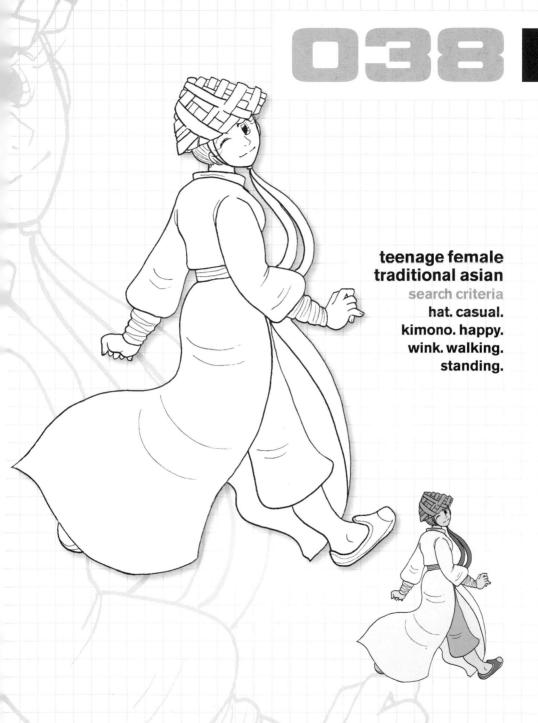

teenage female traditional asian search criteria sad. waving. standing. smart. kimono. 48 500 MANGA CHARACTERS

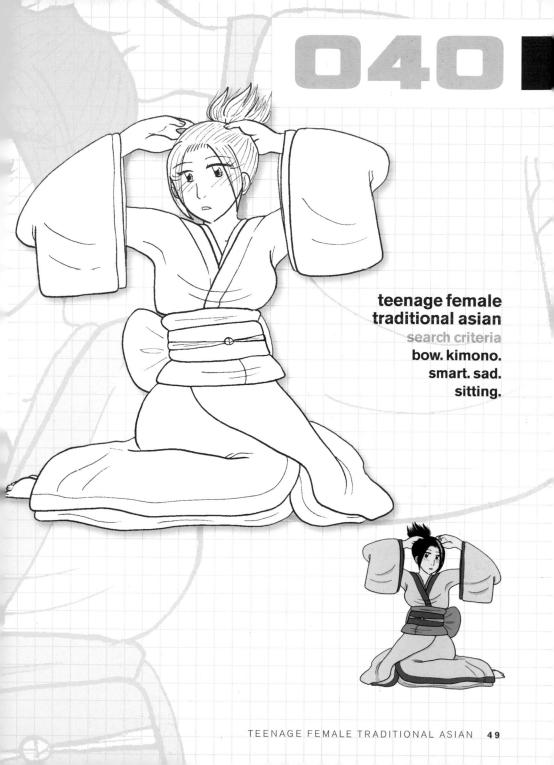

teenage female traditional asian

search criteria

food. casual. happy. crouching. sitting.

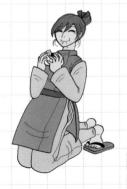

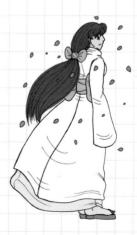

teenage female traditional asian search criteria cheongsam. smart. happy. standing.

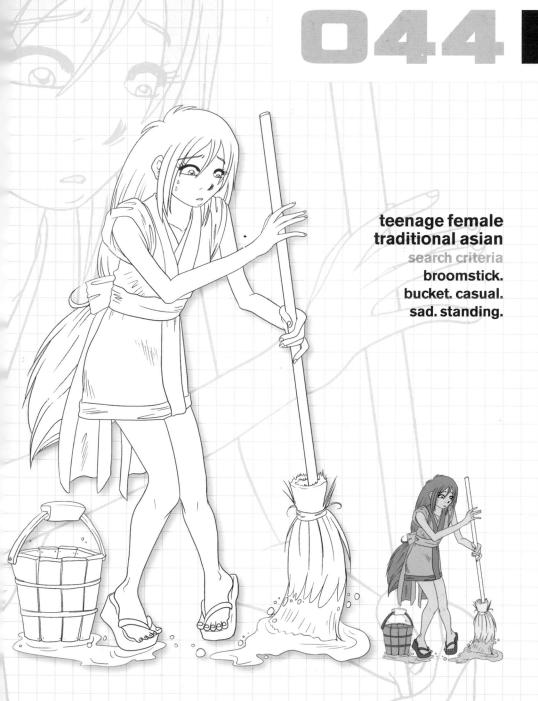

teenage female traditional asian

search criteria

bag. kimono. smart. happy. standing. geta.

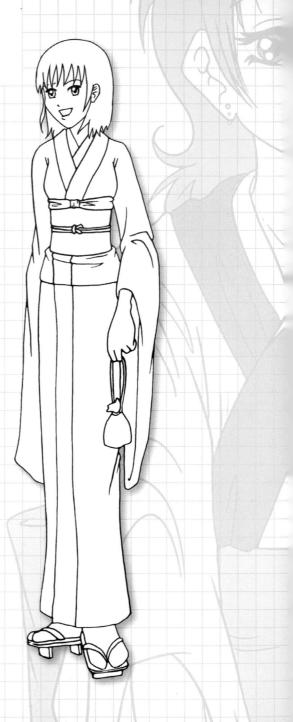

search criteria

kimono. happy. standing. walking. dance. casual.

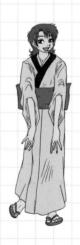

search criteria

standing. fighting. smart. martial arts. cheongsam. action.

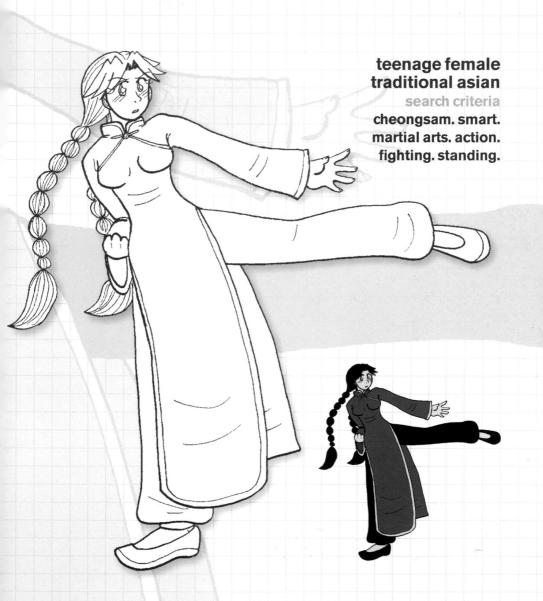

04.9

teenage female traditional asian

search criteria

cheongsam. smart. happy. waving. standing. dance.

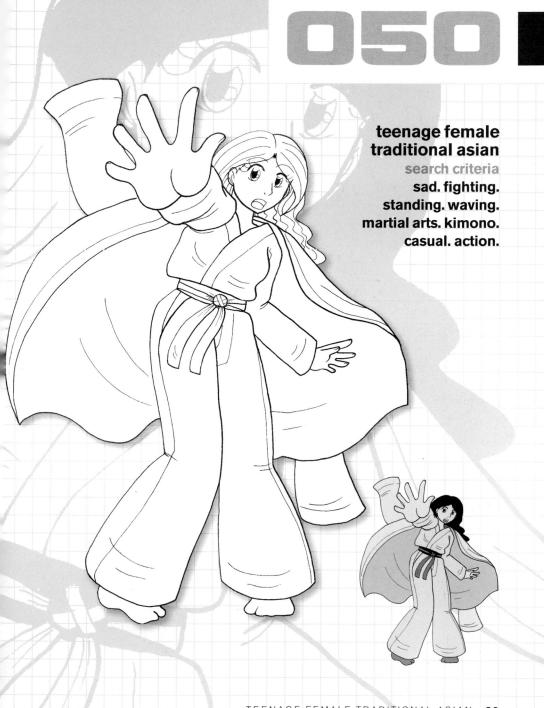

teenage female traditional asian

search criteria

hat. guitar. sanshin. kimono. music. smart. happy. standing.

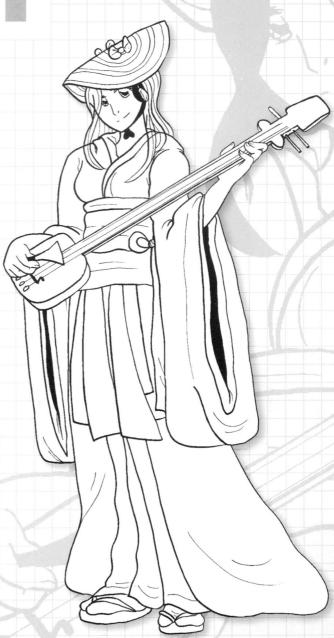

search criteria

bag. geta. kimono. smart. sad. standing.

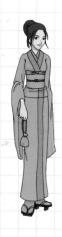

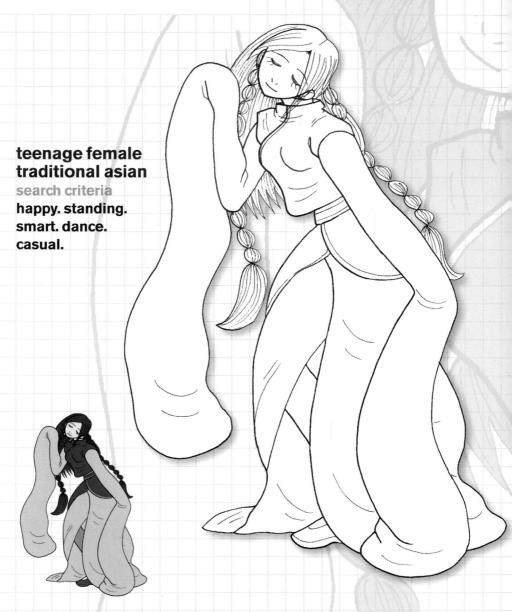

sad. crouching. sitting. smart. kimono.

teenage female traditional asian search criteria weapon. knife. action. warrior. jumping. 64 500 MANGA CHARACTERS

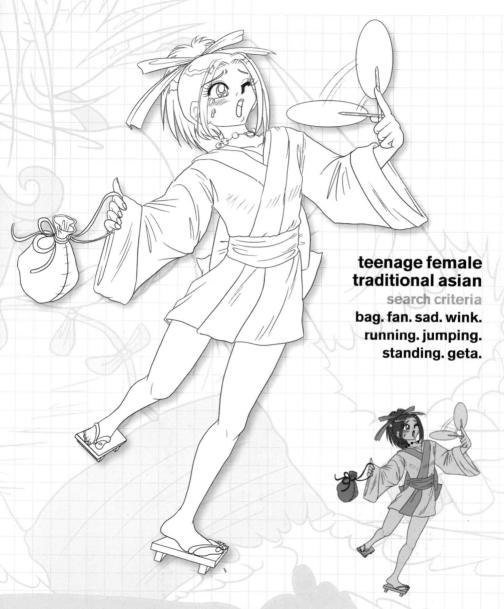

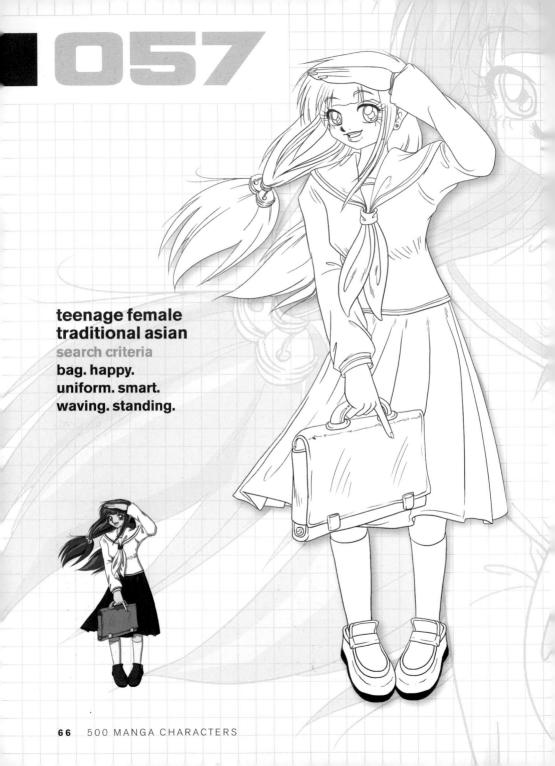

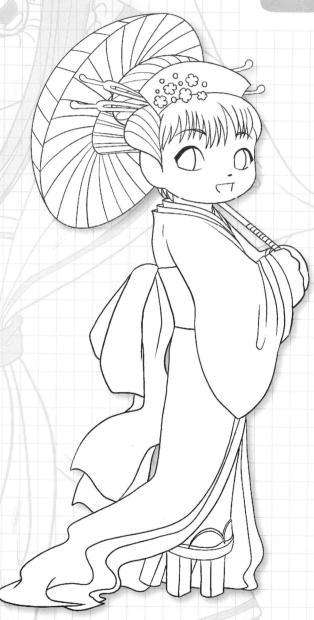

teenage female traditional asian

search criteria

chibi. umbrella. hat. kimono. happy. walking. standing. geta.

teenage female traditional asian

search criteria

standing. sad. kimono. casual.

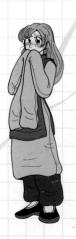

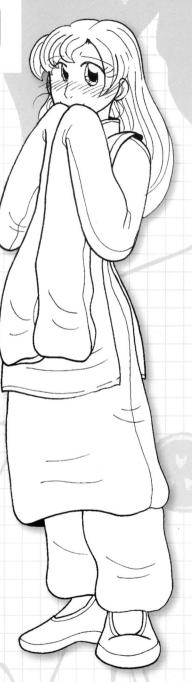

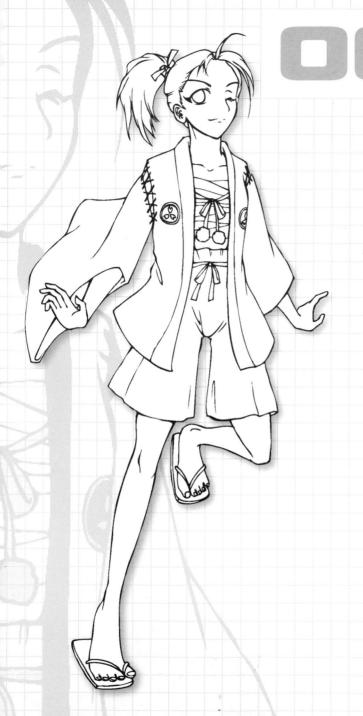

teenage female traditional asian

search criteria

bow. happy. standing. running. jumping. wink.

teenage female traditional asian

search criteria

fan. kimono. smart. happy. standing. walking.

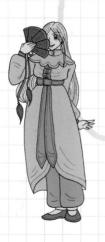

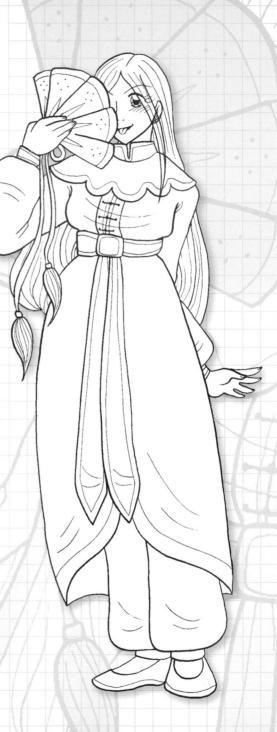

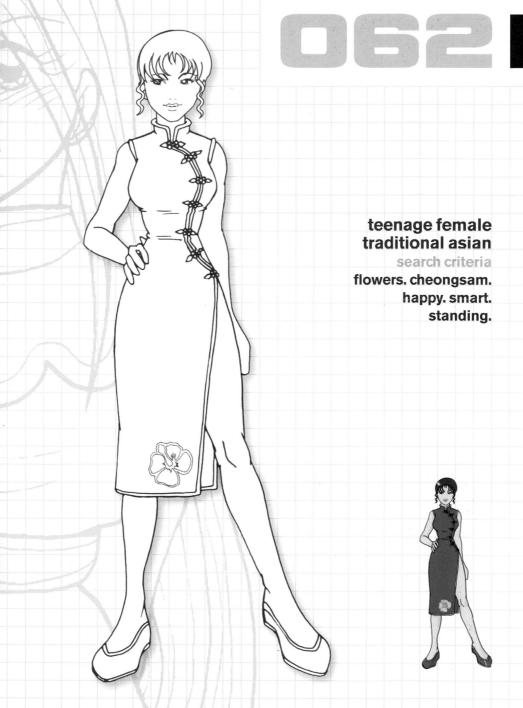

teenage female traditional asian

search criteria

food. animal. fish. bag. happy. kimono. geta. standing. walking.

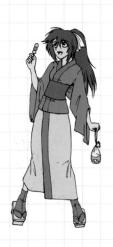

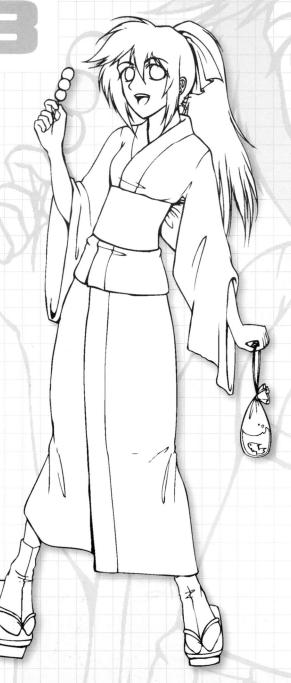

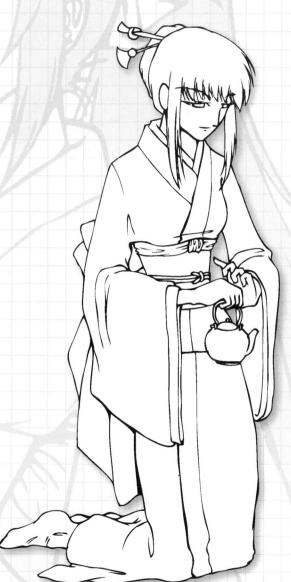

teenage female traditional asian

search criteria

teapot. kimono. food. sad. crouching. sitting.

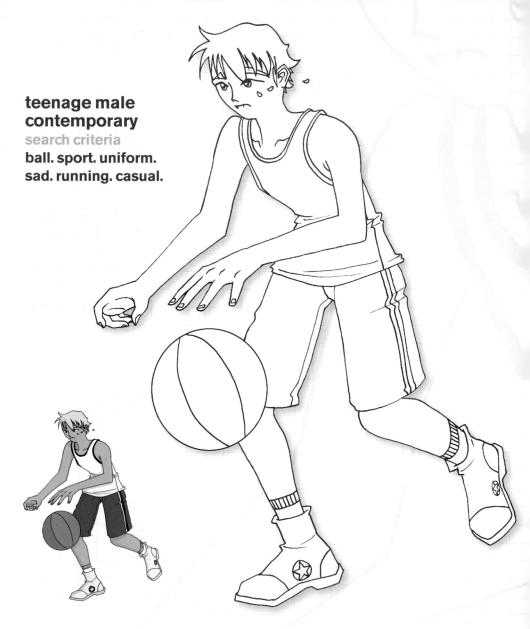

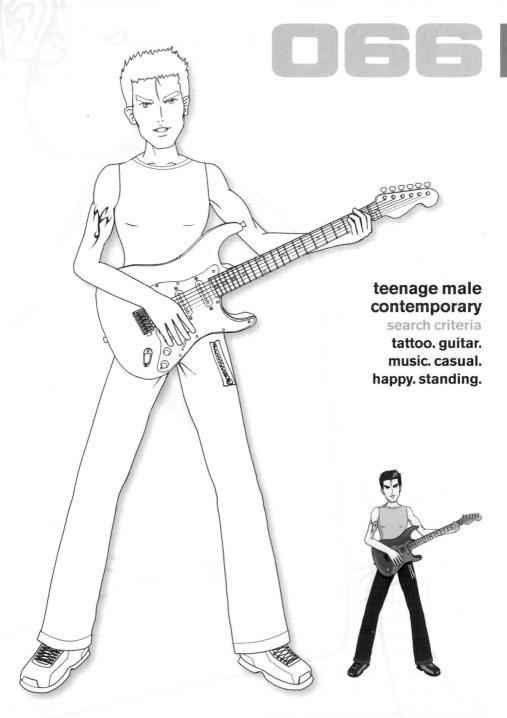

teenage male contemporary

search criteria

bag. glasses. casual. sad. walking. standing.

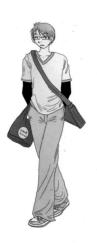

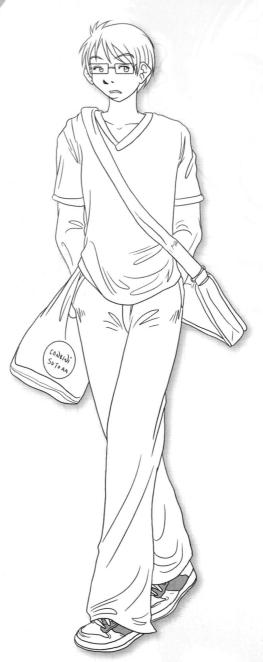

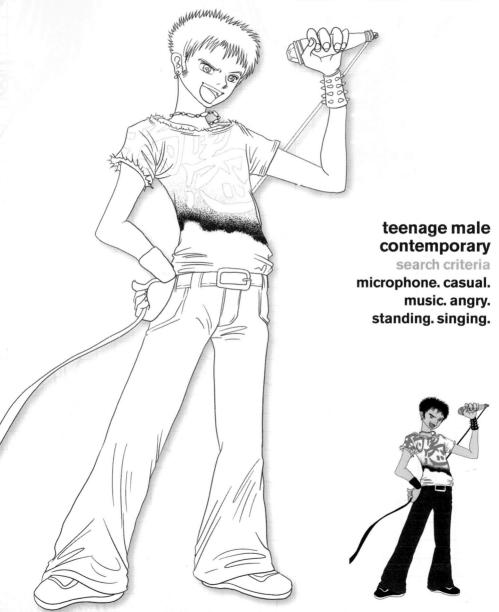

teenage male contemporary

search criteria

hat. skateboard. casual. sport. happy. walking. waving. standing.

search criteria

chain. casual. future. happy. standing.

teenage male contemporary

search criteria bag. music. casual. happy. standing. singing.

search criteria

bag. casual. sad. standing. crouching.

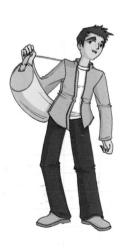

teenage male contemporary

search criteria

chibi. casual. smart. happy. walking. standing.

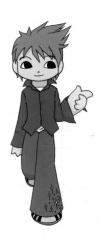

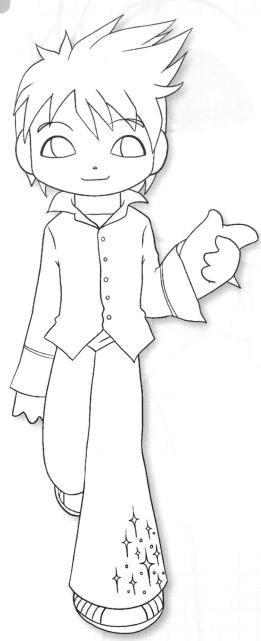

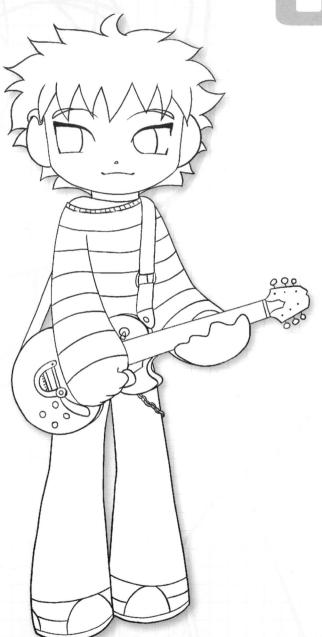

teenage male contemporary

search criteria

chibi. guitar. music. casual. happy. standing.

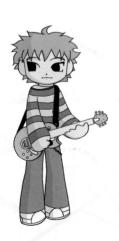

teenage male contemporary

search criteria

casual. sport. action. happy. fighting. standing.

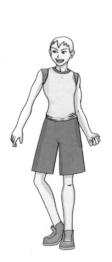

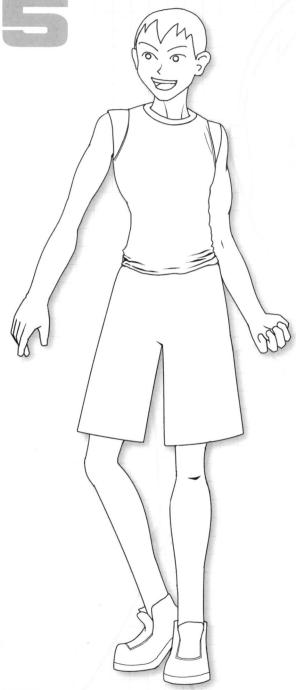

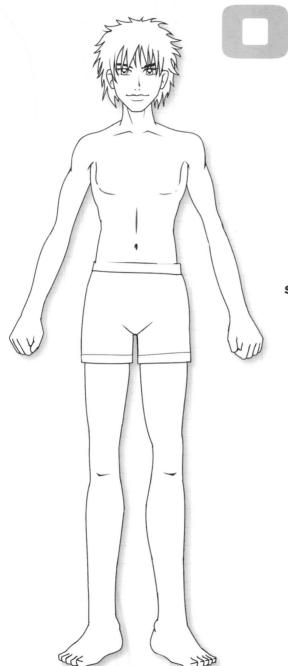

search criteria

casual. sport. swimwear. happy. standing. swimming.

search criteria

casual. action. sport. sad. standing. fighting.

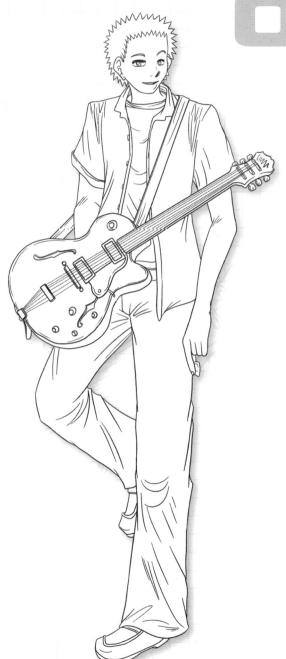

search criteria

guitar. plectrum. casual. music. happy. standing.

teenage male contemporary

search criteria

skateboard. casual. sport. sad. angry. standing.

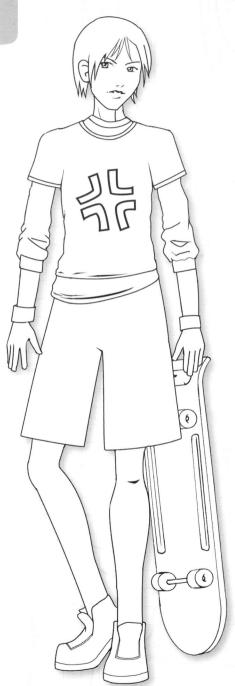

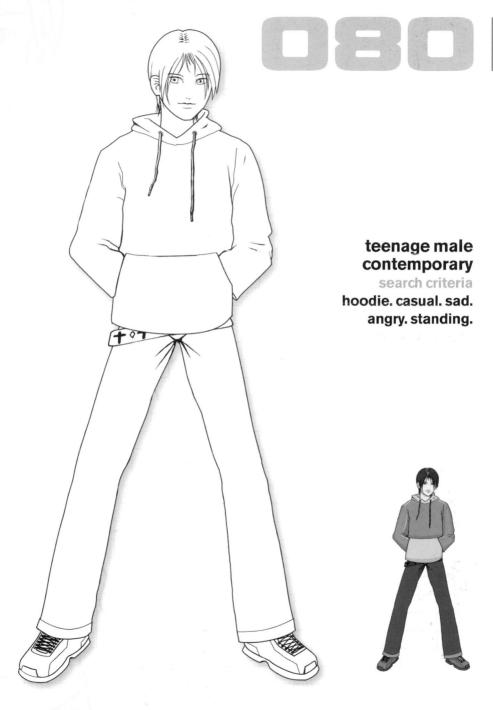

search criteria

towel. goggles. casual. swimwear. sad. standing. swimming. walking.

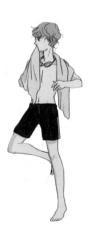

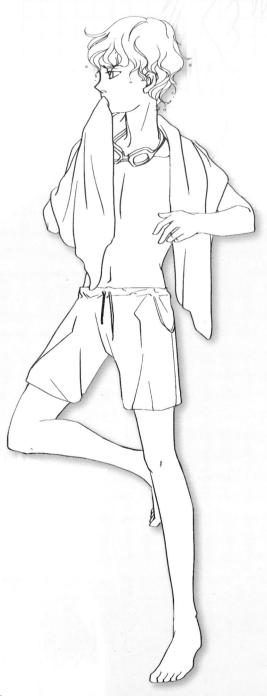

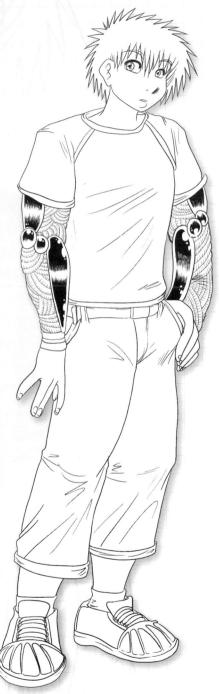

search criteria

tattoo. casual. sad. angry. standing.

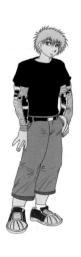

teenage male contemporary

search criteria

cigarette. tattoo. casual. sad. angry. standing.

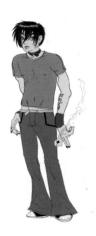

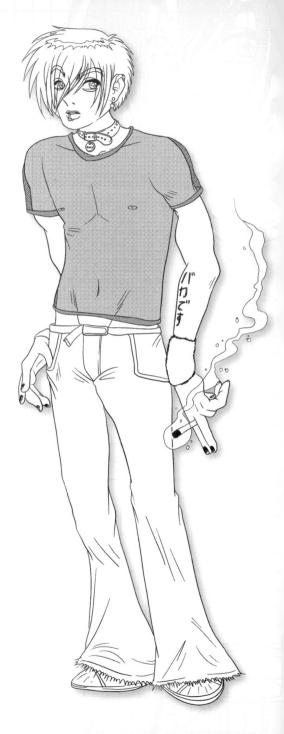

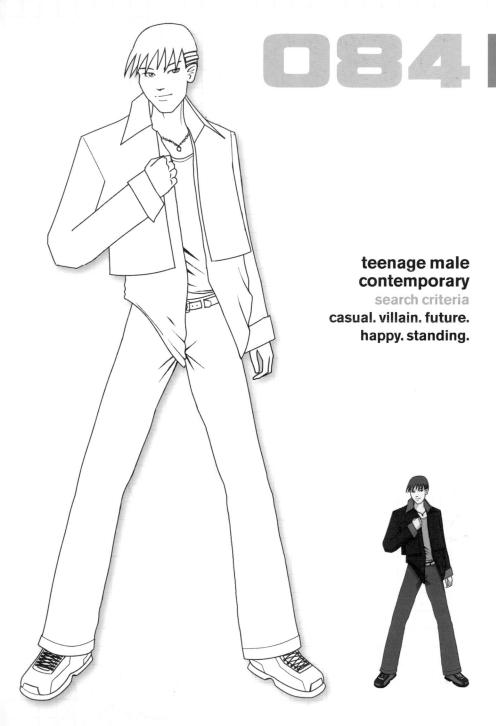

teenage male contemporary

search criteria

villain. smart. suit. future. sad. standing.

teenage male contemporary

search criteria

suit. smart. sad. casual. walking. standing.

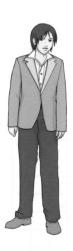

teenage male contemporary

search criteria

spray can. chain. tattoo. casual. sad. standing.

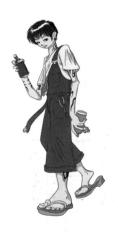

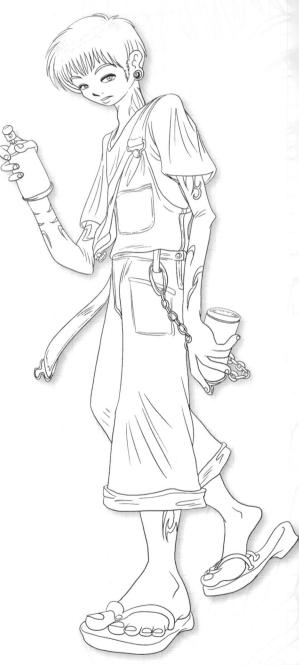

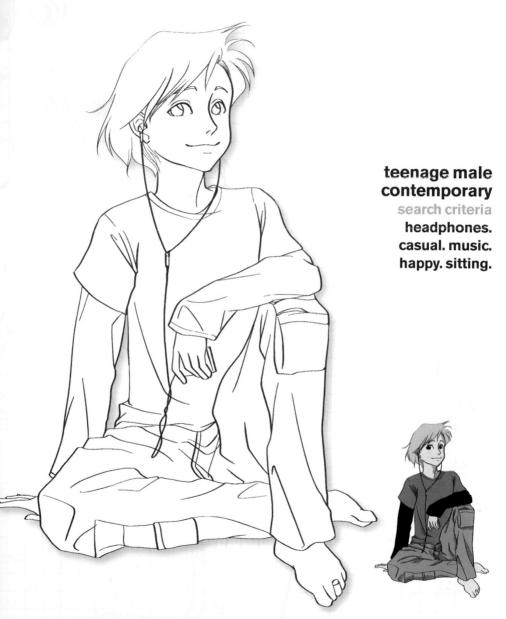

teenage male contemporary

search criteria

hat. food. knife. historical. casual. angry. sitting.

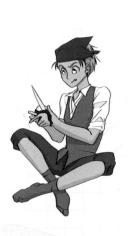

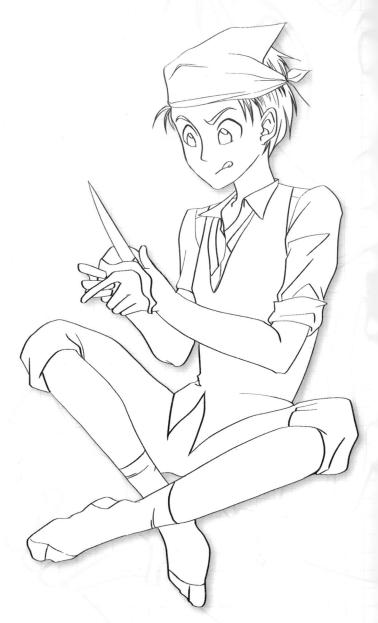

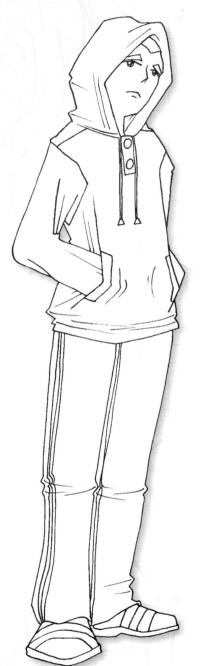

search criteria

hoodie. casual. villain. sad. standing.

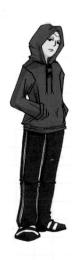

teenage male contemporary

search criteria

watch. casual. sad. angry. standing.

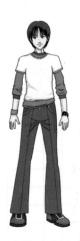

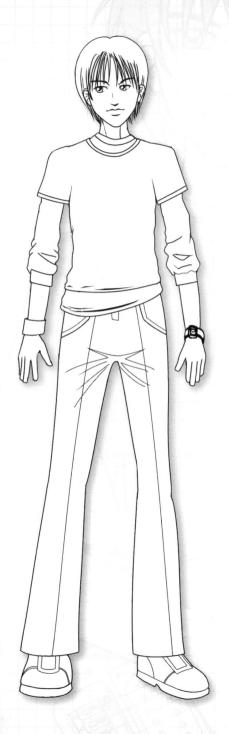

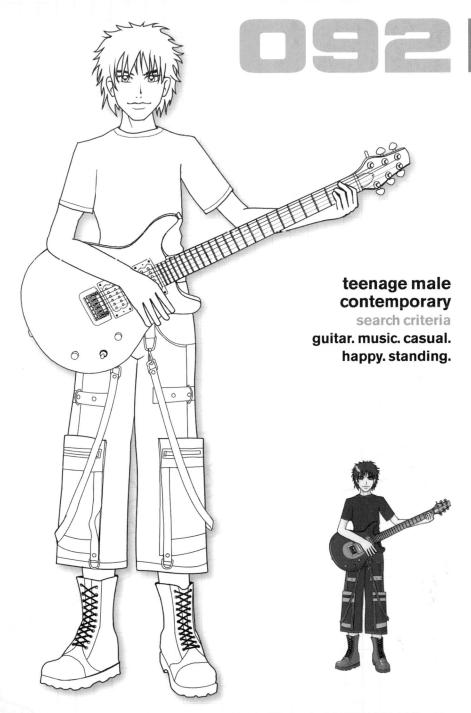

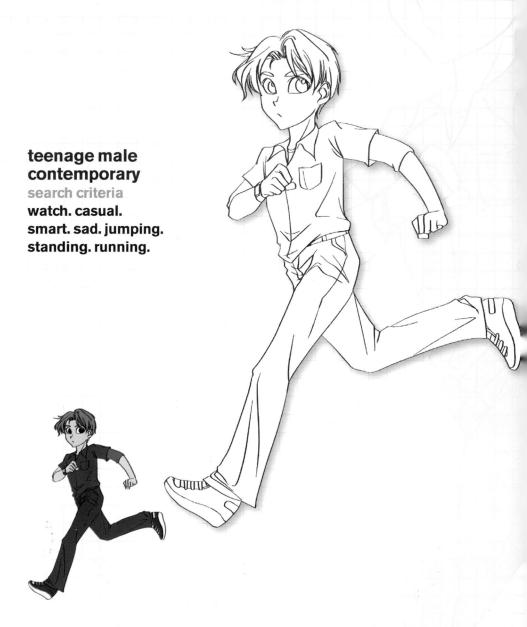

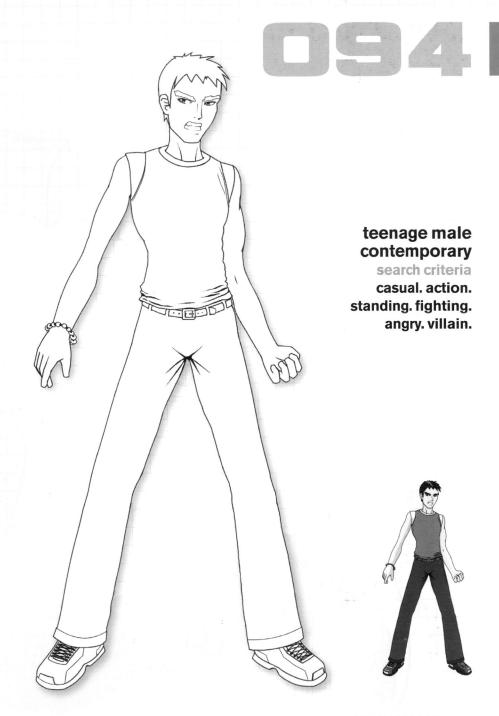

teenage male contemporary

search criteria

chibi. skull. sad. casual. standing. walking.

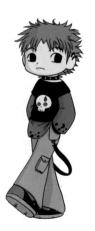

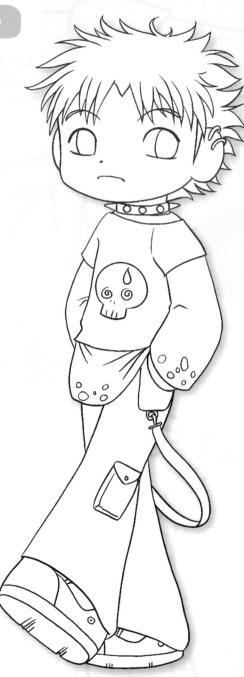

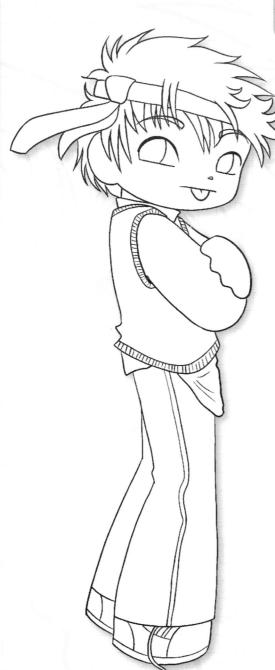

search criteria

chibi. casual. future. standing. angry.

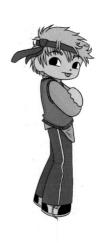

teenage male traditional asian

search criteria

weapon. sword. keikogi. martial arts. happy. fighting. standing. action.

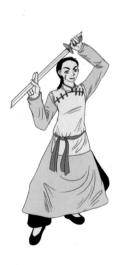

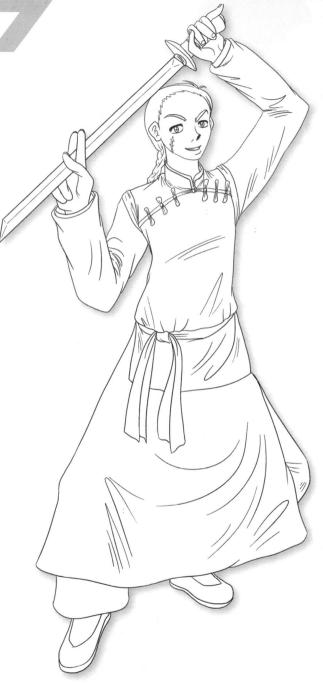

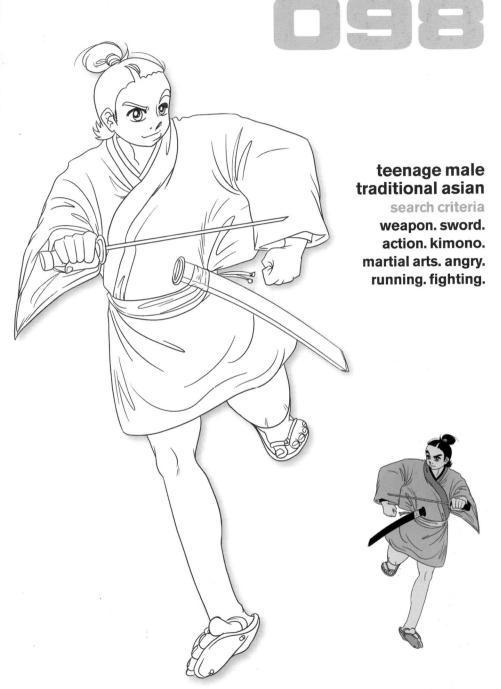

teenage male traditional asian

search criteria

weapon. pipe. action. martial arts. angry. standing. fighting.

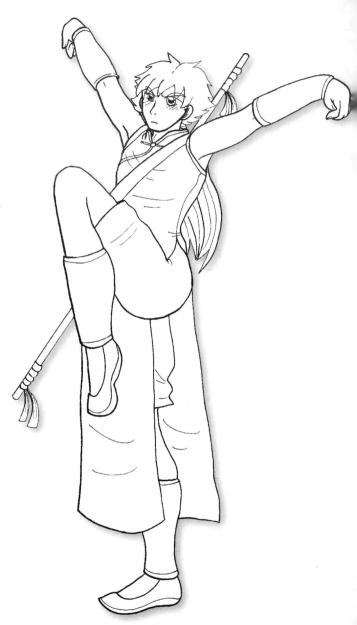

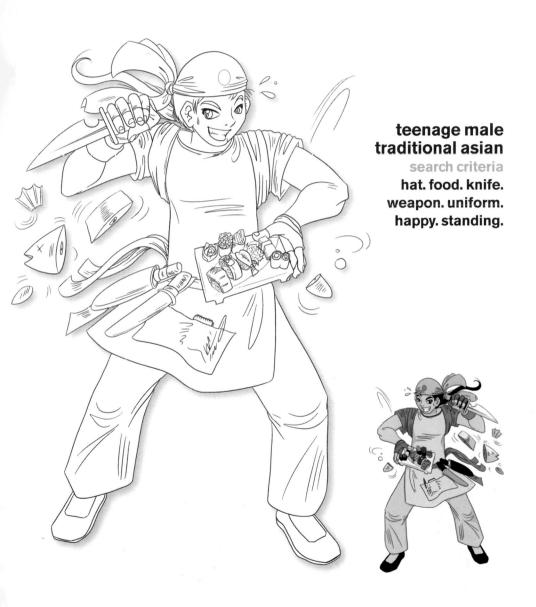

teenage male traditional asian

search criteria umbrella. kimono. casual. happy. standing.

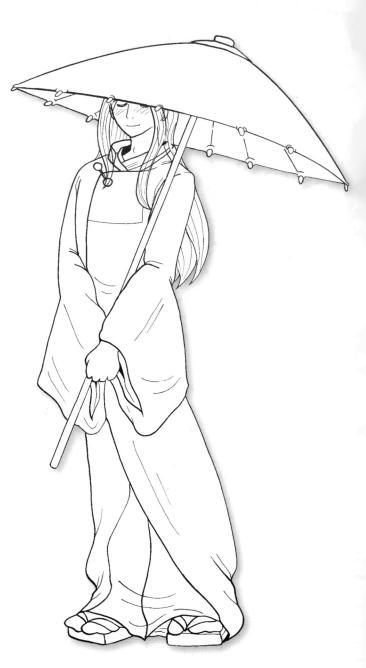

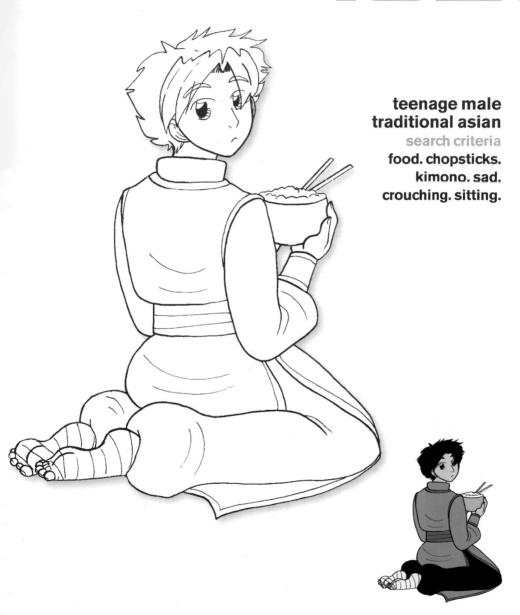

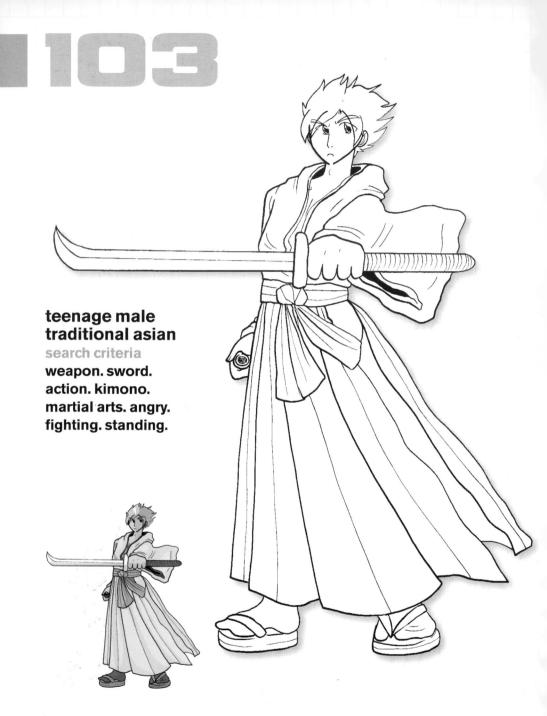

teenage male traditional asian

search criteria

weapon. sword. action. kimono. martial arts. happy. fighting. standing.

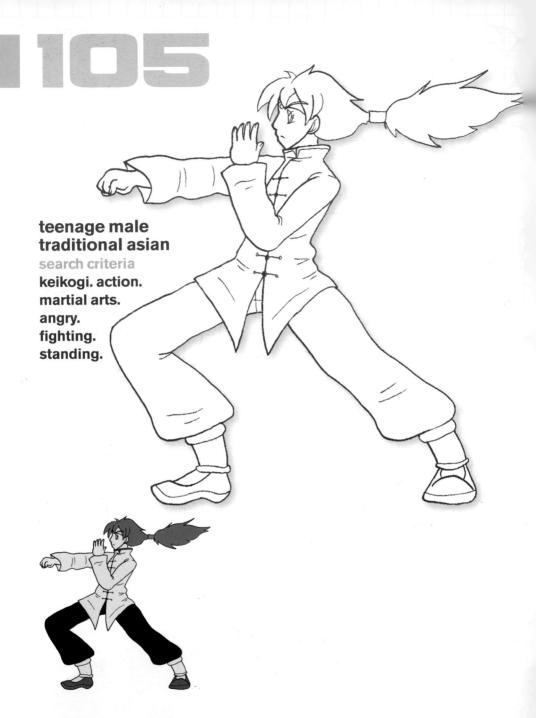

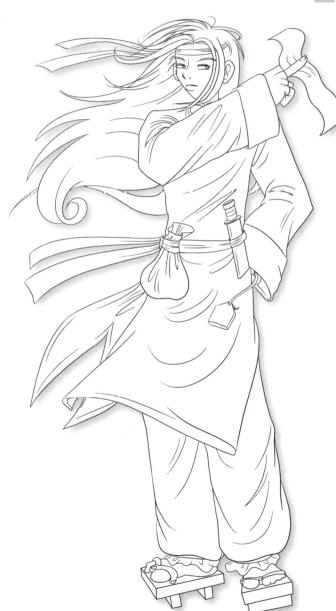

teenage male traditional asian

search criteria

geta. bag. knife. weapon. kimono. angry. standing.

teenage male traditional asian

search criteria

weapon. sword. action. kimono. martial arts. standing. fighting. sad.

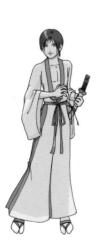

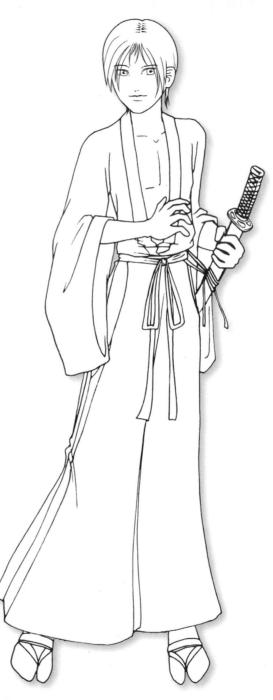

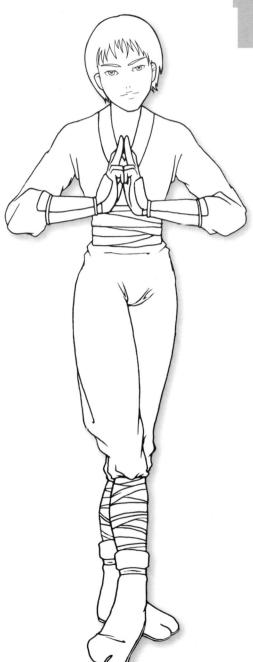

teenage male traditional asian

search criteria action. sad. martial arts. angry. standing.

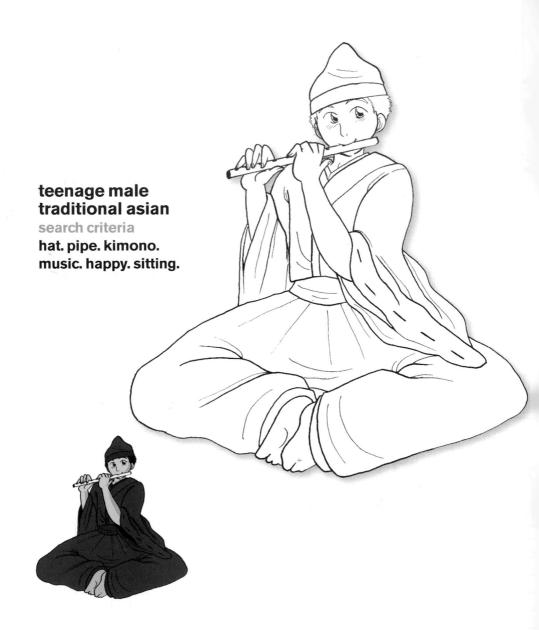

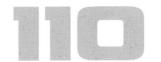

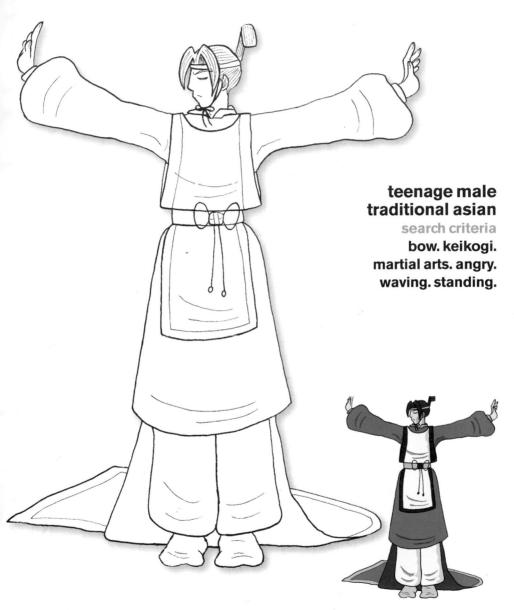

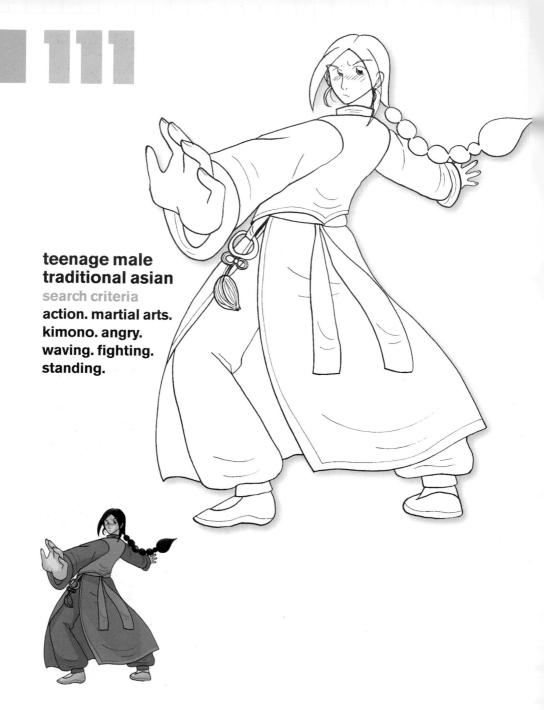

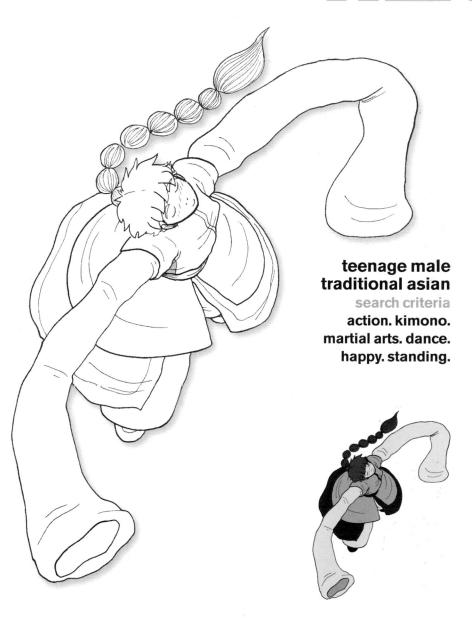

teenage male traditional asian

search criteria chibi. geta. hat. casual. happy. standing.

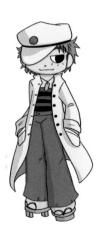

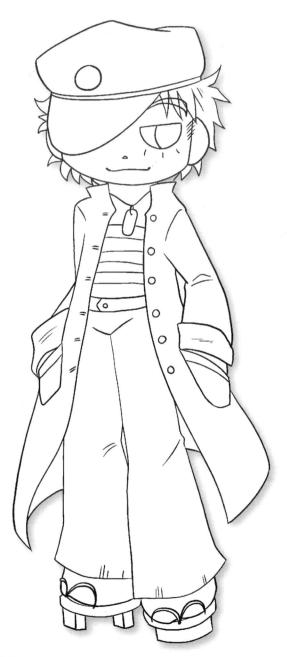

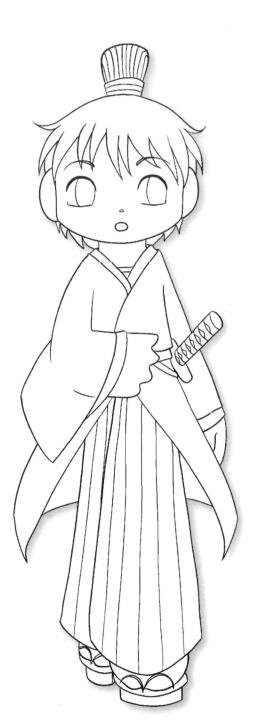

114.

teenage male traditional asian

search criteria

chibi. weapon. sword. geta. action. kimono. sad. standing. walking. fighting.

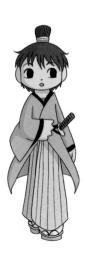

teenage male traditional asian

search criteria

chibi. happy. smart. standing. walking.

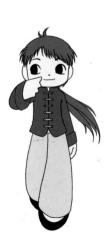

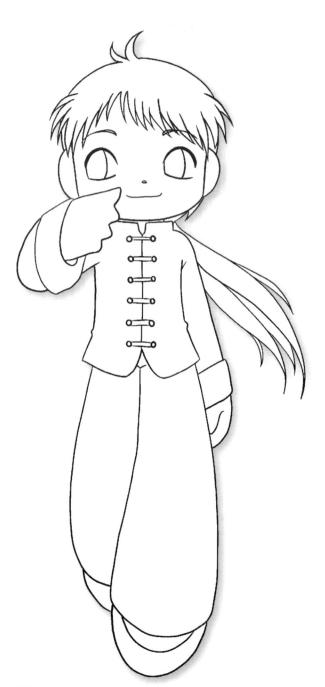

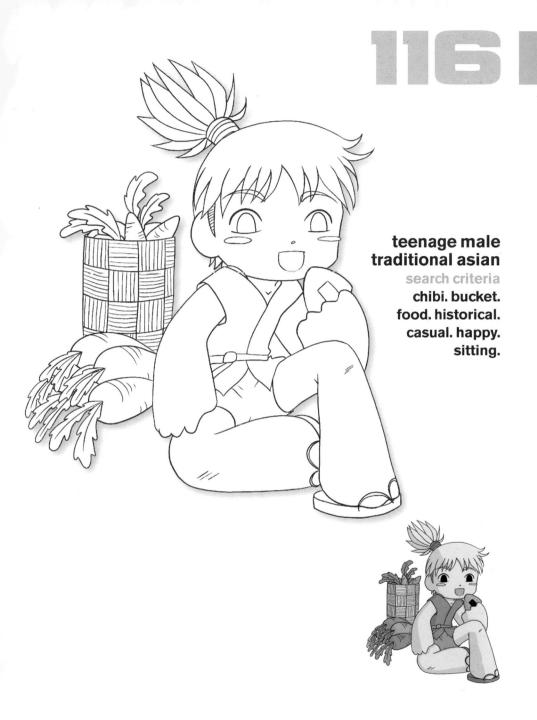

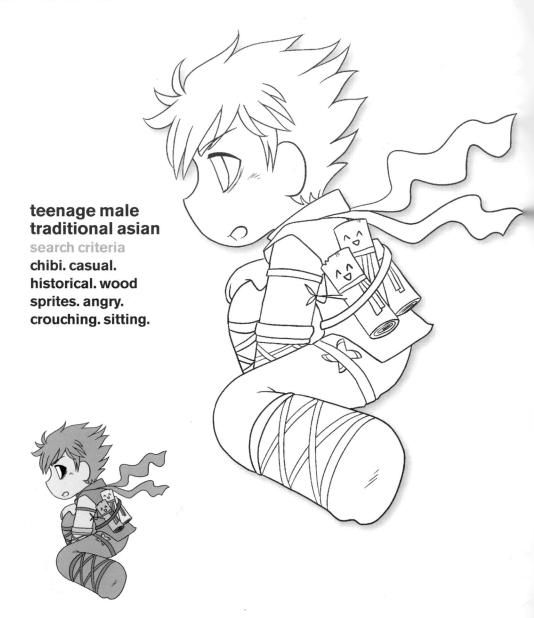

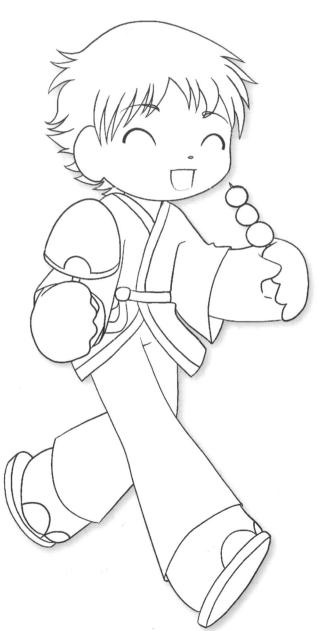

teenage male traditional asian

search criteria

chibi. food. kimono. happy. walking. standing.

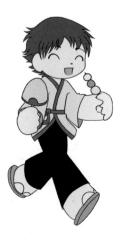

teenage male traditional asian

search criteria

bag. sad. smart. uniform. standing.

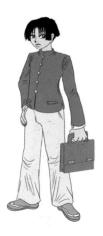

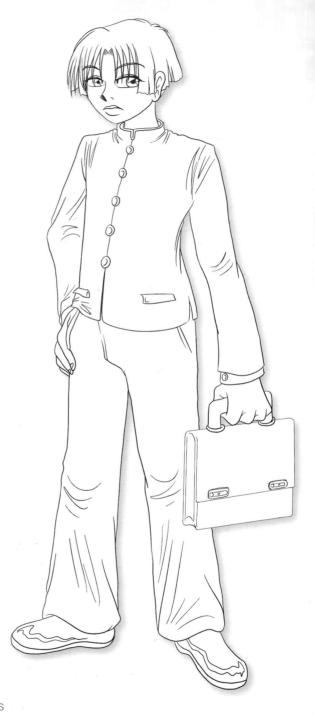

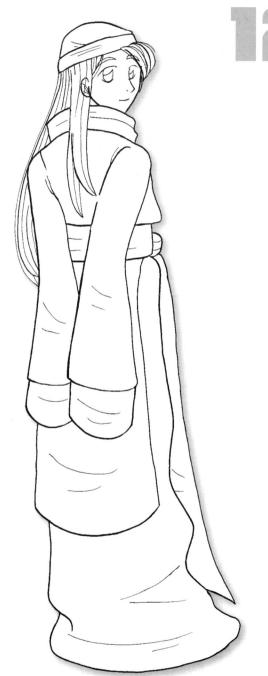

teenage male traditional asian

search criteria

hat. happy. kimono. standing. sad.

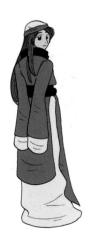

teenage male traditional asian

search criteria

happy. wink. waving. standing. kimono.

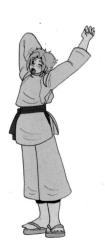

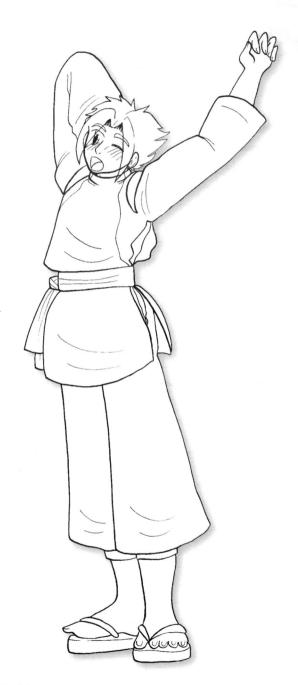

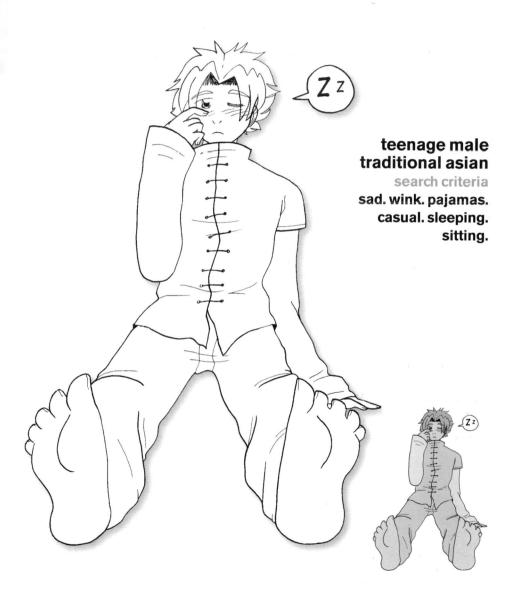

teenage male traditional asian

search criteria angry. sad. martial arts. action. standing.

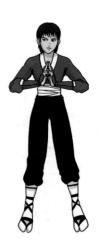

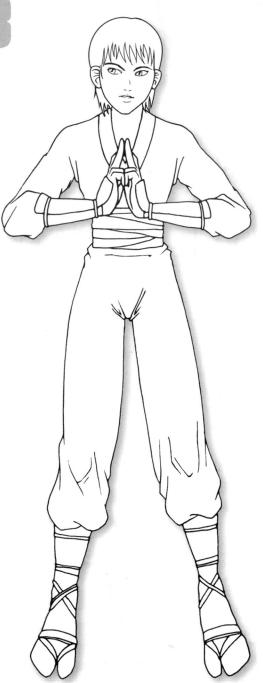

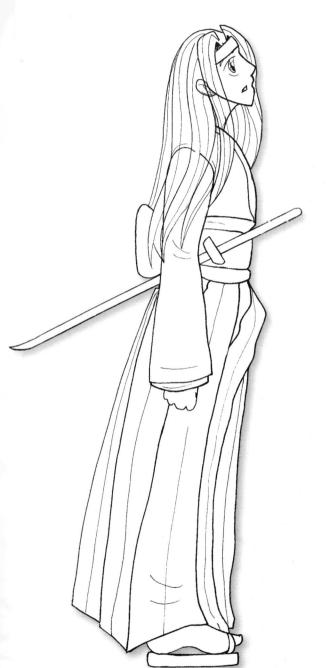

teenage male traditional asian

search criteria weapon. sword. action. kimono. martial arts. standing. fighting. sad.

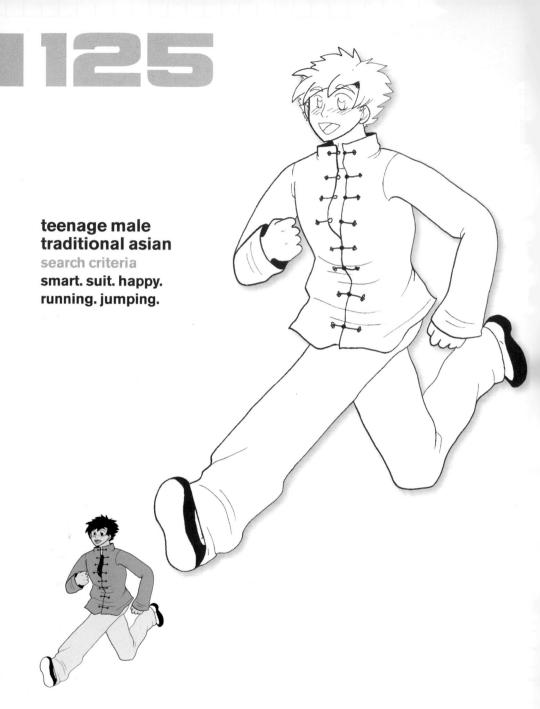

teenage male traditional asian

search criteria

fan. happy. kimono. smart. standing. waving.

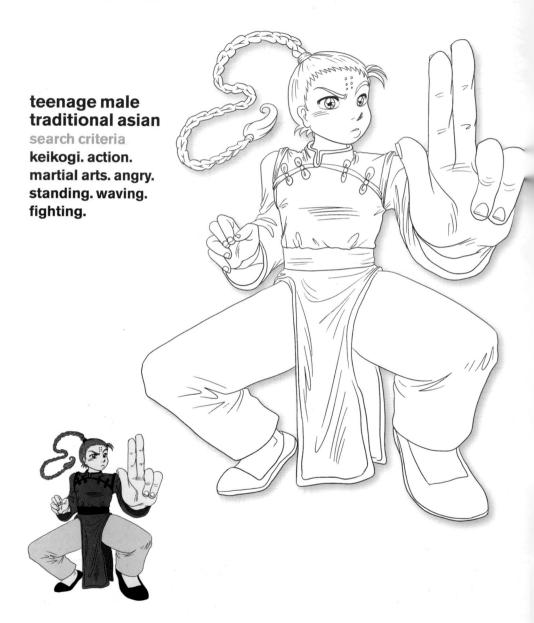

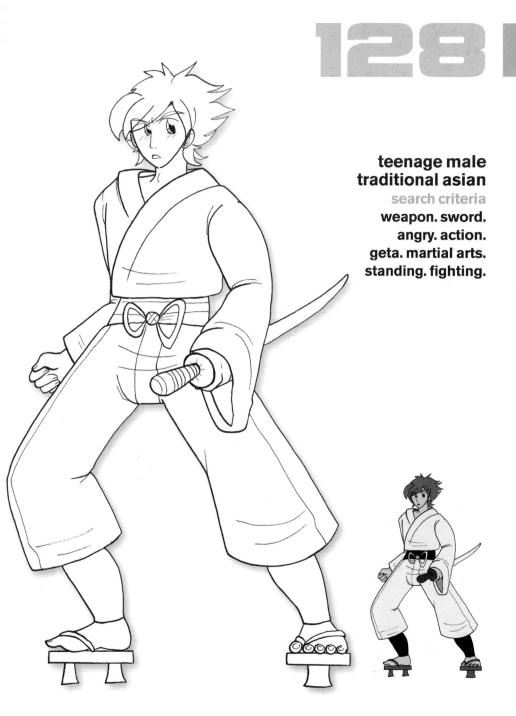

fantasy

search criteria

hat. gun. weapon. action. male. future. warrior. angry. standing.

fantasy

search criteria

hat. weapon. bow. arrow. animal. action. male. bird. wings. warrior. future. angry. standing.

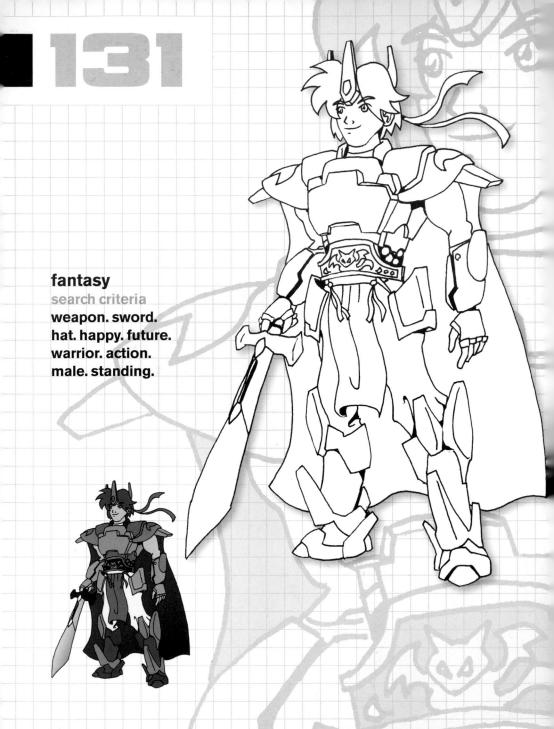

fantasy

search criteria

weapon. sword. shield. male. warrior. action. angry. standing. fighting.

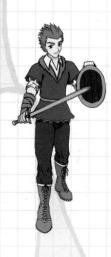

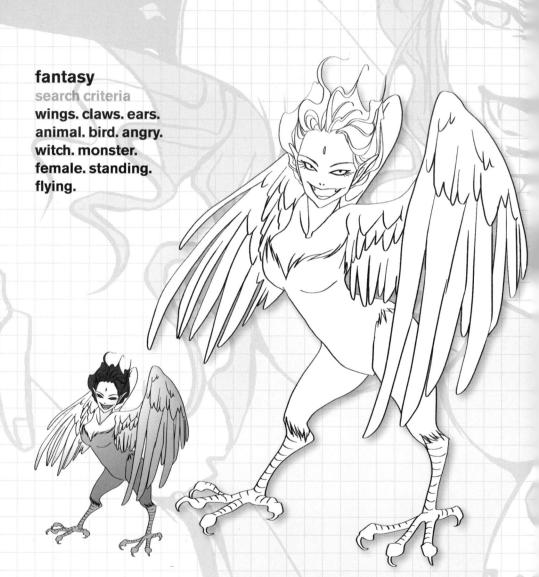

fantasy search criteria

wings. teeth. vampire. angry. feathers. ears. monster. crouching. female.

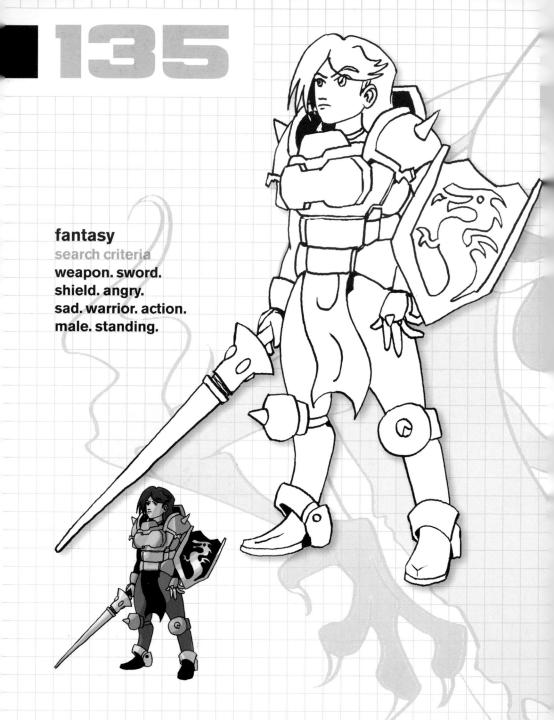

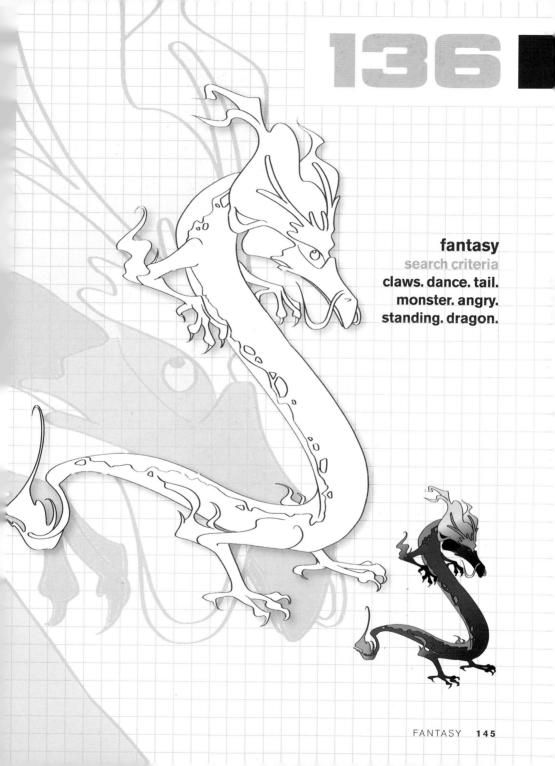

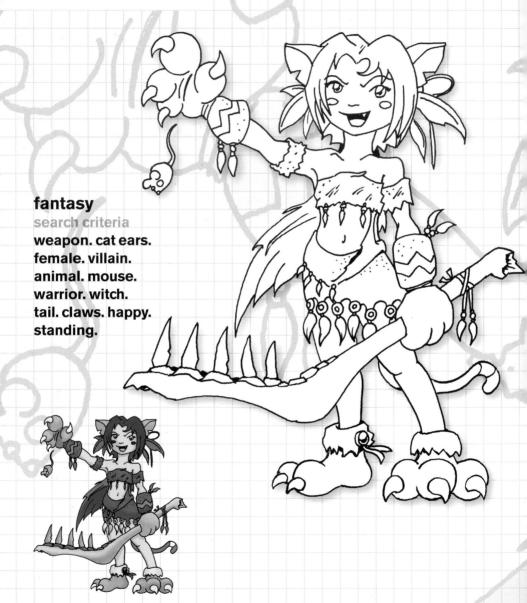

fantasy search criteria

ears. claws. tail. dragon. monster. female. sad. standing.

.))

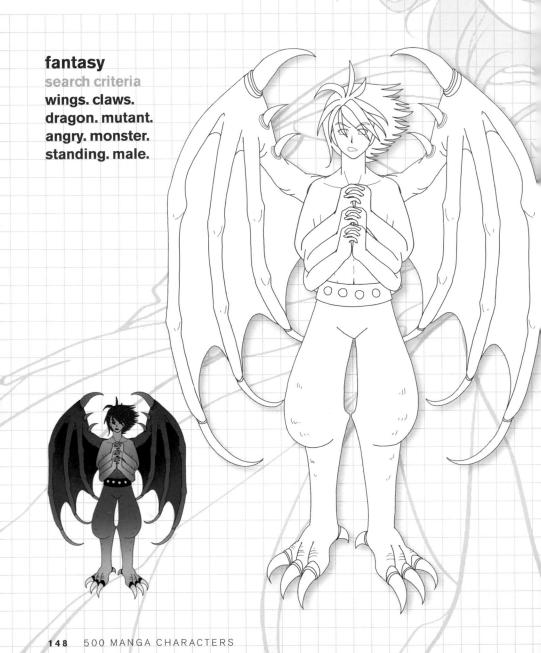

fantasy search criteria wings. ears. fairy. flying. horns. male. elf. angel.

happy. sitting.

fantasy search criteria

horns. angel. wings. feathers. male. sad. standing.

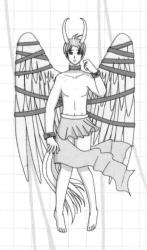

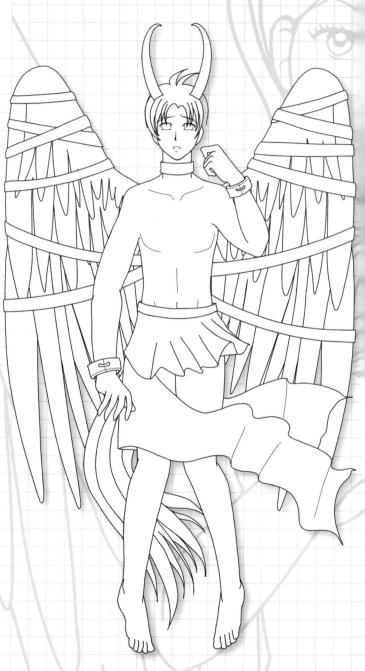

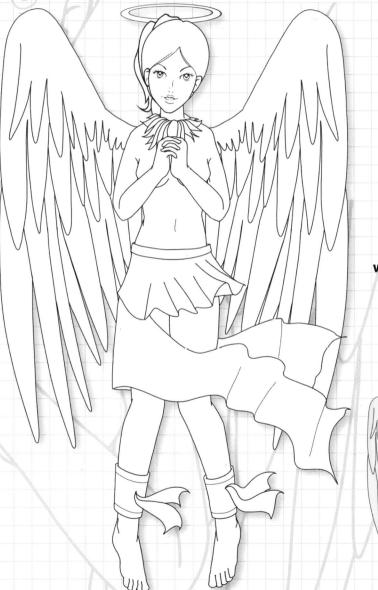

fantasy search criteria

female. sad. standing. halo. wings. feathers. angel.

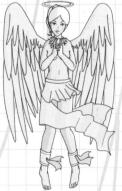

14.3

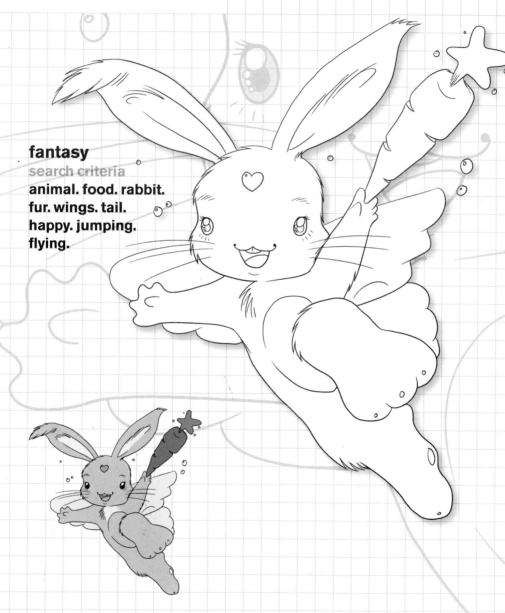

fantasy search criteria animal. cat. fur. tail. wings. happy. flying.

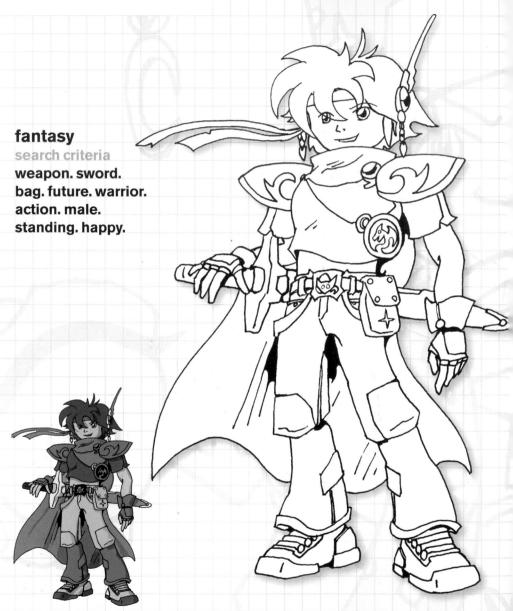

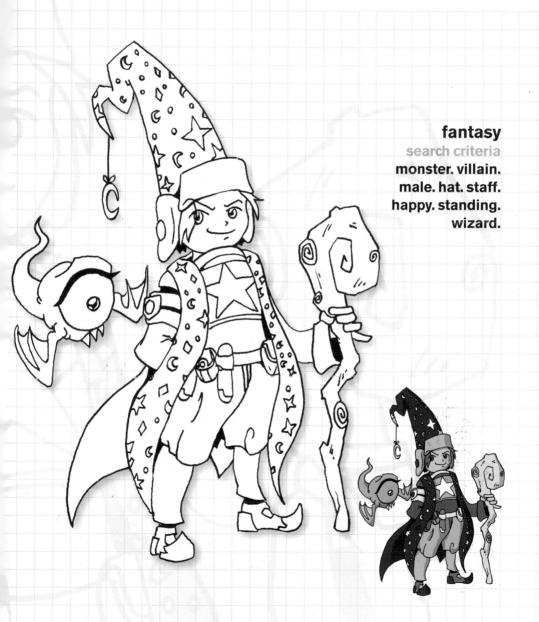

fantasy

search criteria

weapon. knife.
cigarette. money.
happy. casual. future.
action. villain. bag.
male. standing.

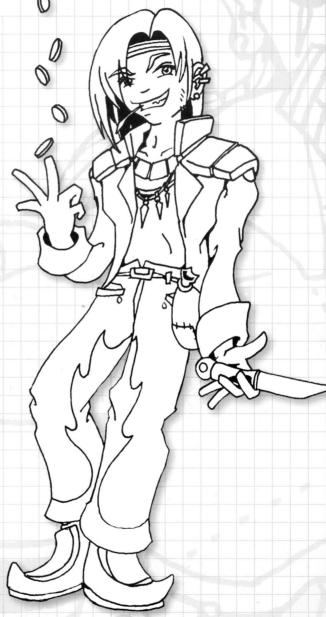

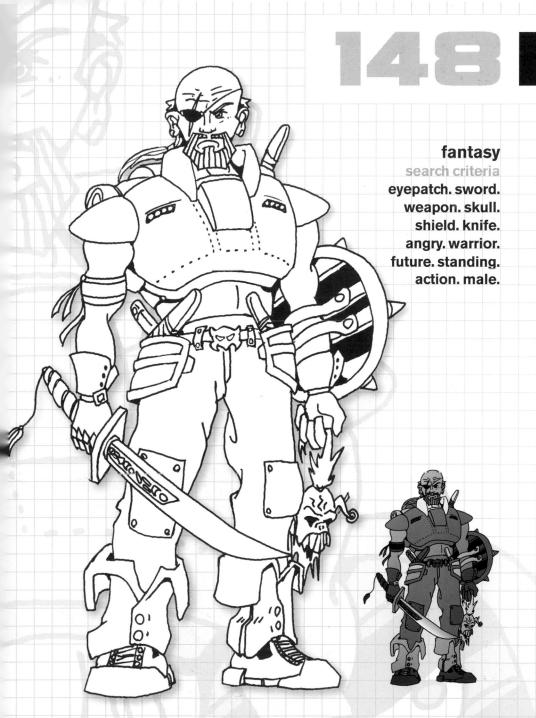

14.9

fantasy
search criteria
tail. fins.
mermaid.
swimming.
female. sad.
sea creature.

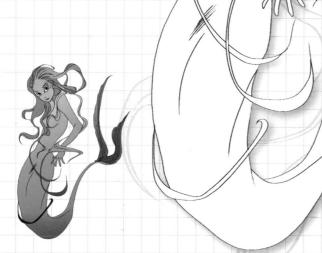

fantasy search criteria ears. sad. merman. sea creature. fins. tail. male. swimming. FANTASY 159

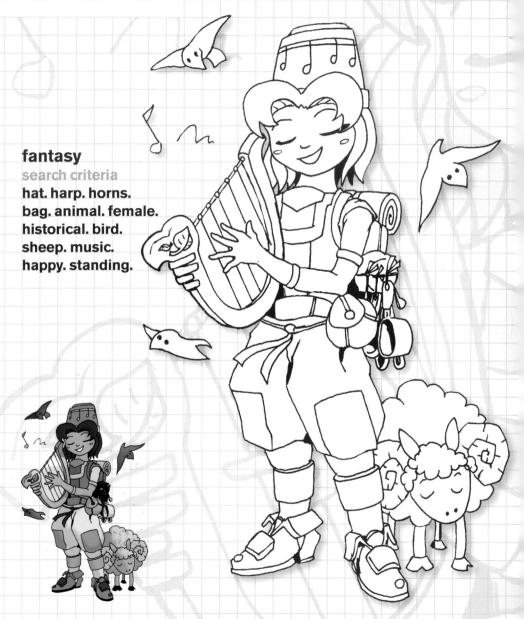

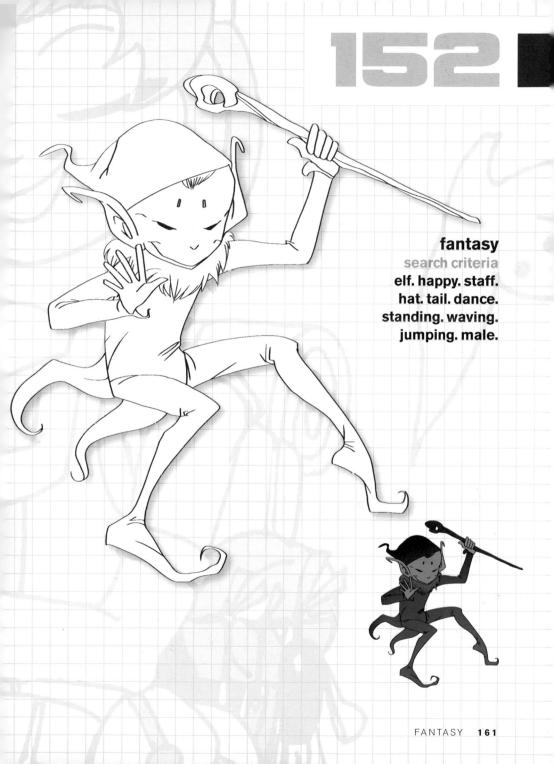

fantasy

search criteria

book. hat. chair. monster. male. happy. angry. future. wizard. ears. standing.

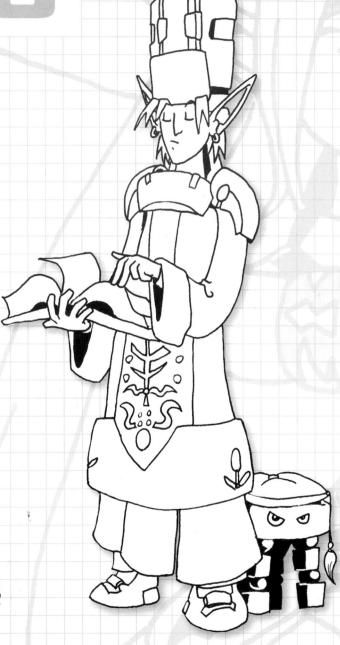

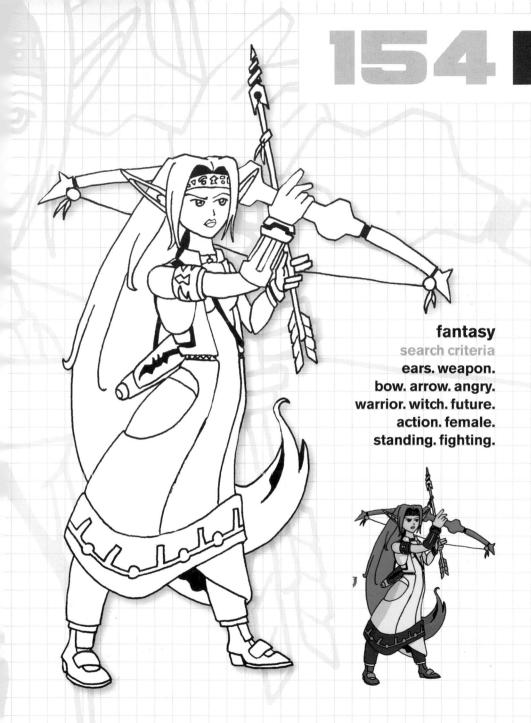

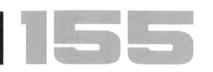

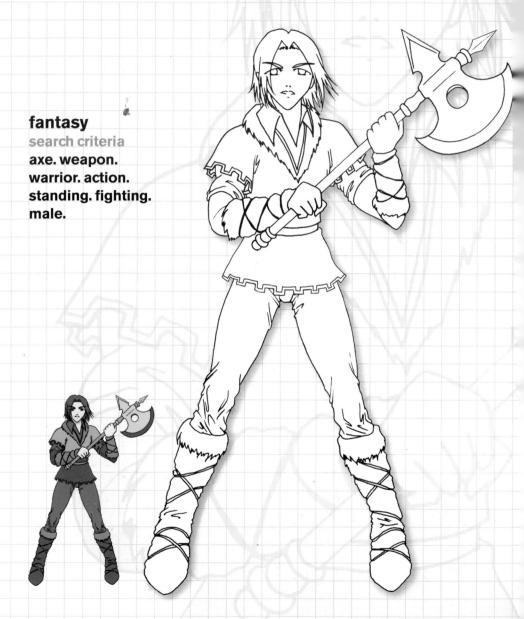

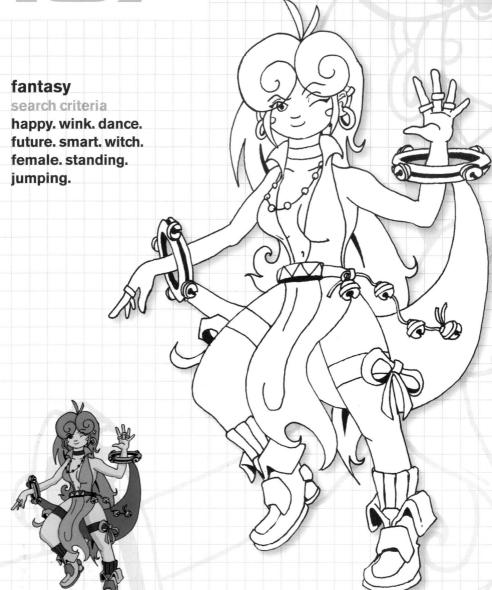

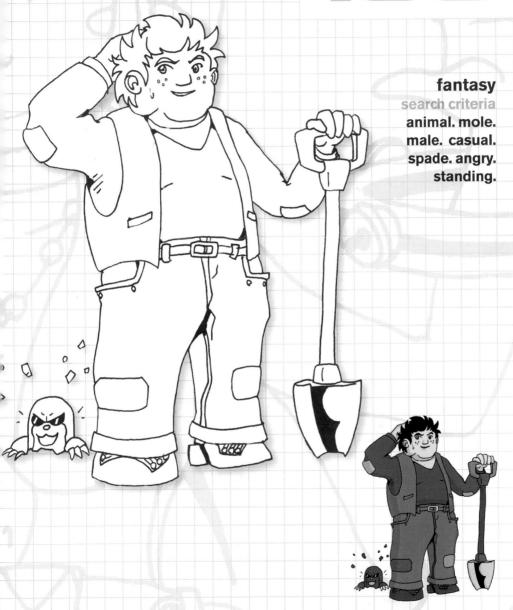

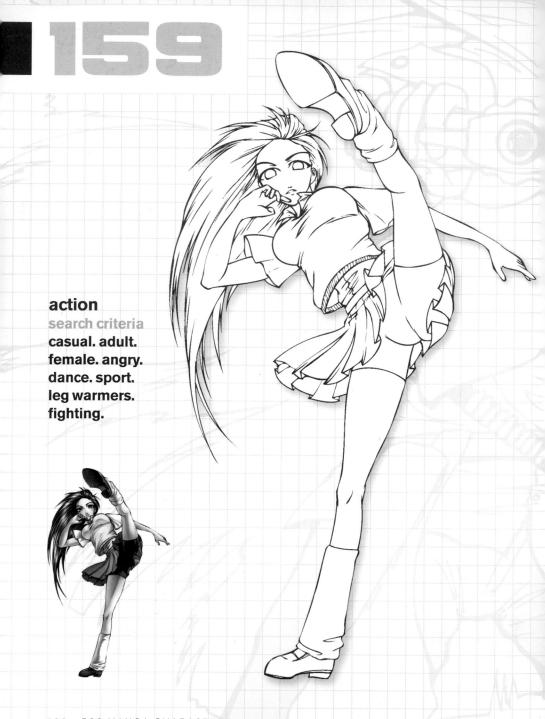

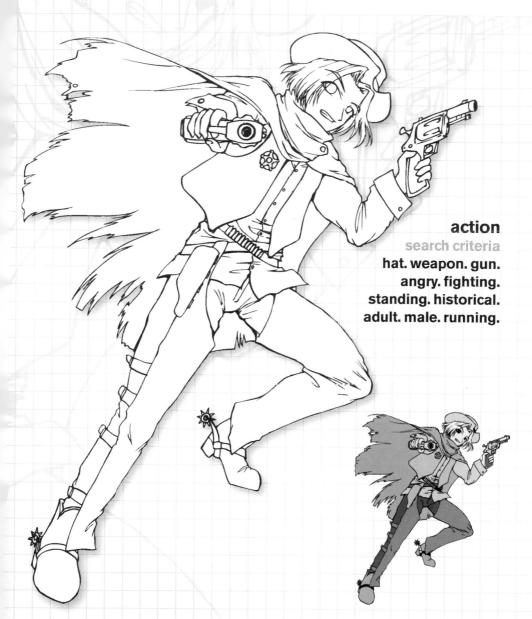

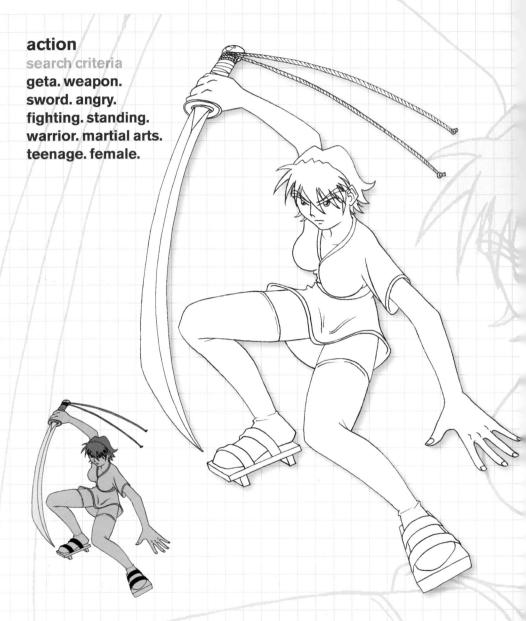

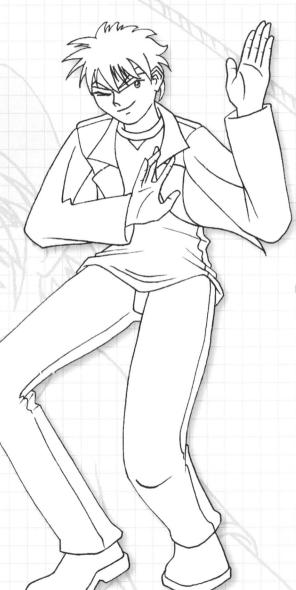

action

search criteria

happy. smart. martial arts. future. fighting. standing. adult. male.

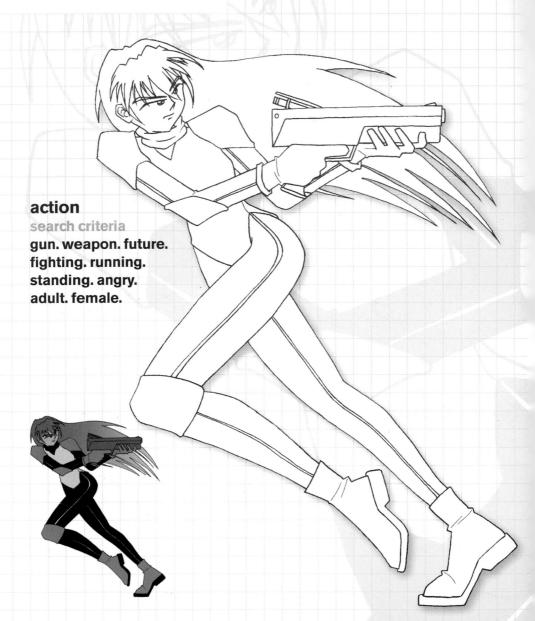

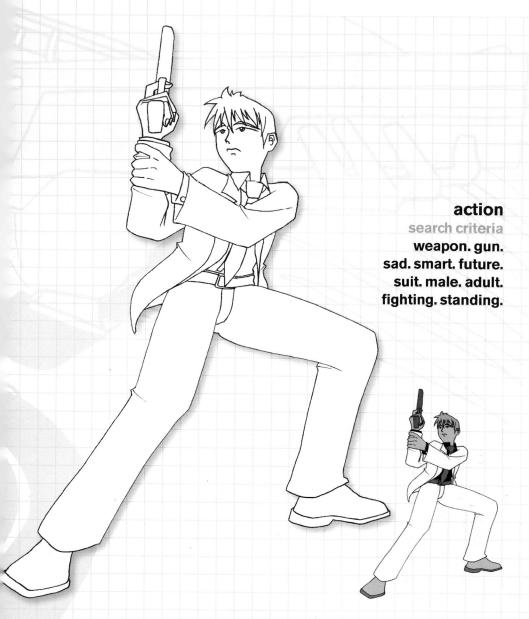

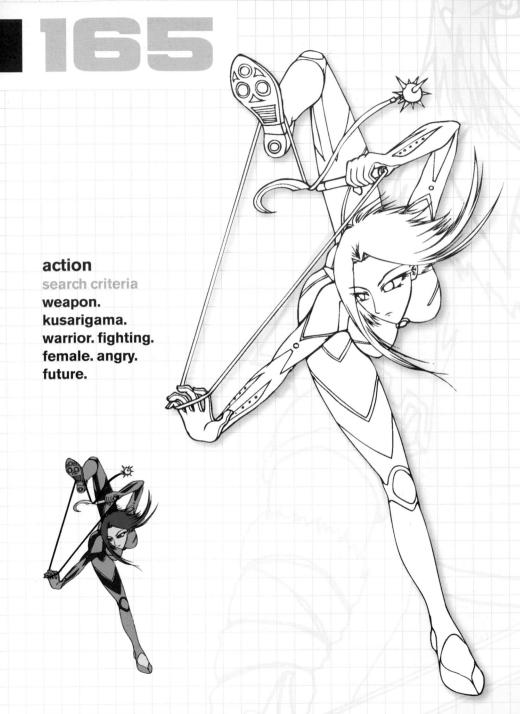

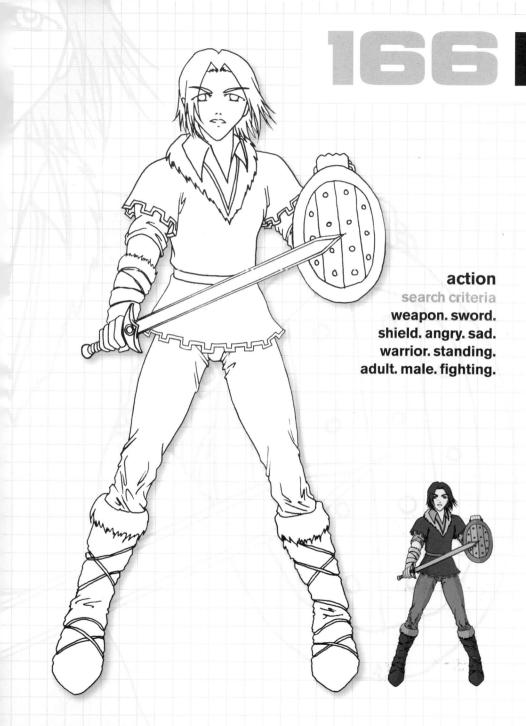

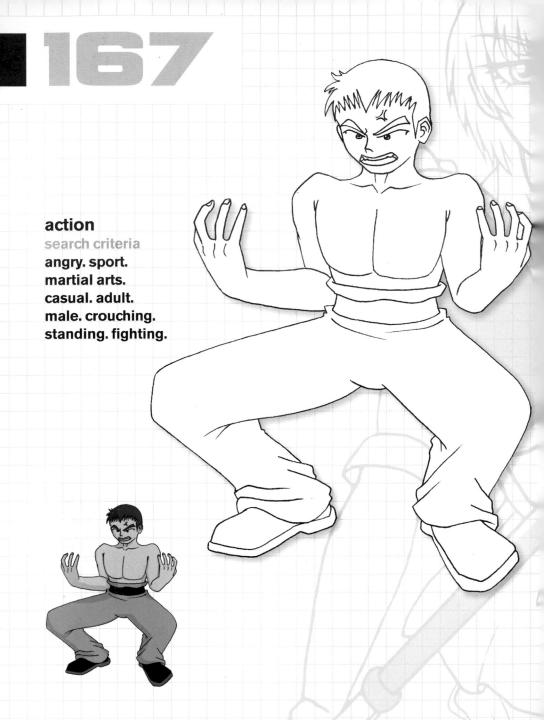

action search criteria

weapon. mace. shield. angry. warrior. standing. fighting. adult. female

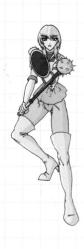

action

search criteria

weapon. sword. curved blades. warrior. male. adult. angry. fighting.

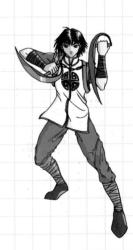

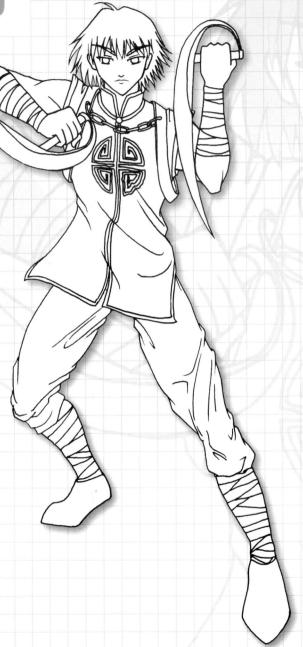

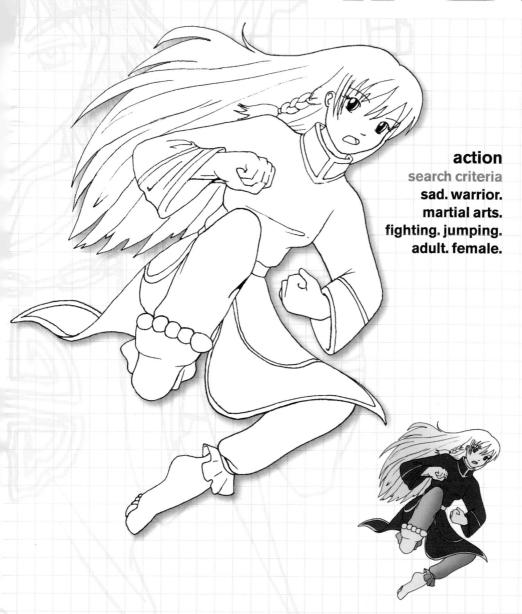

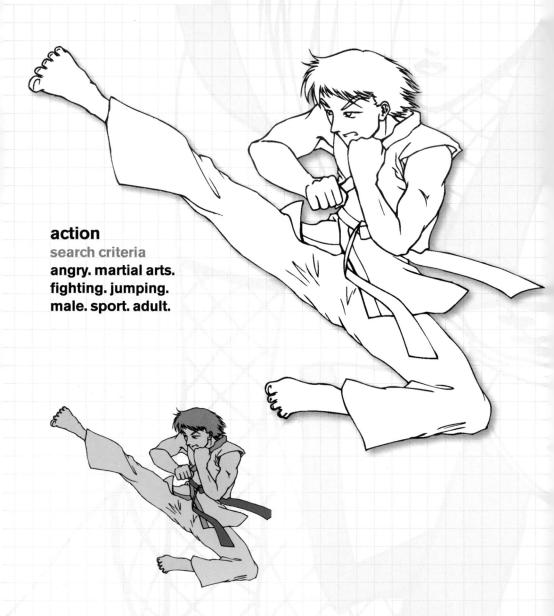

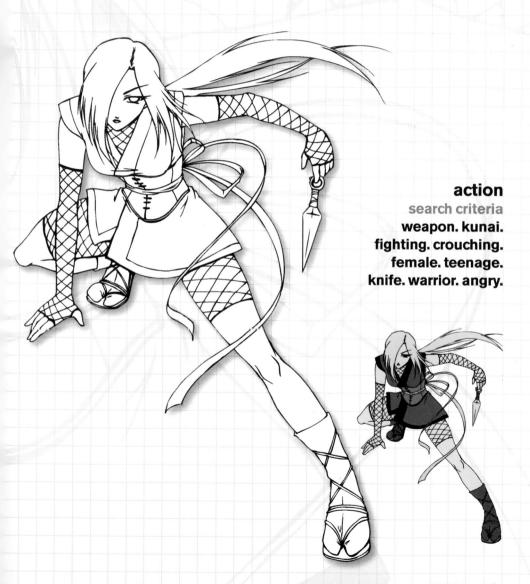

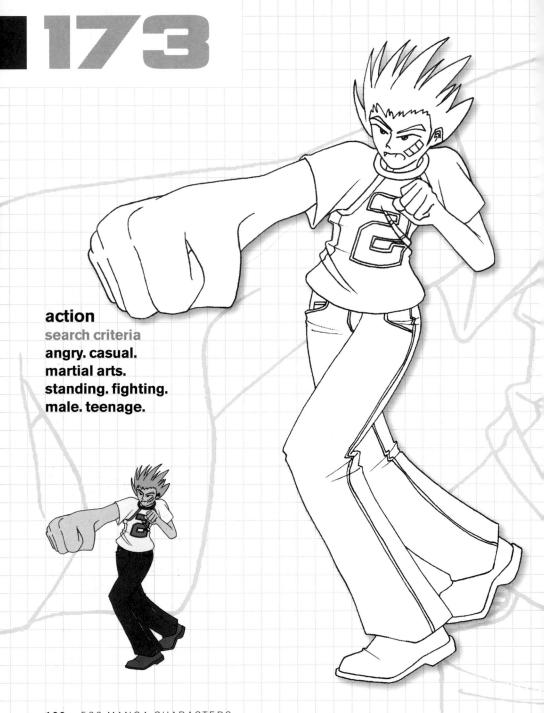

card. happy. smart.

cheongsam. standing. walking. adult. female. villain.

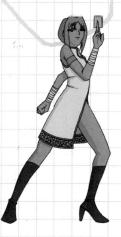

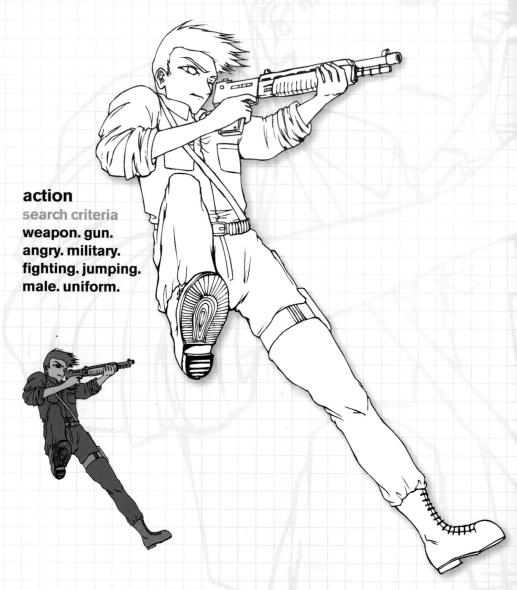

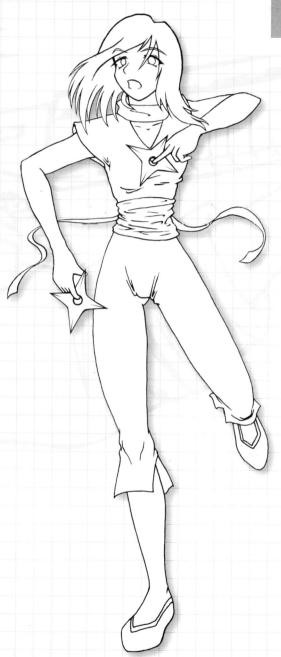

action

search criteria

weapon. throwing stars. warrior. sad. standing. fighting. adult. female.

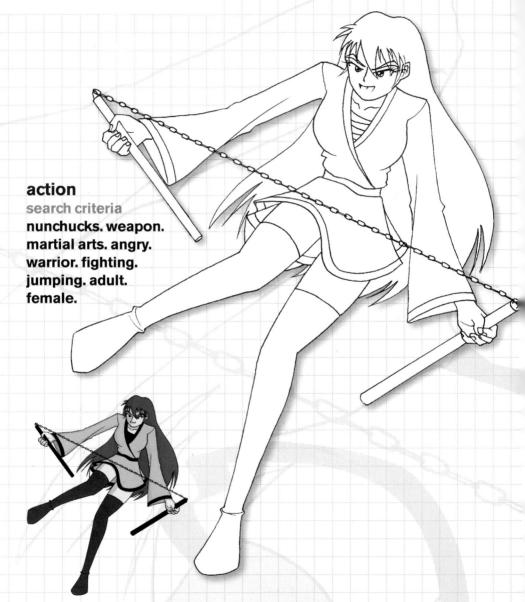

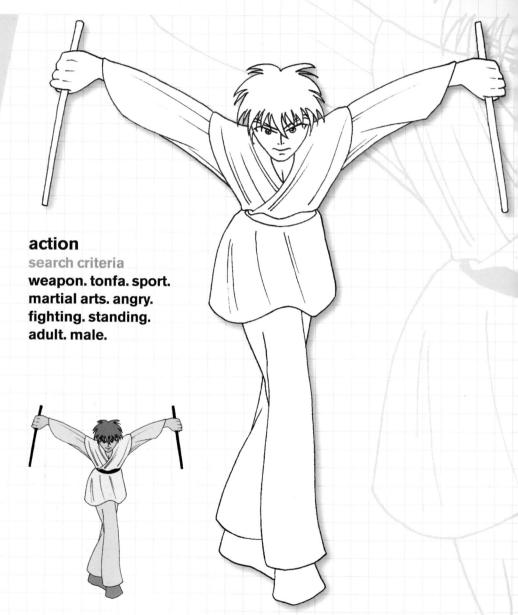

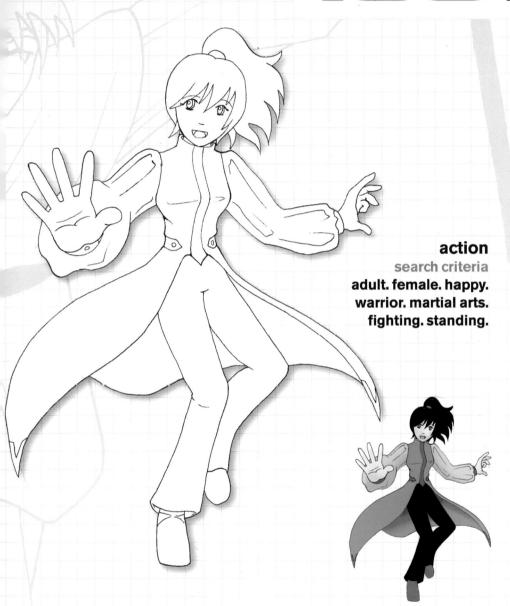

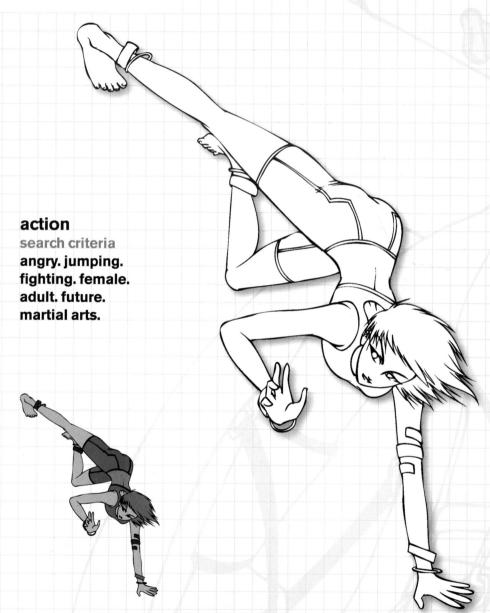

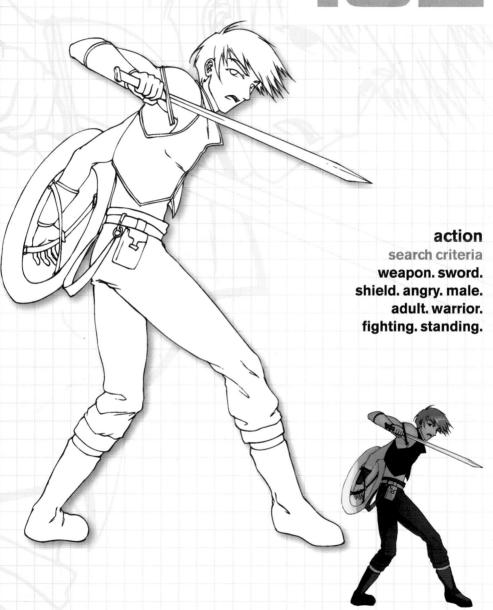

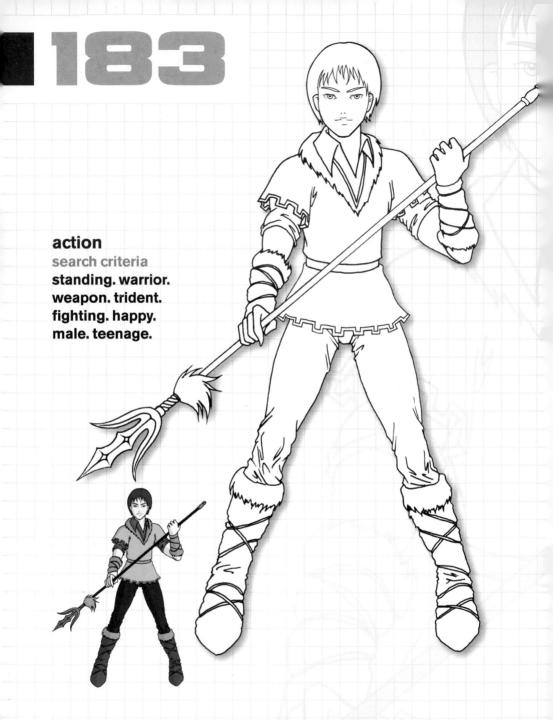

action

search criteria

standing. warrior. weapon. fighting. kunai. knife. angry. adult. male.

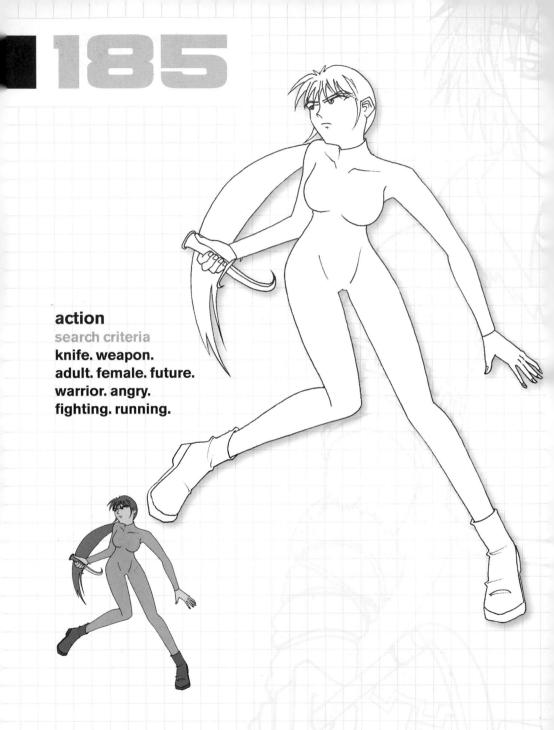

action

search criteria

weapon. kusarigama. male. adult. warrior. angry. standing.

action

search criteria

standing. warrior. weapon. tonfa. adult. male. angry. sad.

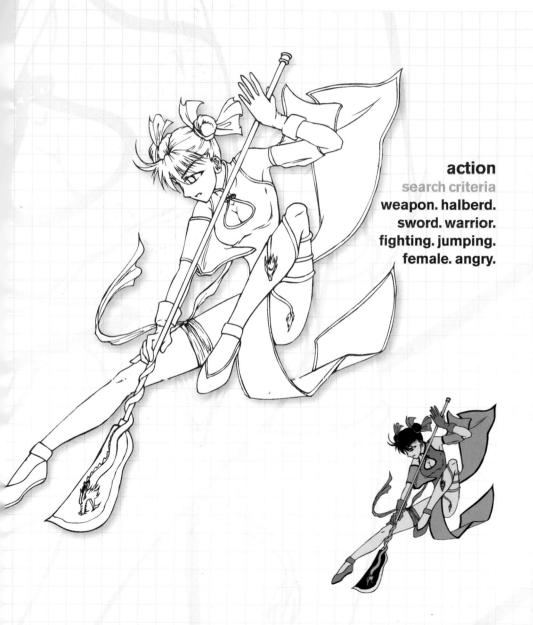

sci-fi search criteria

future. phone. helmet. happy. smart. standing. child. female.

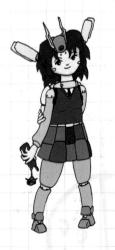

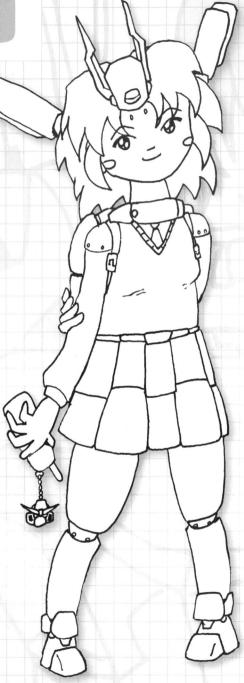

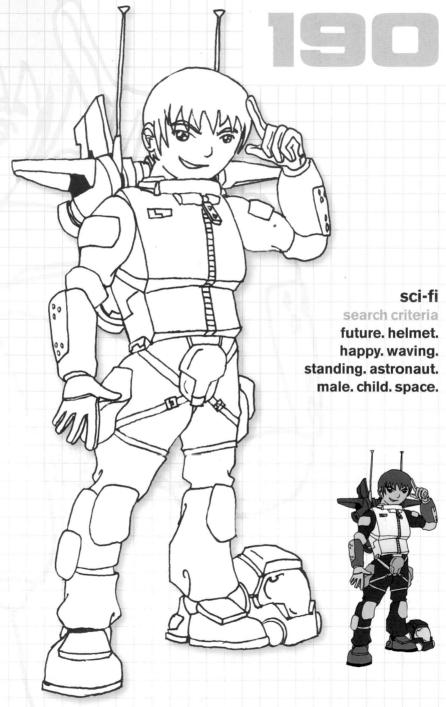

sci-fi

search criteria

future. chibi. sad. goggles. glasses. weapon. sword. teenage. male. warrior. action. standing. fighting.

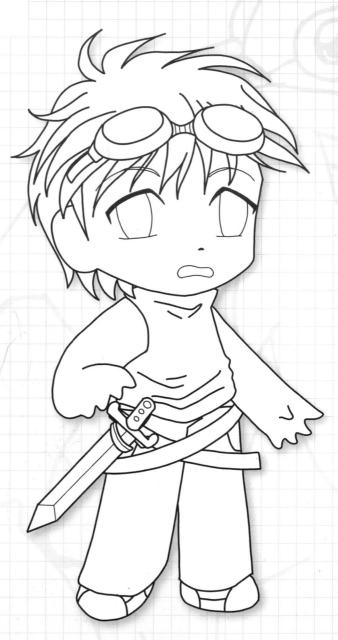

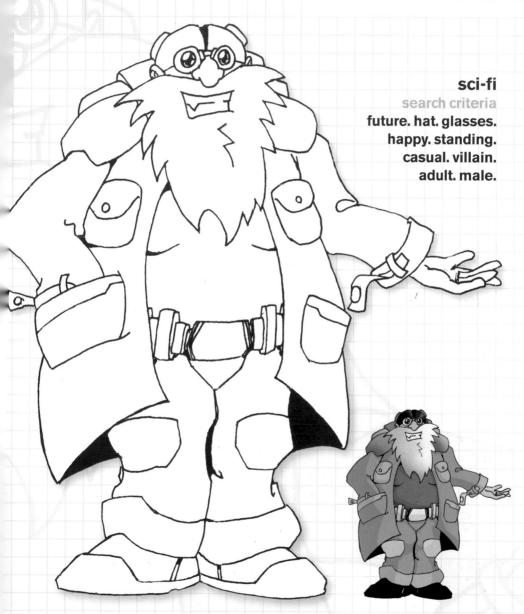

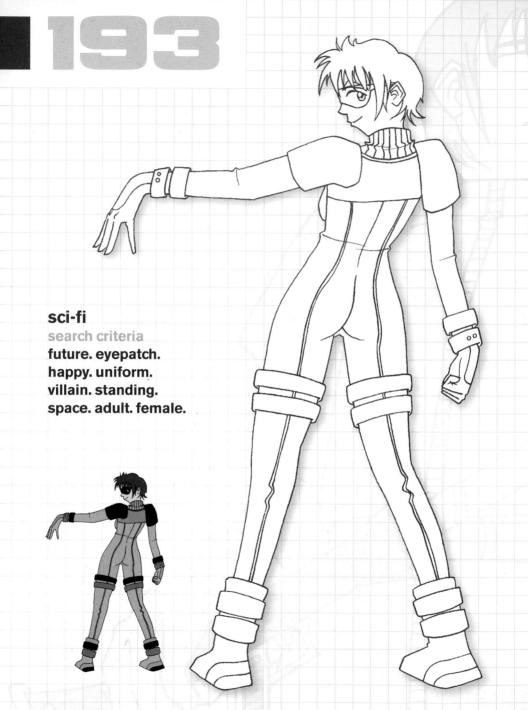

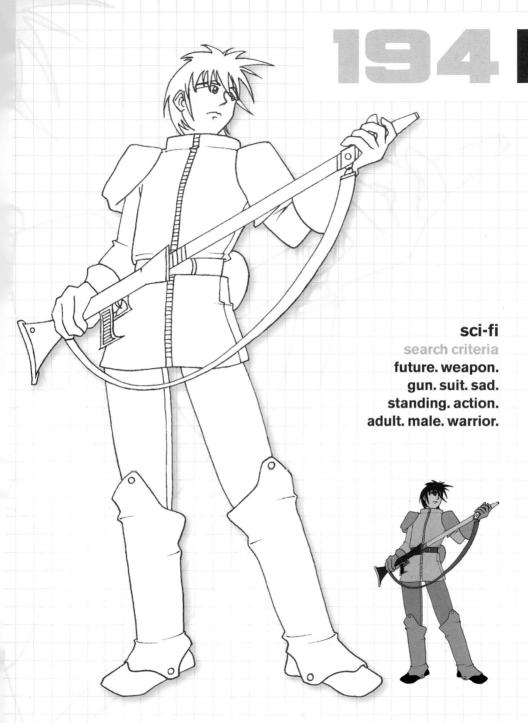

sci-fi search criteria

future. happy. smart. standing. teenage. male.

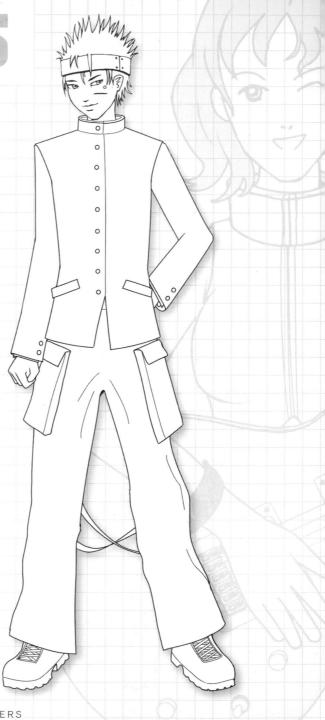

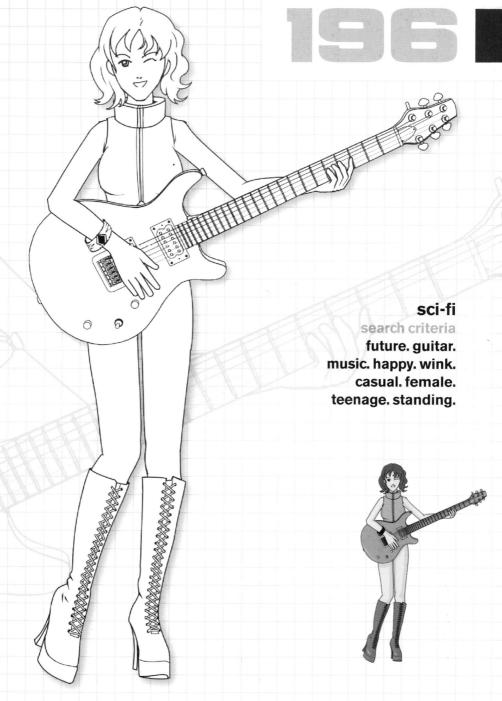

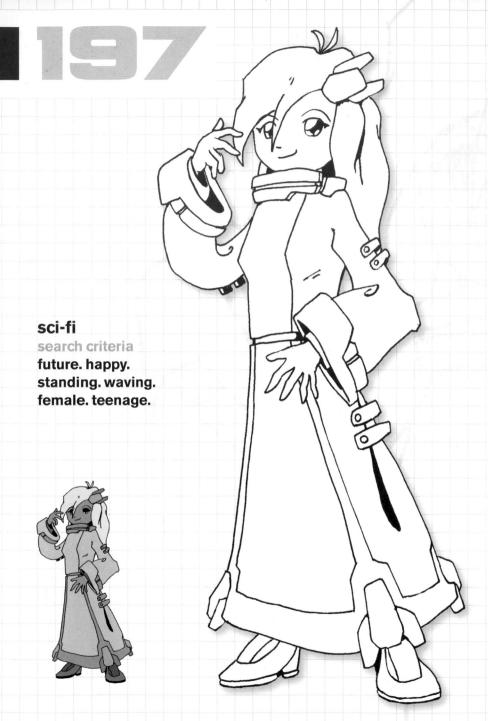

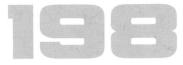

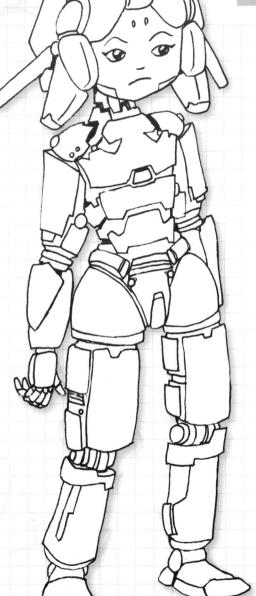

sci-fi

search criteria

future. helmet. sad. alien. robot. standing. female.

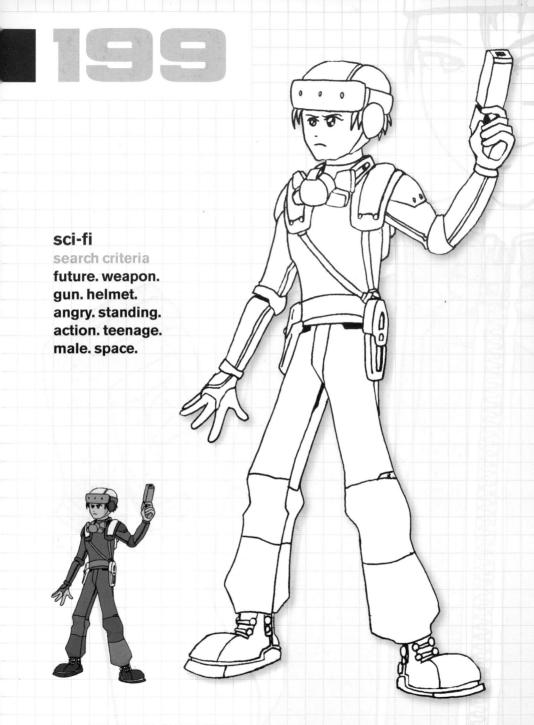

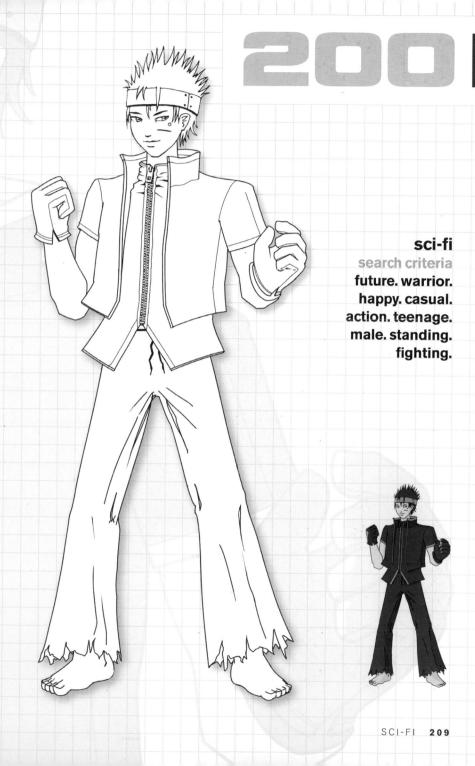

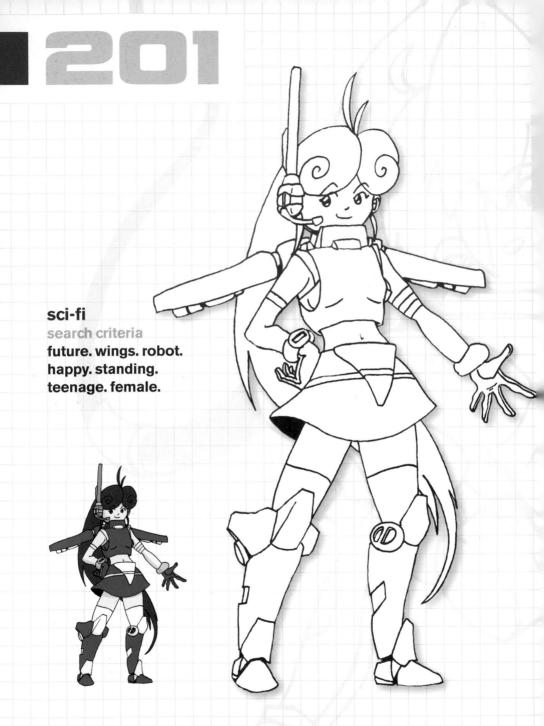

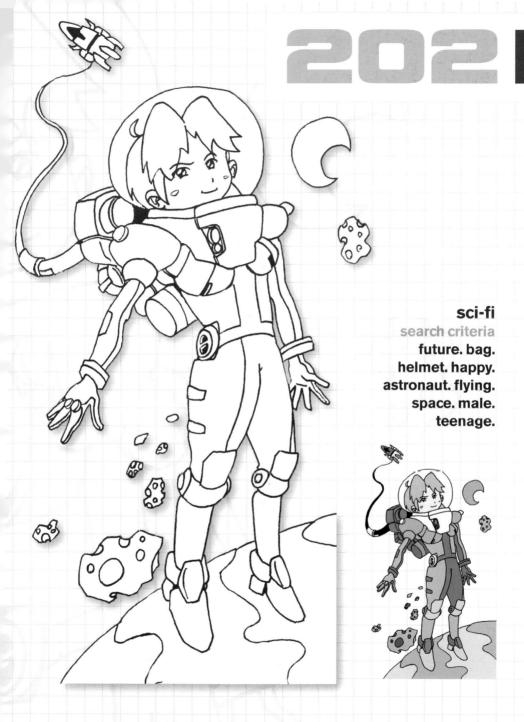

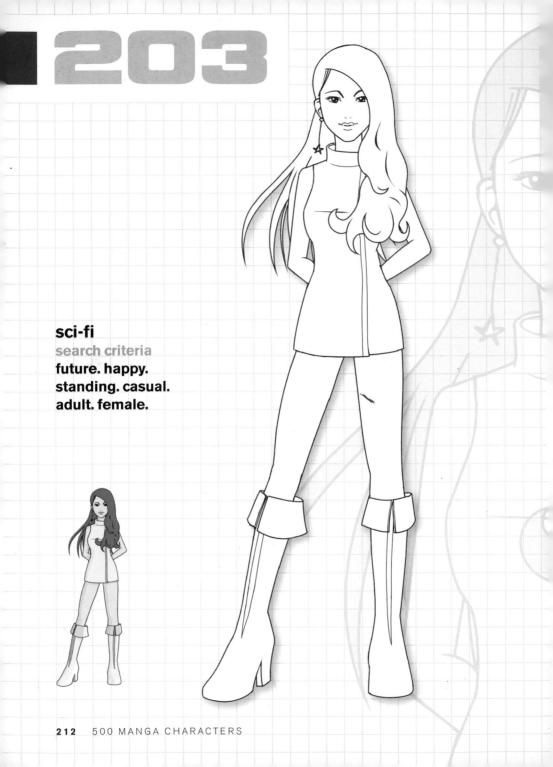

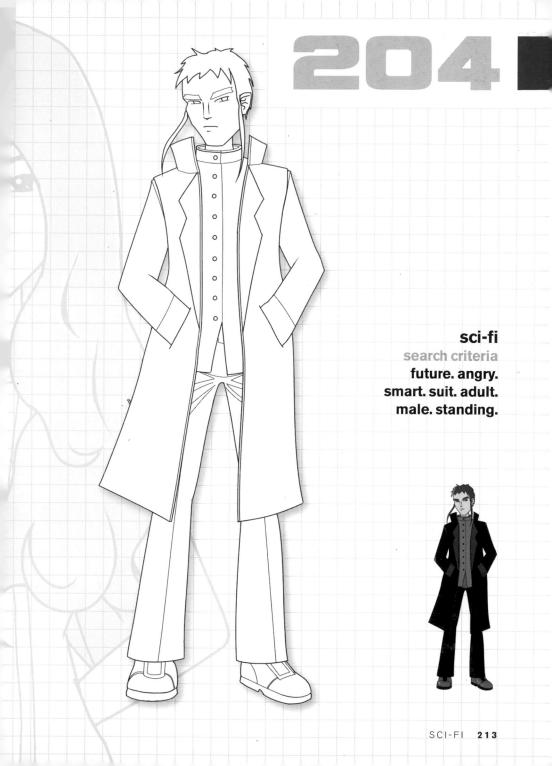

sci-fi search criteria

future. gadget. pen. space. happy. standing. adult. female.

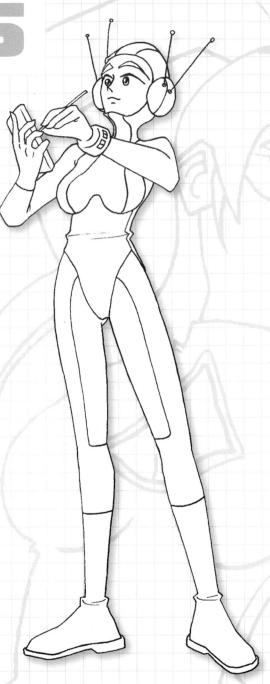

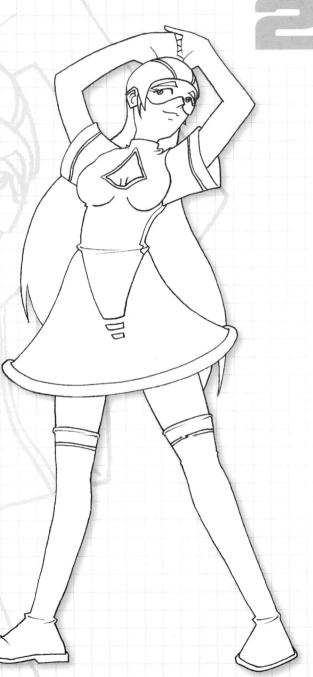

sci-fi search criteria

future. glasses. space. standing. happy. adult. female.

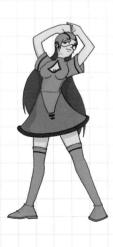

sci-fi search criteria

future. angry. casual. standing. teenage. male.

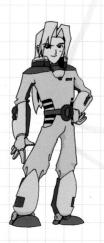

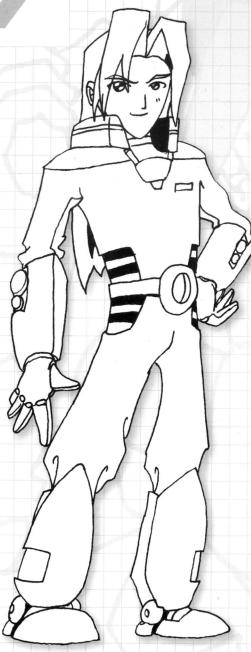

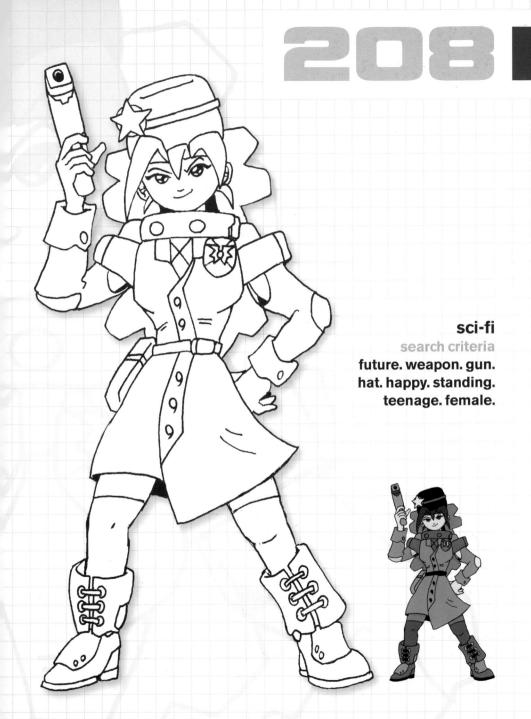

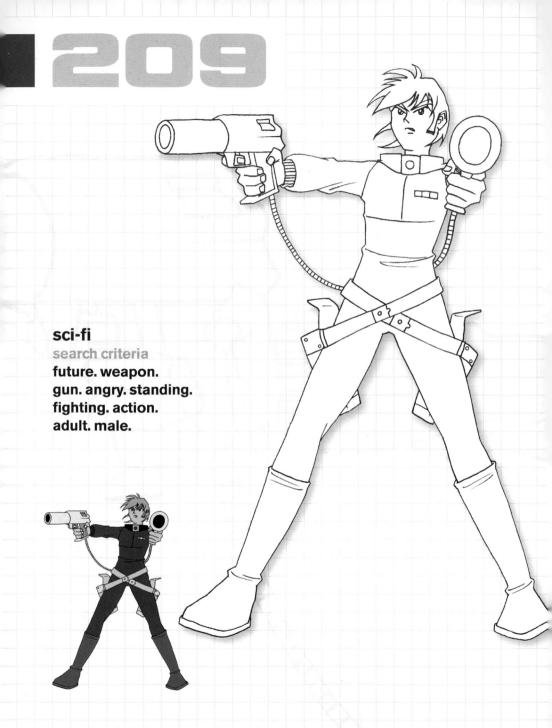

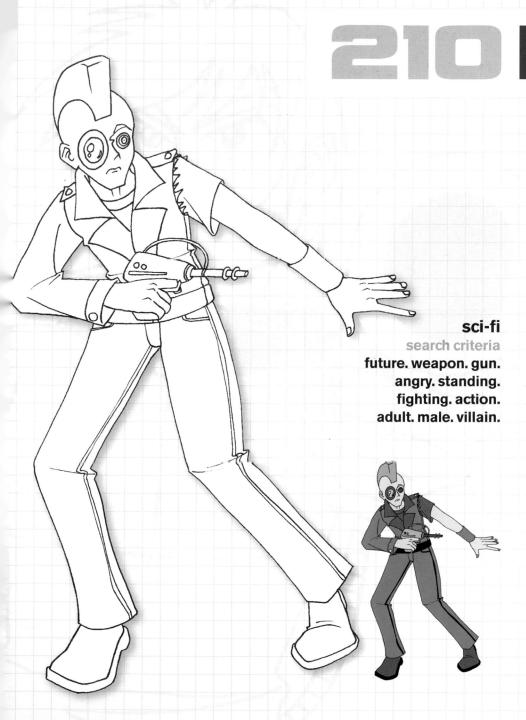

sci-fi search criteria

future. angry. casual. action. teenage. male. fighting. standing.

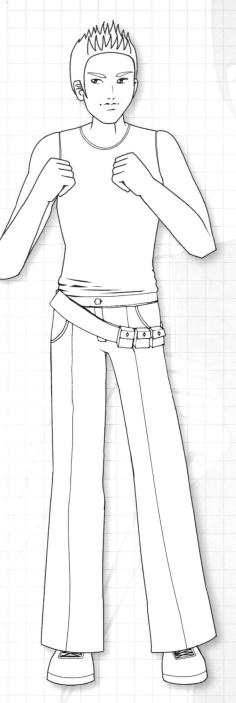

sci-fi search criteria

future. sad. casual. standing. adult. female.

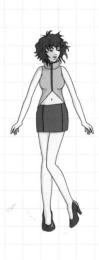

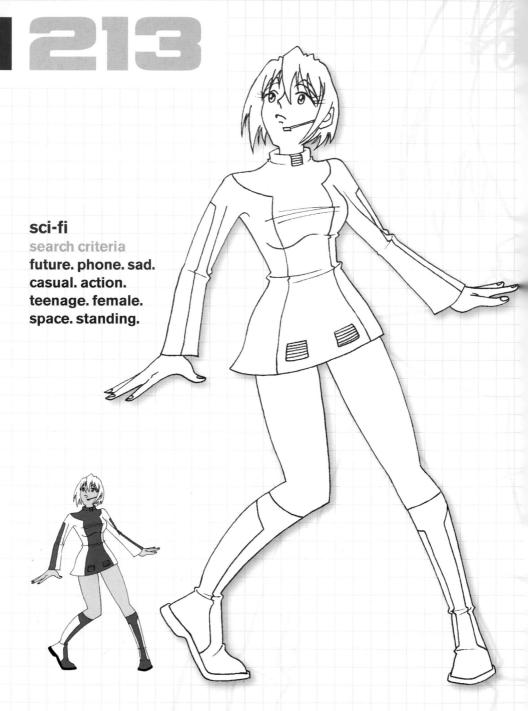

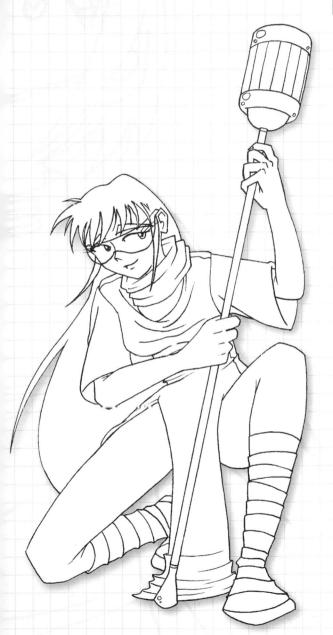

sci-fi search criteria

future. glasses. lantern. happy. casual. crouching. adult. female.

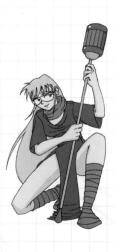

sci-fi search criteria

future. sad. mutant. casual. standing. teenage. female.

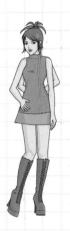

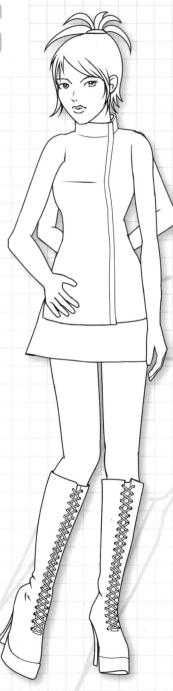

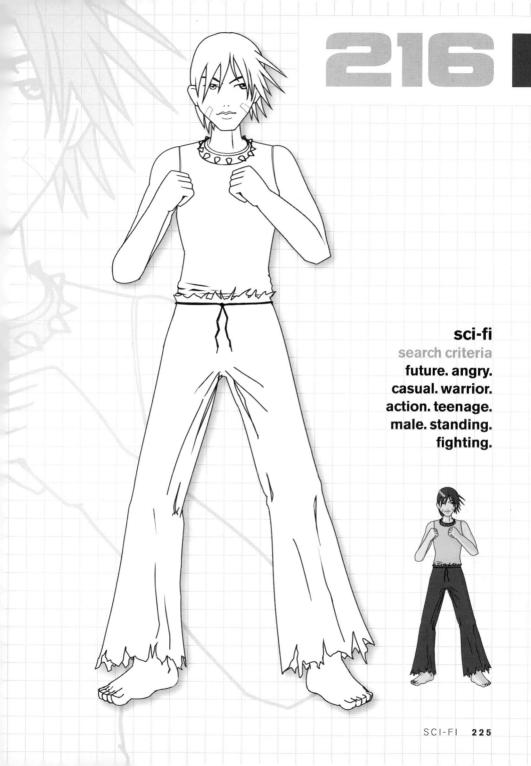

sci-fi

search criteria

future. happy. robot. mutant. villain. sitting. crouching.

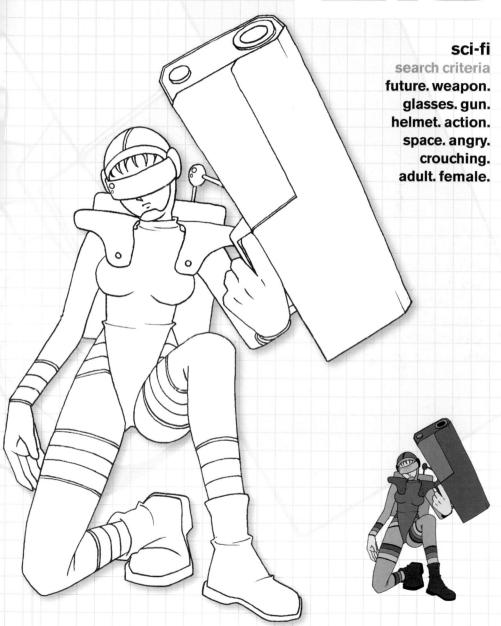

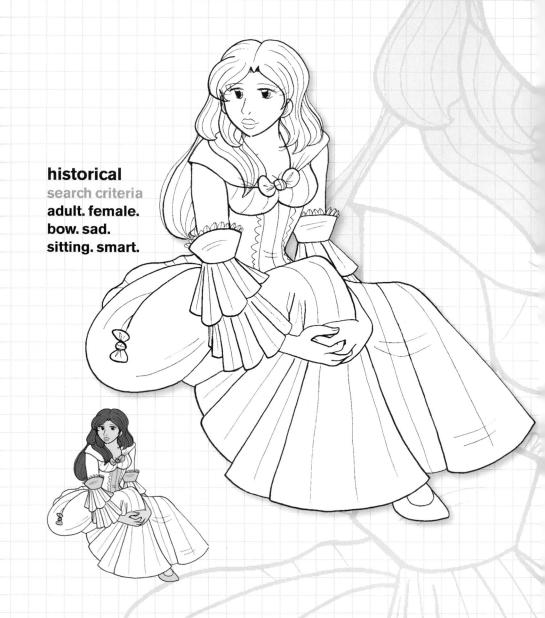

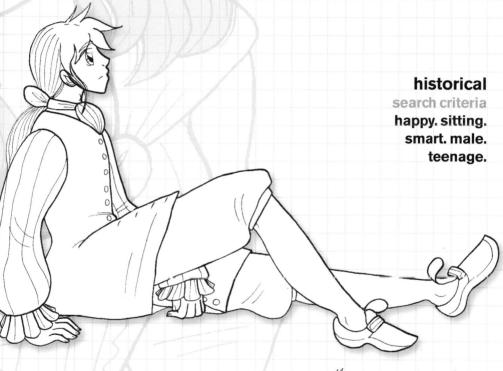

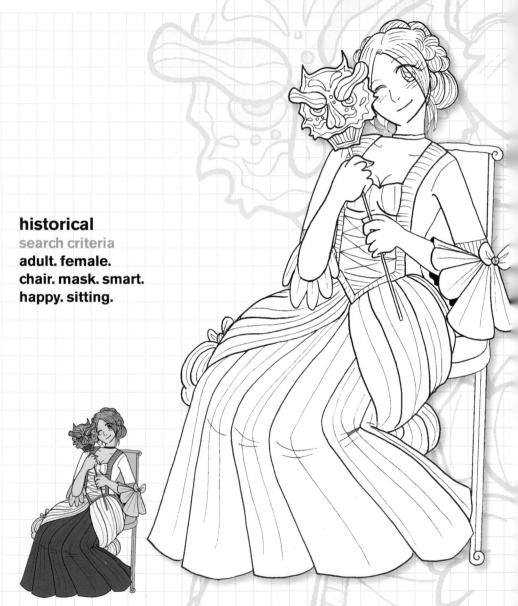

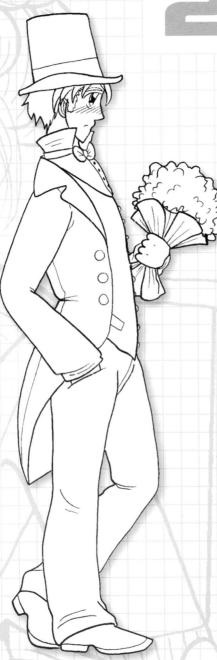

historical

search criteria

flowers. hat. sad. wedding. smart. walking. standing. suit. adult. male.

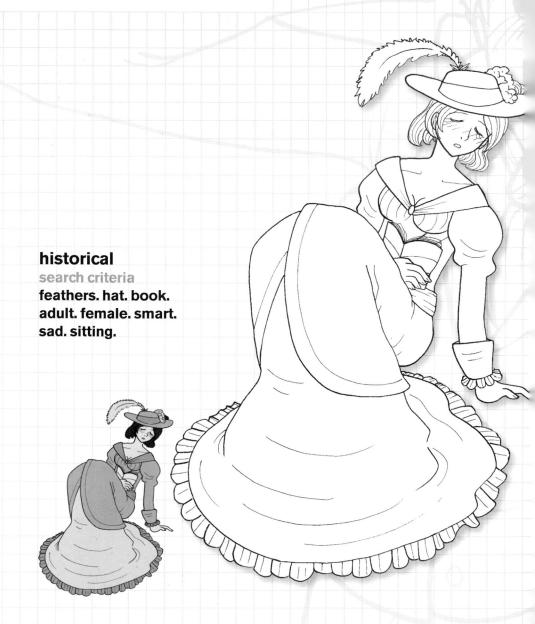

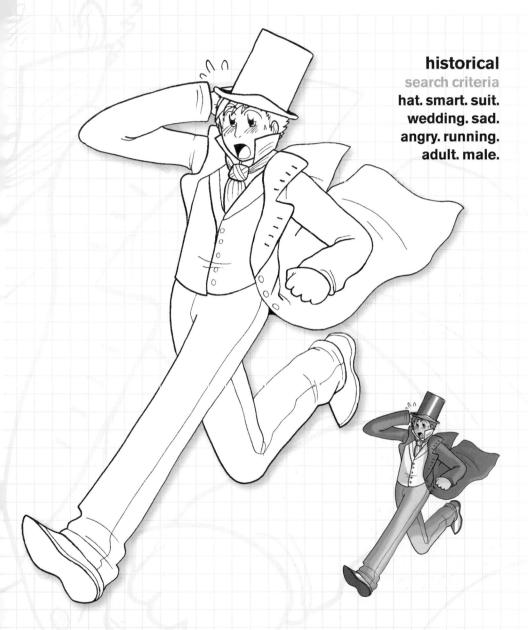

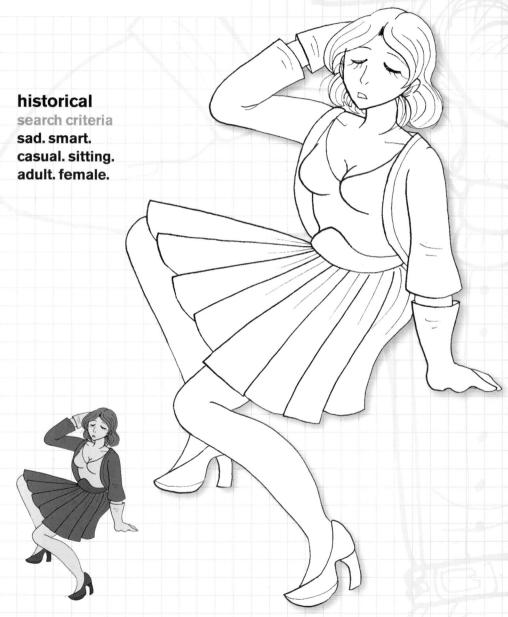

historical

search criteria

hat. happy. casual. dance. waving. standing. male. teenage.

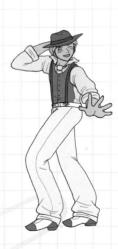

historical search criteria suit. smart. adult. female. angry. standing.

historical search criteria hat. happy. wedding. smart. suit. standing. male. teenage.

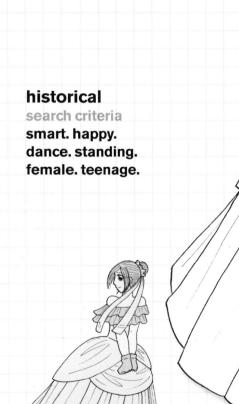

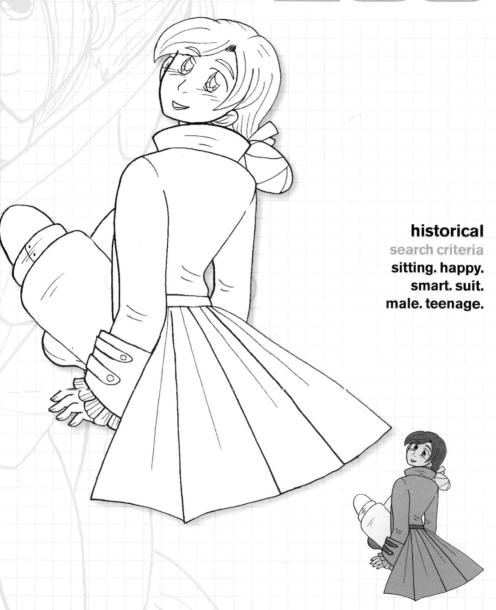

historical search criteria casual. teenage. female. smart. sad. running.

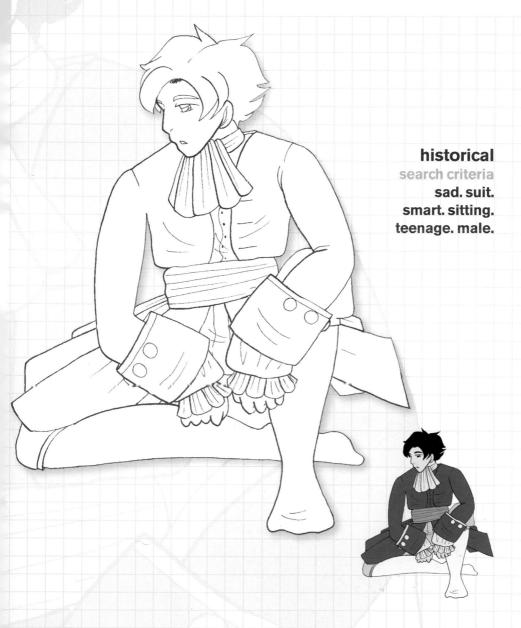

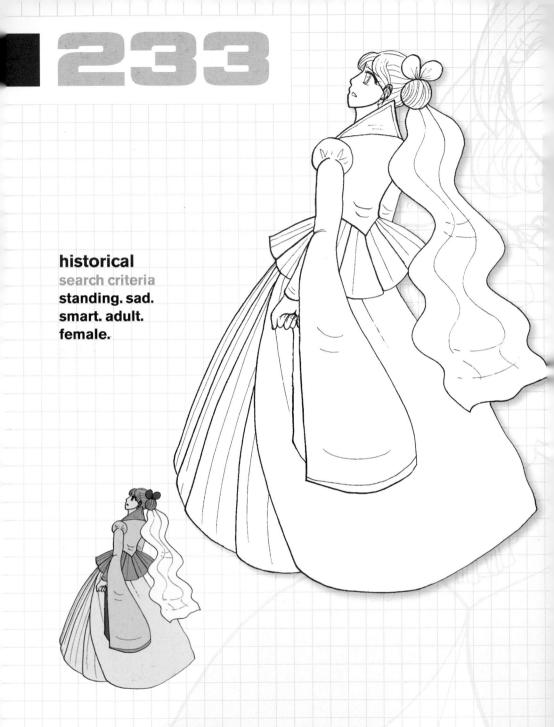

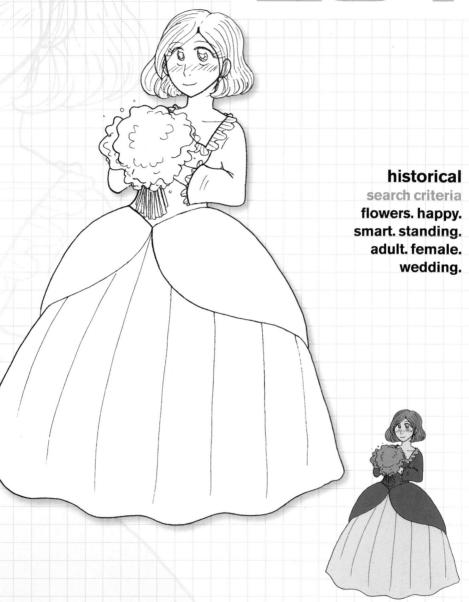

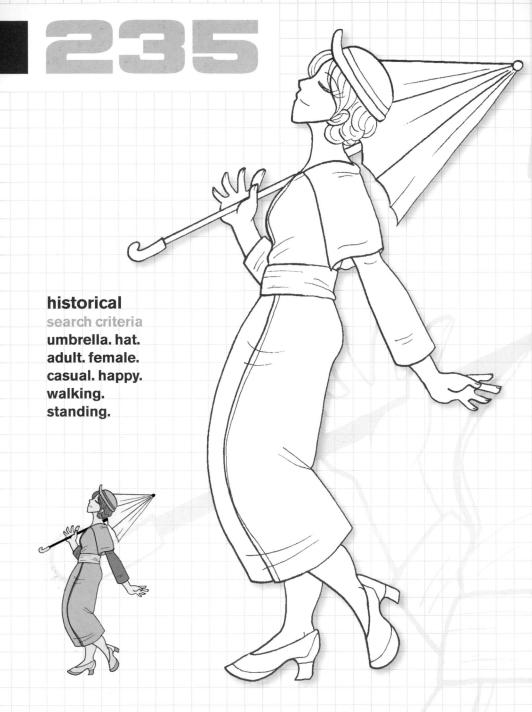

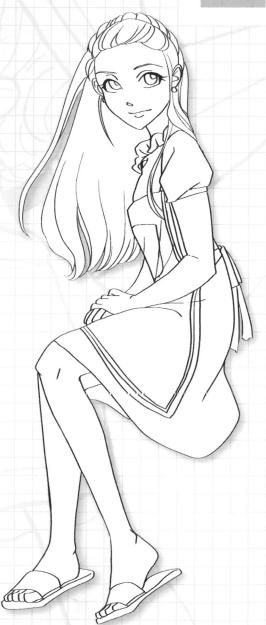

historical

search criteria

sad. smart. uniform. sitting. female. teenage.

historical

search criteria

male. adult. violin. music. smart. happy. standing.

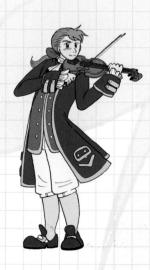

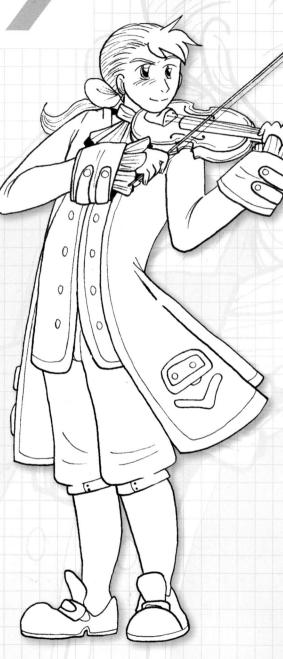

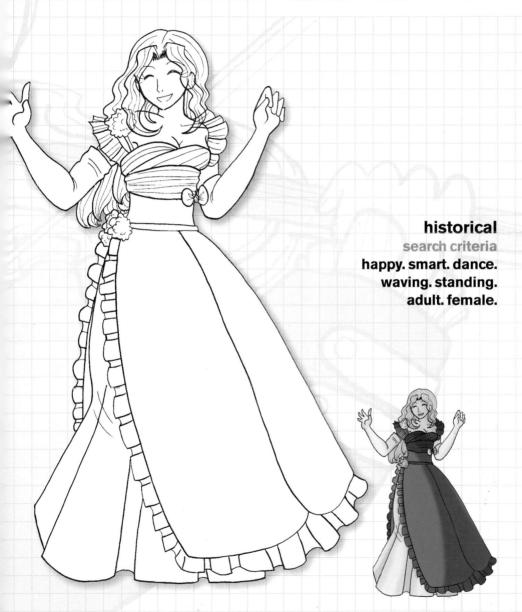

historical

search criteria

duster. feathers. happy. wink. uniform. smart. standing. female. teenage.

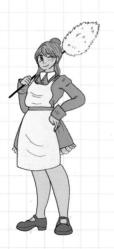

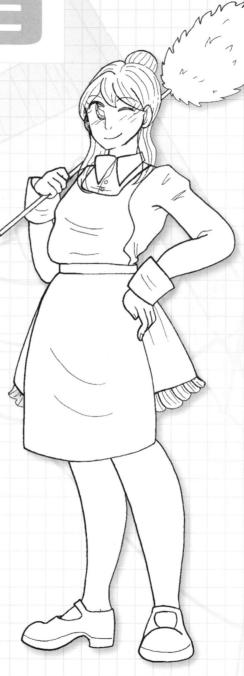

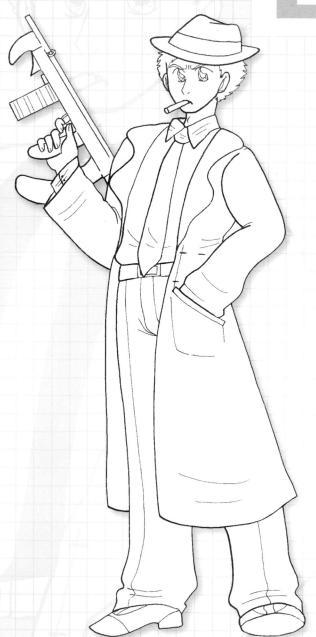

historical

search criteria

weapon. gun. hat. cigarette. adult. male. smart. suit. angry. standing.

historical search criteria cane. hat. angry. smart. suit. standing. adult. male.

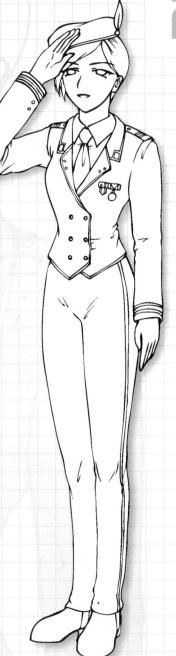

historical search criteria

hat. smart. uniform. military. waving. standing. action. female. suit.

gothic lolita

search criteria

female. teenage. smart. bag. suspenders. happy. dance. standing. walking.

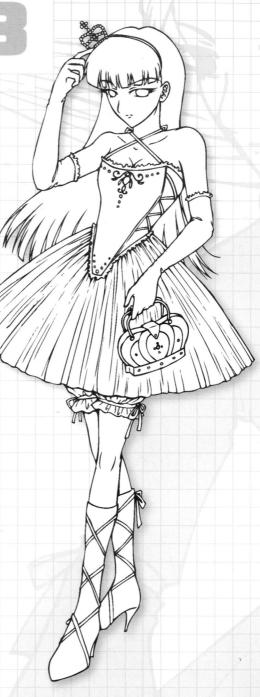

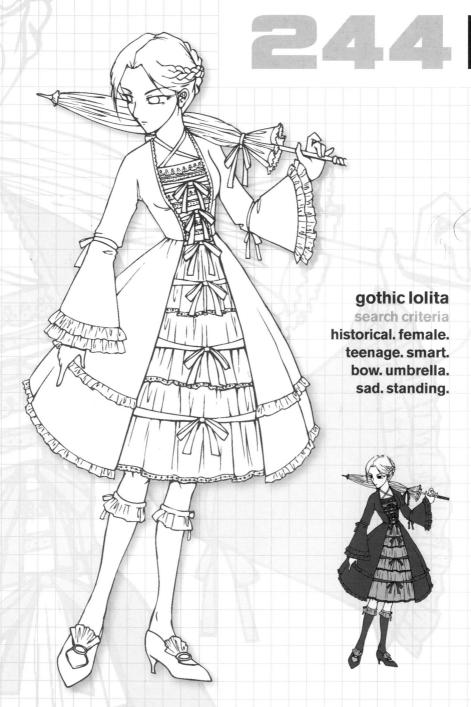

24.5

gothic Iolita

search criteria

female. teenage. smart. hat. flowers. sad. wedding. standing.

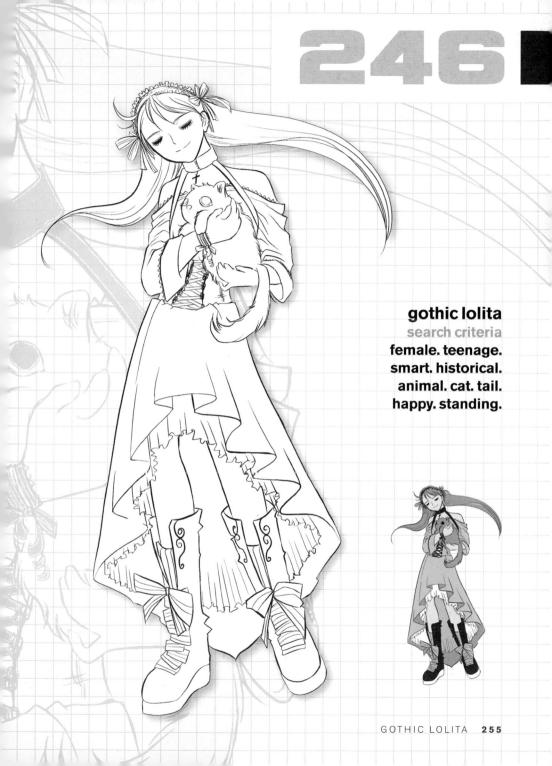

gothic lolita

search criteria

historical. female. teenage. smart. hat. food. teapot. sad. standing.

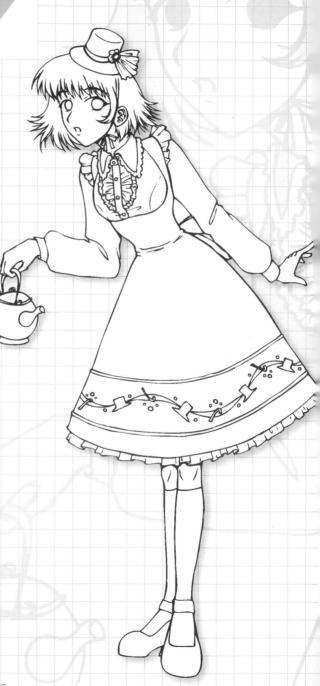

walking. standing.

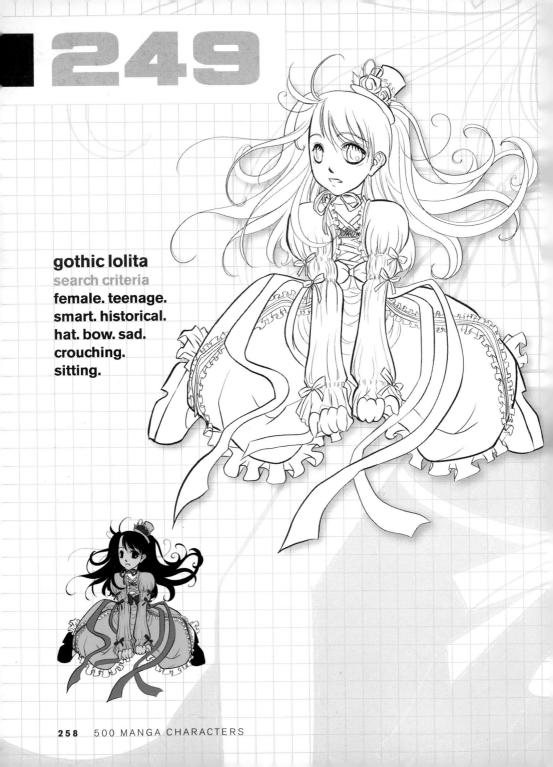

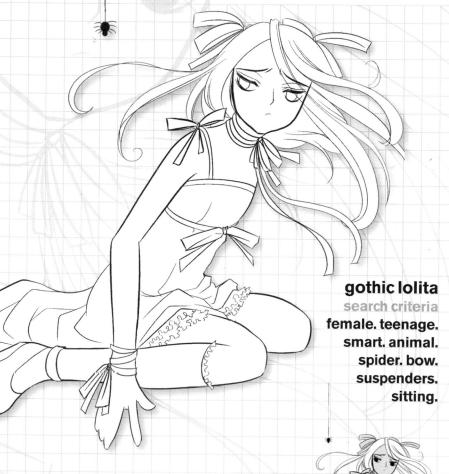

gothic lolita

search criteria

historical. female. suspenders. happy. smart. teenage. standing. bow.

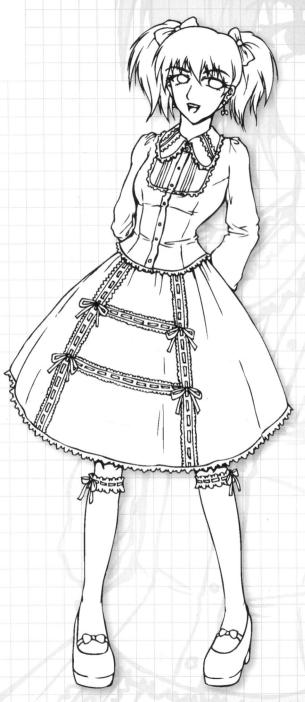

search criteria

bow. bag. sad. smart. historical. teenage. female. standing.

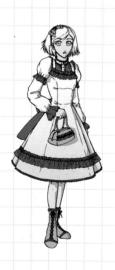

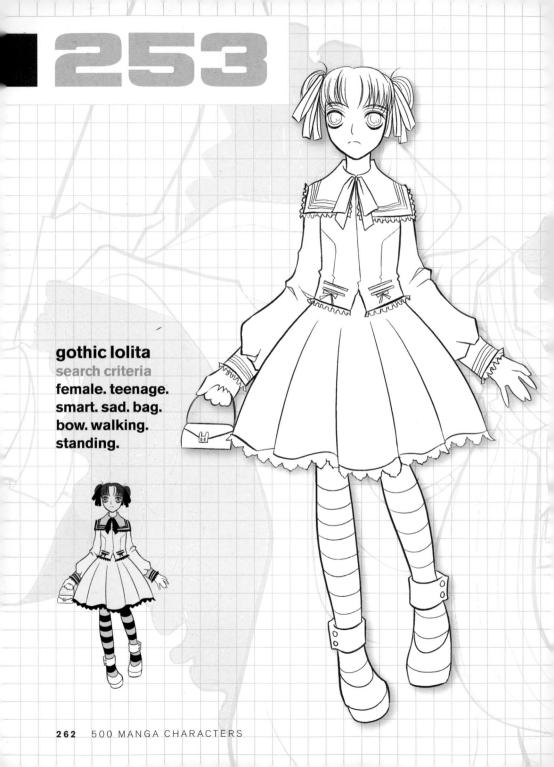

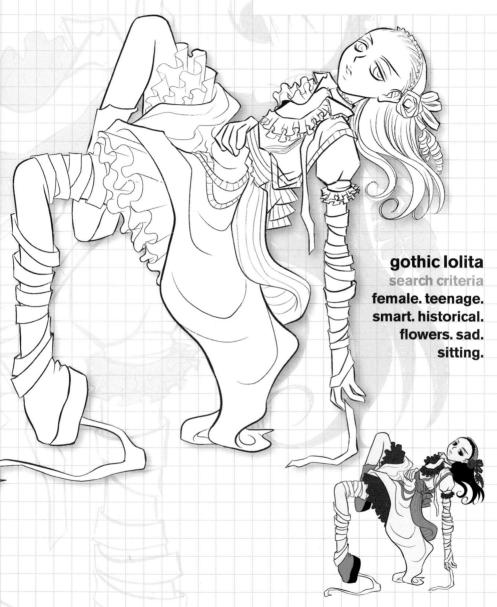

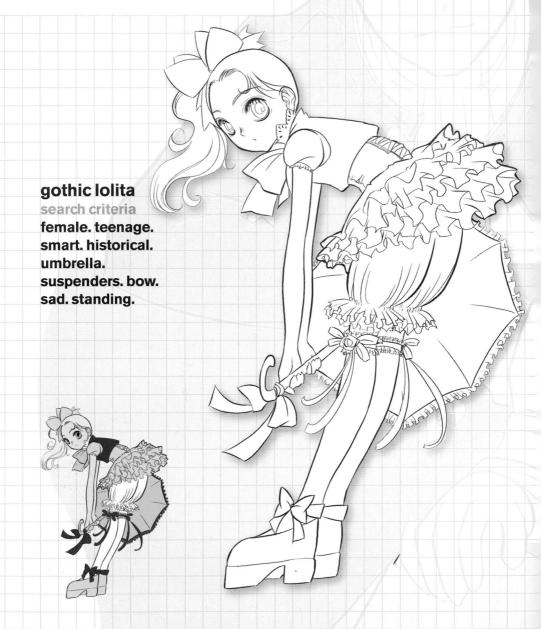

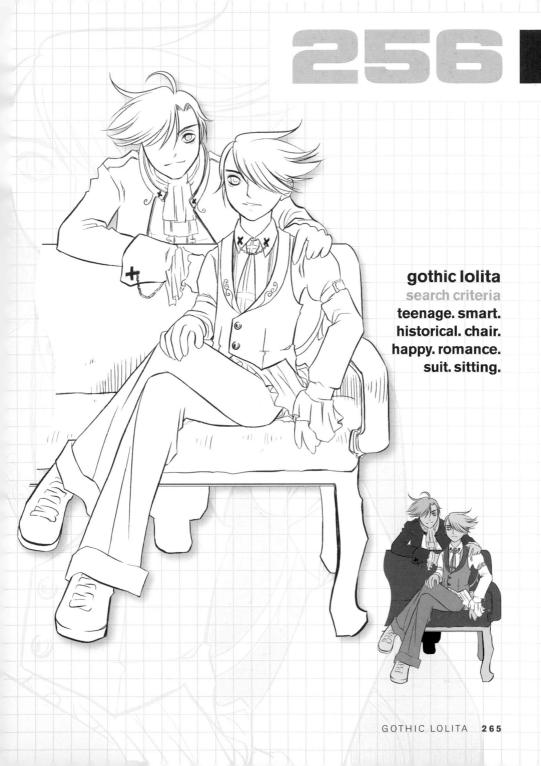

gothic lolita search criteria

female. teenage. historical. smart. cheongsam. traditional. bow. sad. suspenders. standing.

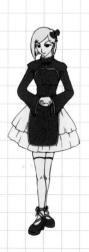

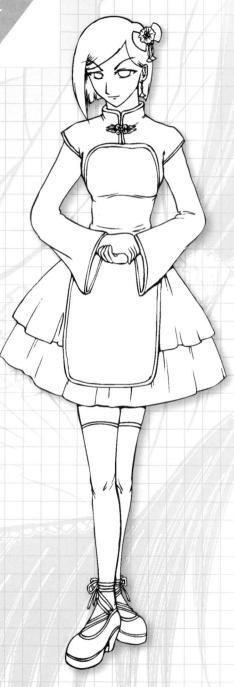

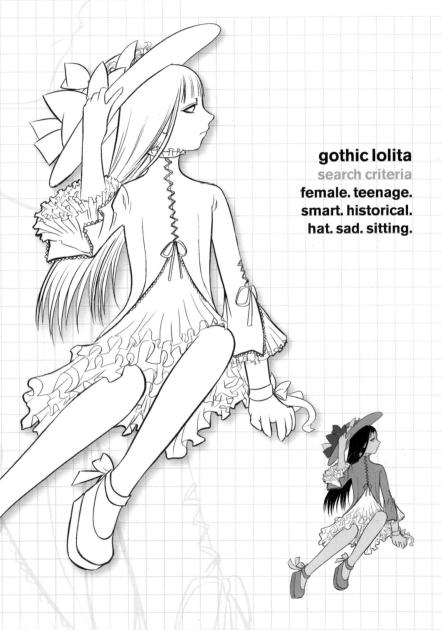

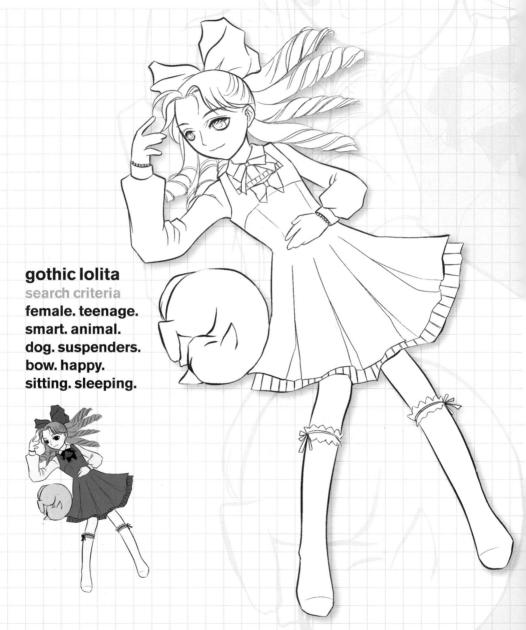

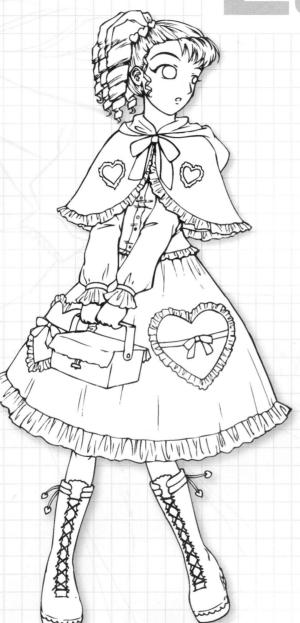

gothic Iolita

search criteria

female. teenage. historical. smart. bag. bow. sad. standing.

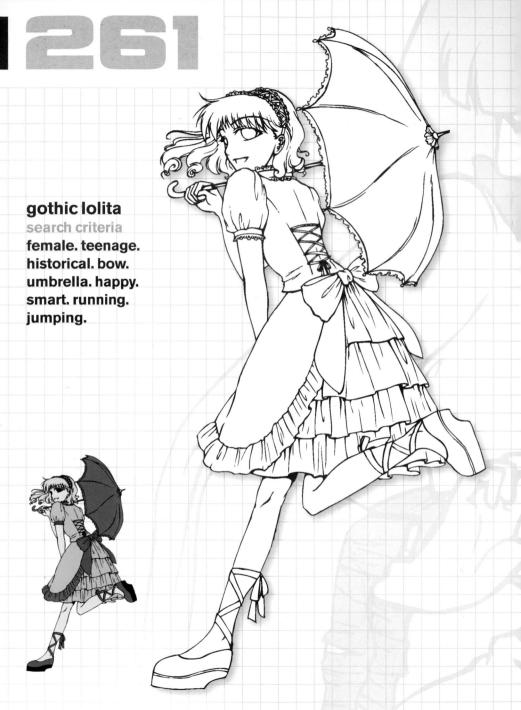

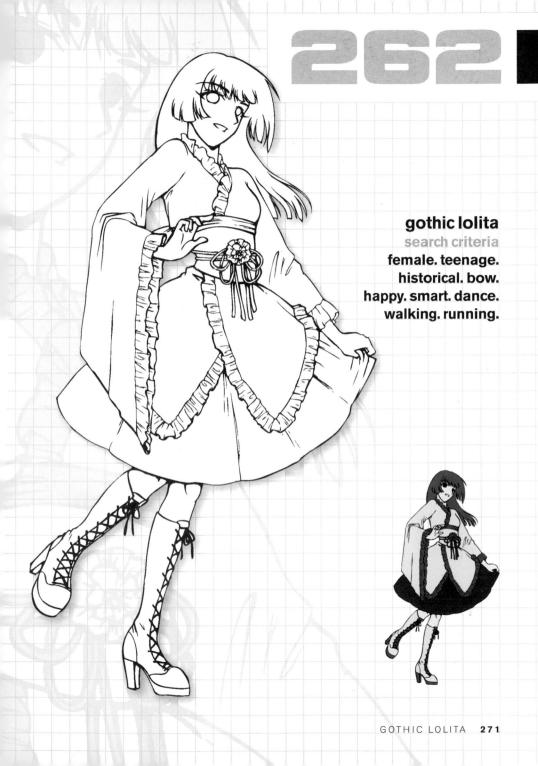

child male search criteria lantern. bag. horns. animal. monster. fantasy. villain. warrior. riding. sad.

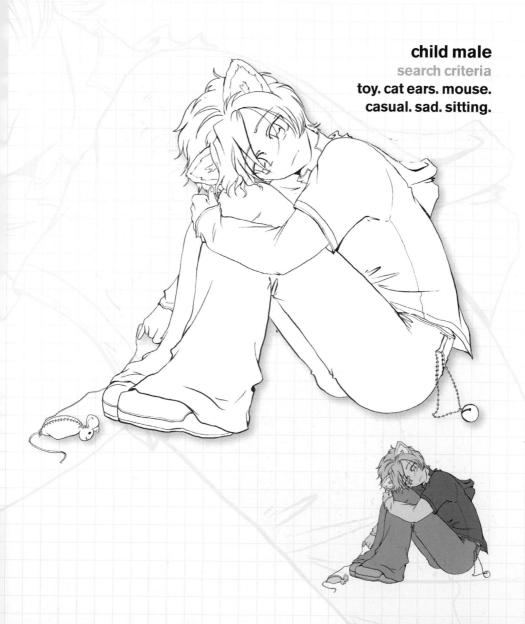

child male search criteria halo. casual. feathers. wings. angel. standing. waving. happy.

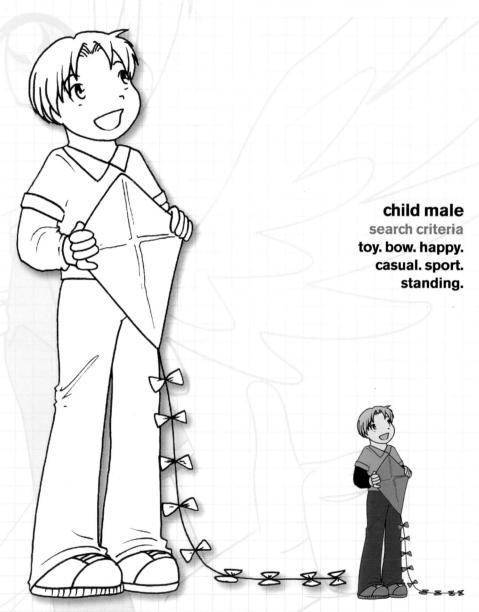

child male search criteria chibi. book.

happy. casual. smart. standing.

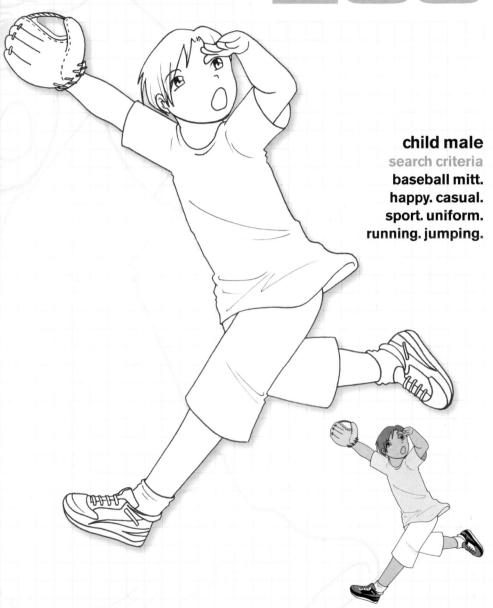

child male search criteria glasses. happy. casual. running. jumping. fighting.

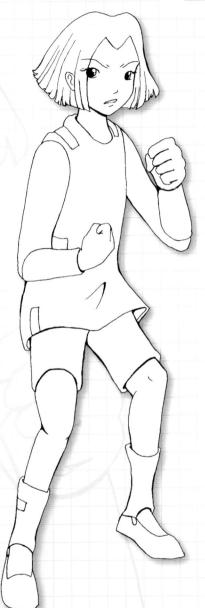

child male search criteria angry. casual. future. warrior. historical. fighting. standing.

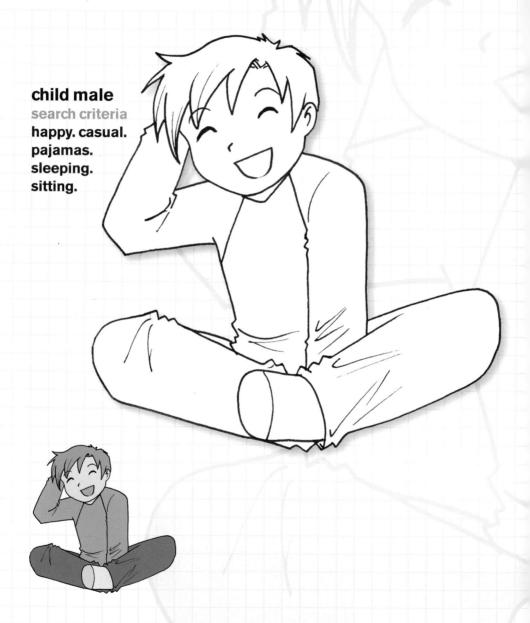

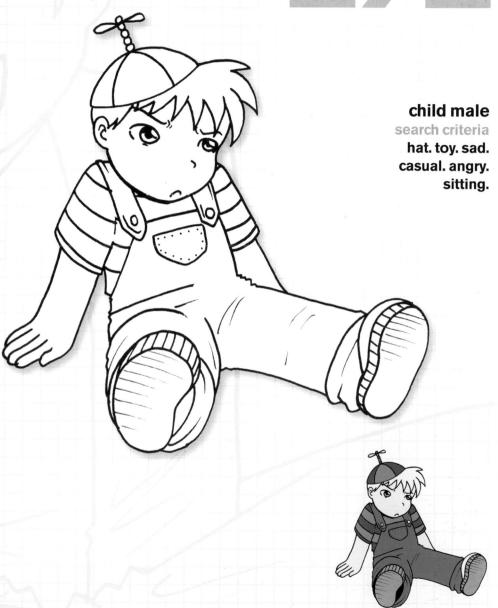

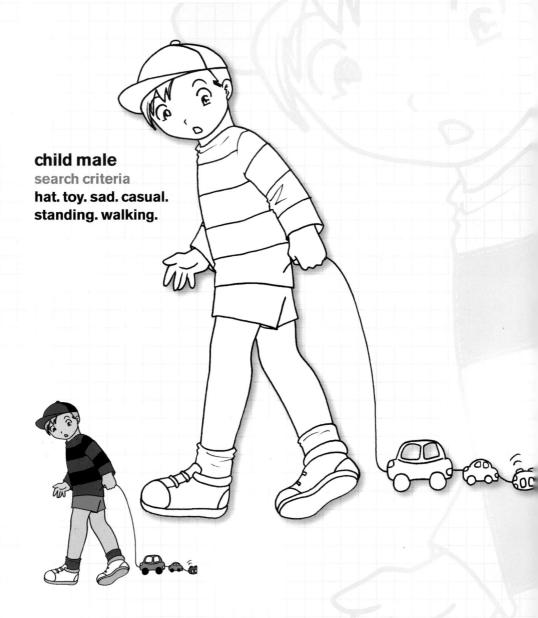

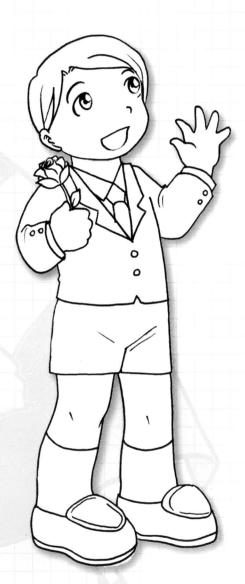

child male

search criteria

flowers. happy. smart. wedding. suit. waving. standing.

child male

search criteria

book. pen. bow. sad. smart. uniform. suit. historical. standing.

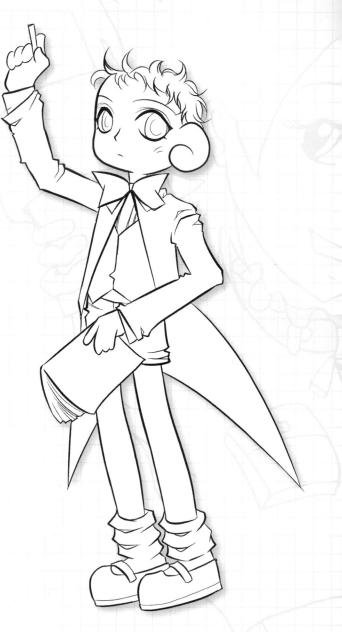

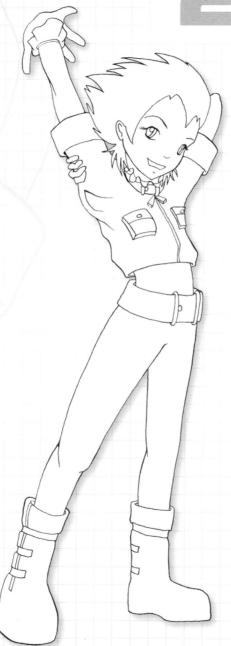

child male

search criteria

happy. casual. future. fantasy. waving. standing.

child male search criteria sad. angry. casual. pajamas. sitting.

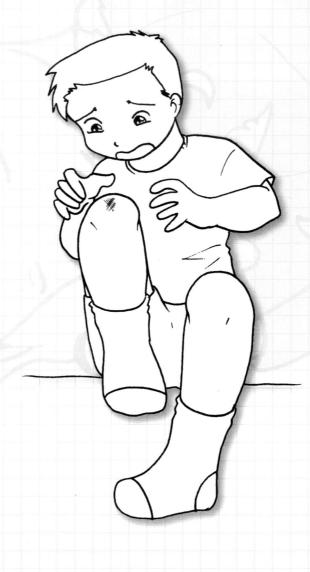

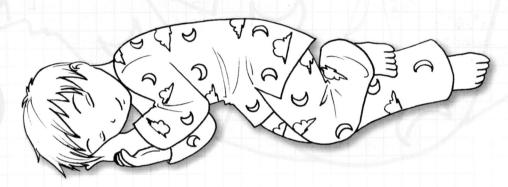

child male

search criteria

happy. pajamas. casual. sitting. sleeping.

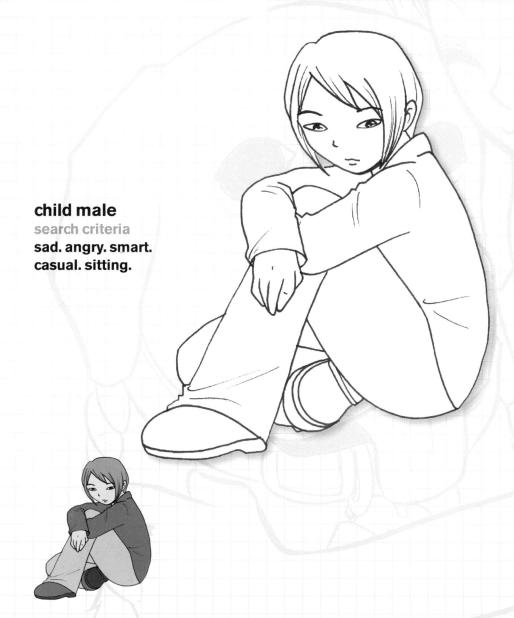

child male search criteria animal. dog. collar. happy. smart. historical. sitting. crouching.

child male search criteria ball. toy. sad. casual. sitting.

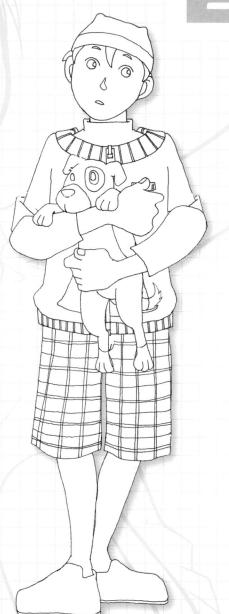

child male search criteria

hat. animal. dog. smart. tail. sad. standing.

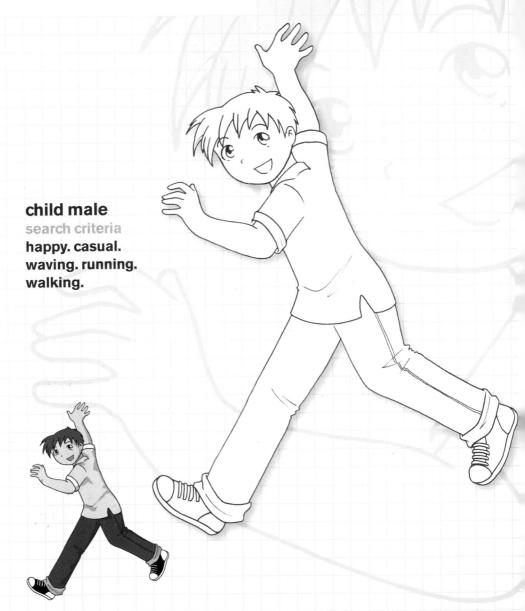

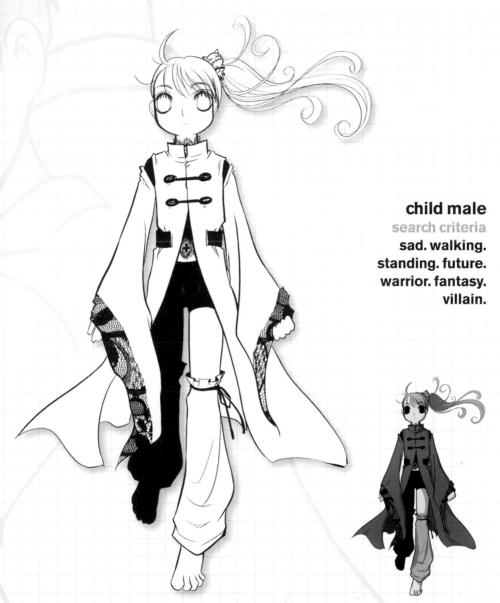

child male search criteria chain. angry. casual. hoodie. standing.

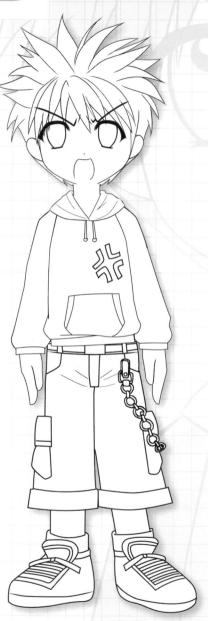

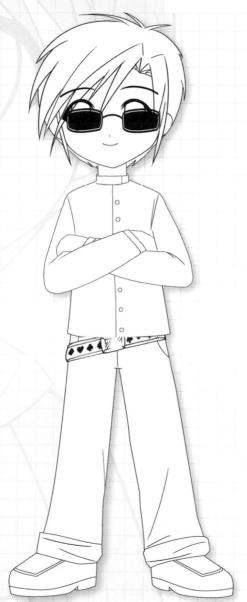

child male search criteria

glasses. happy. smart. future. casual. standing.

child female

search criteria

bag. bow. sad. angry. smart. uniform. standing.

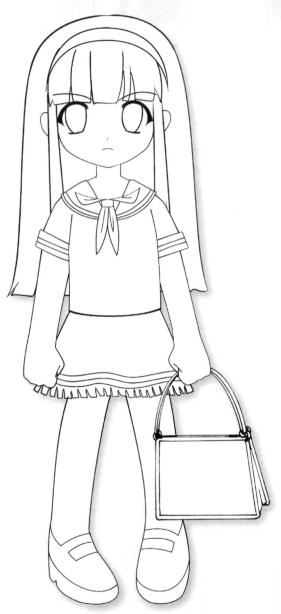

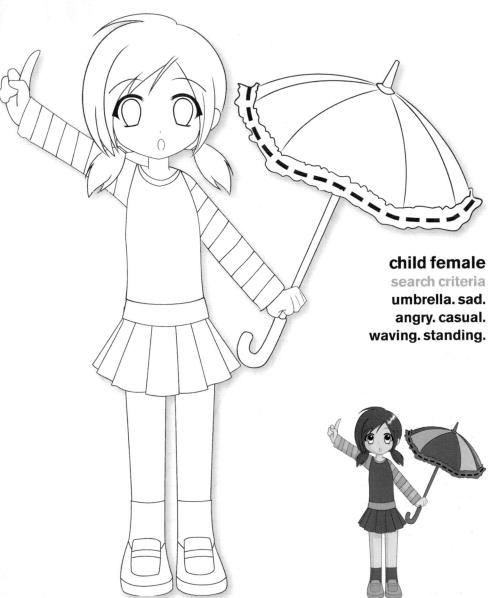

child female search criteria animal. dog. tail. smart. happy. standing.

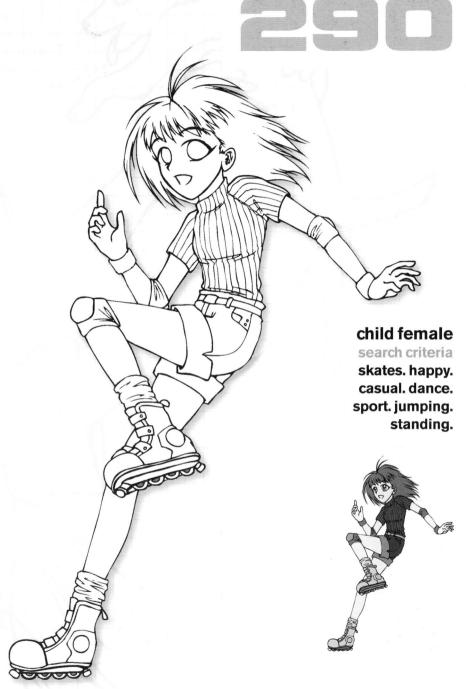

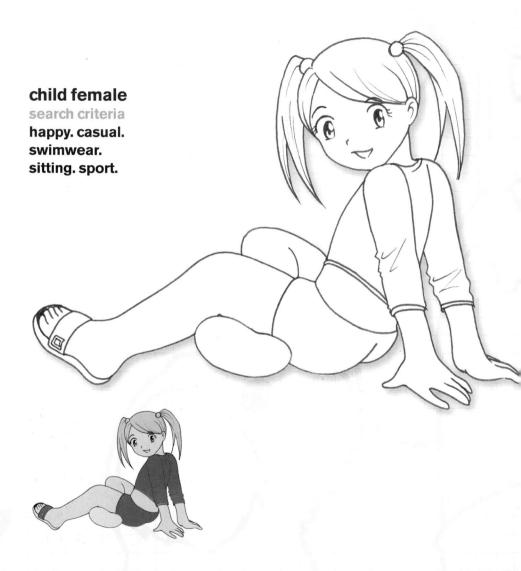

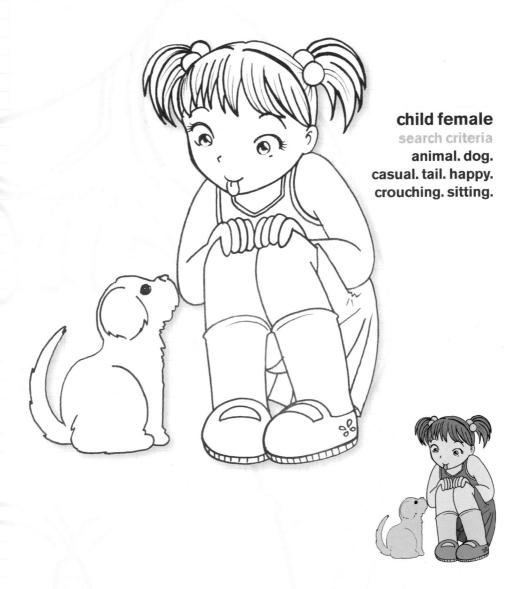

child female

search criteria

bag. bow. smart. uniform. watch. standing. running.

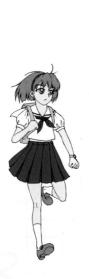

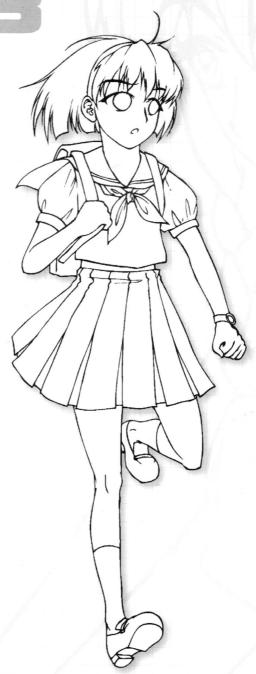

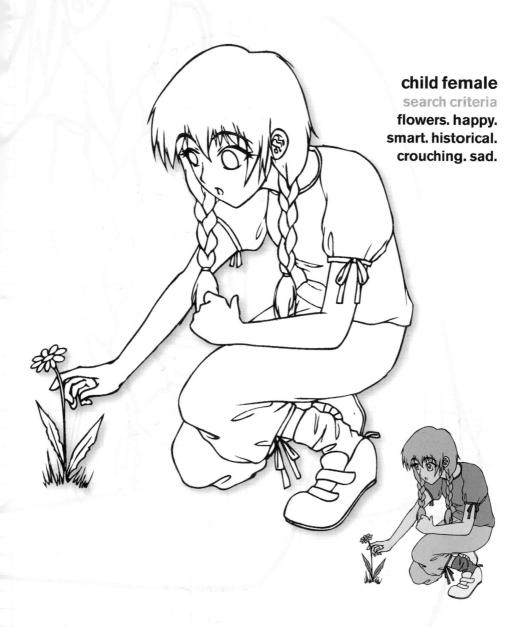

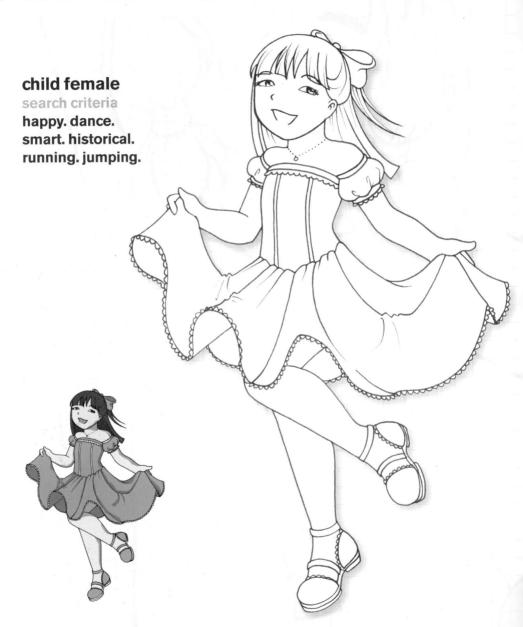

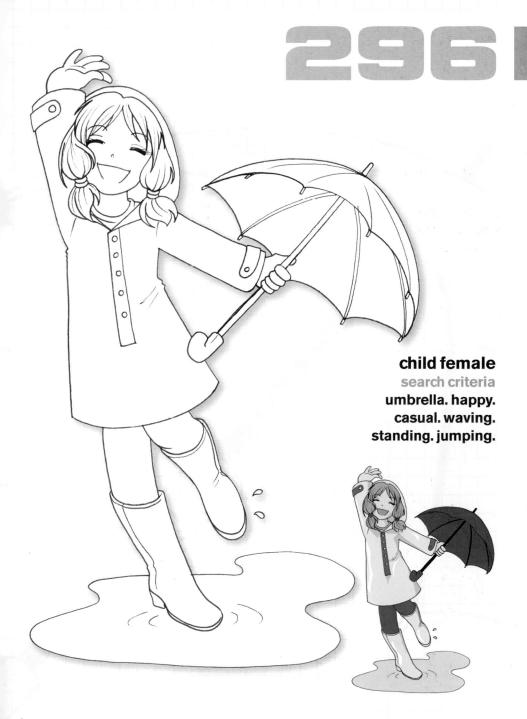

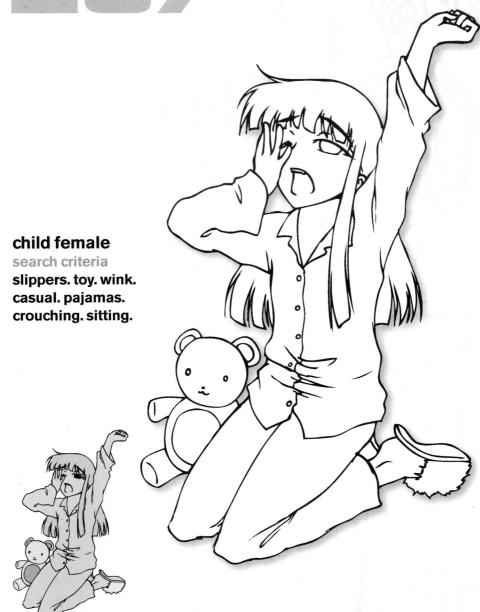

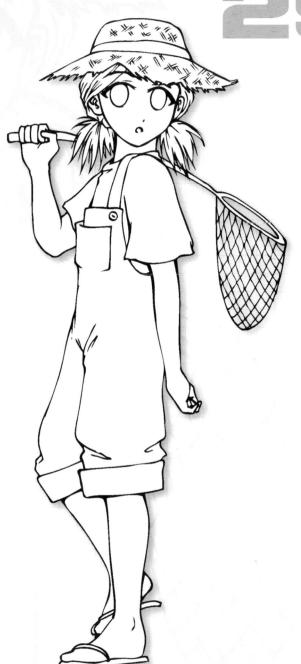

child female

search criteria

hat. net. sad. fishing. casual. sport. standing.

child female

search criteria suspenders. happy. dance. smart. historical. standing.

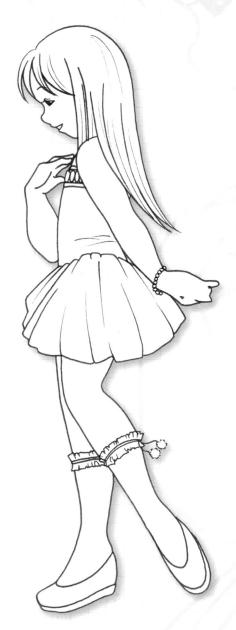

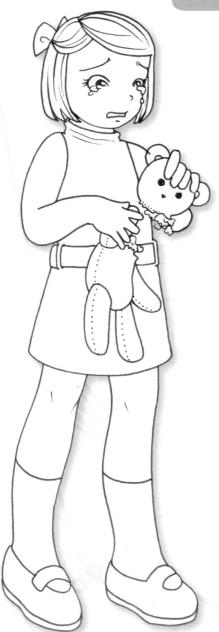

child female search criteria toy. sad. smart. standing. angry.

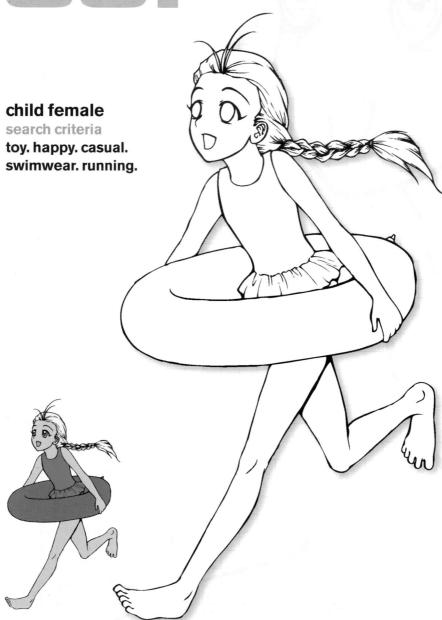

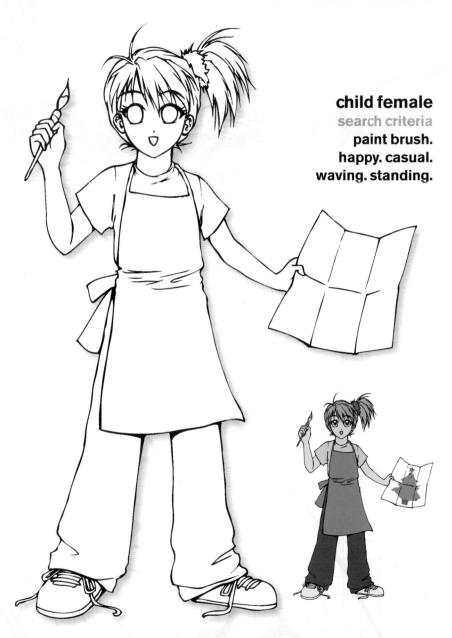

child female

search criteria

ball. hat. food. happy. casual. swimwear. standing.

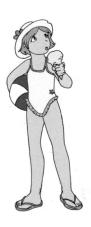

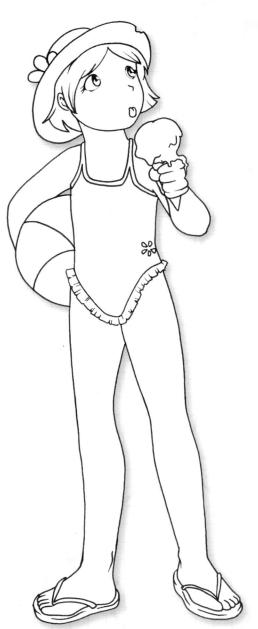

child female search criteria smart. dance. sad. historical. waving. standing.

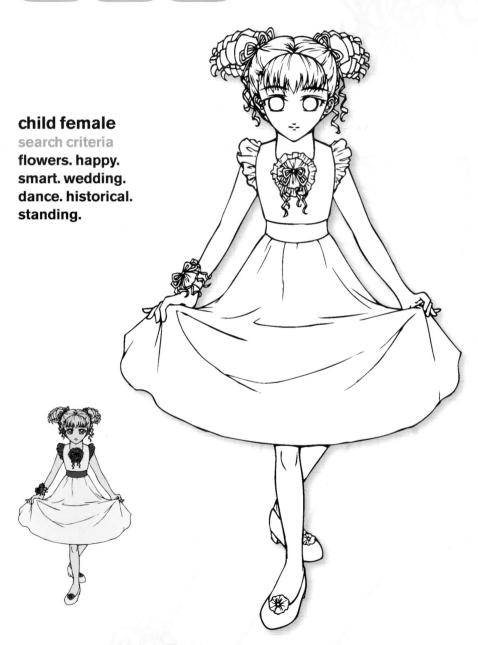

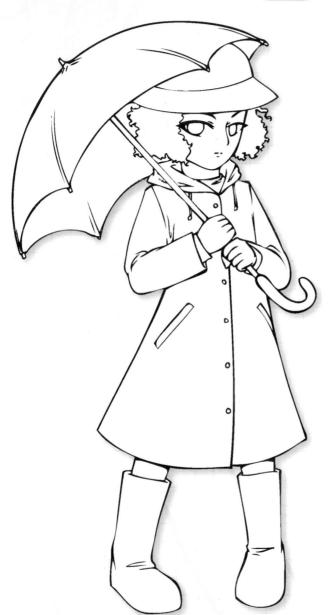

child female

search criteria

hat. umbrella. sad. angry. casual. standing.

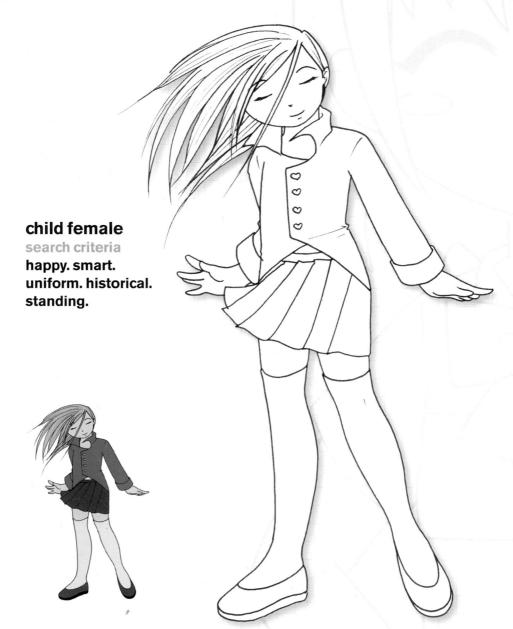

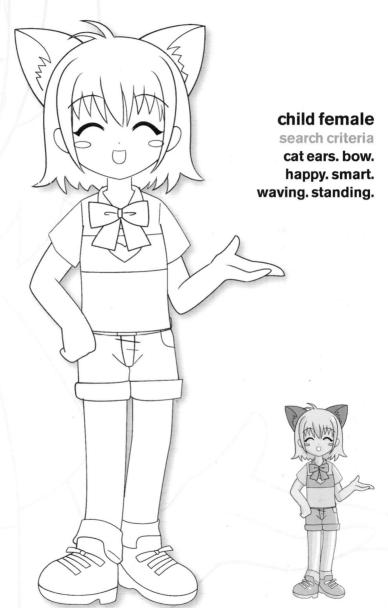

child female

search criteria pillow. slippers. pajamas. happy. standing. casual.

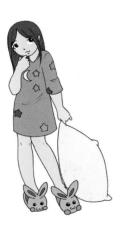

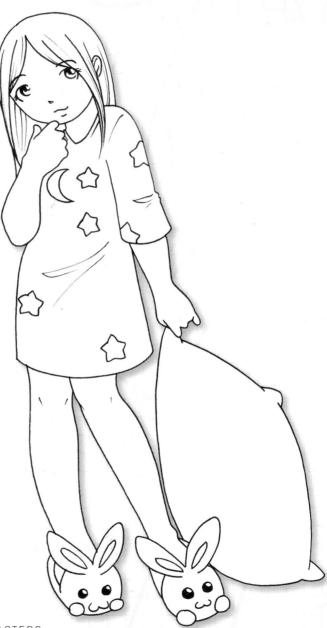

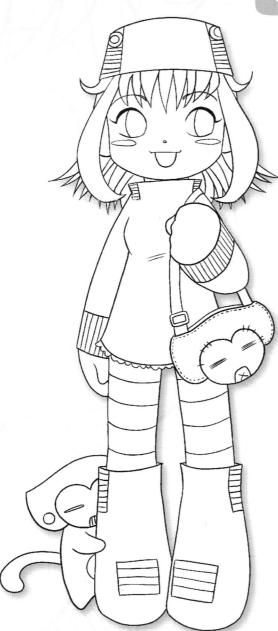

child female

search criteria

chibi. bag. hat. toy. animal. monkey. smart. future. tail. happy. standing.

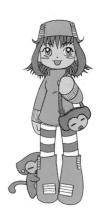

adult male search criteria angry. sad. suit. smart. casual. standing.

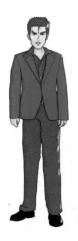

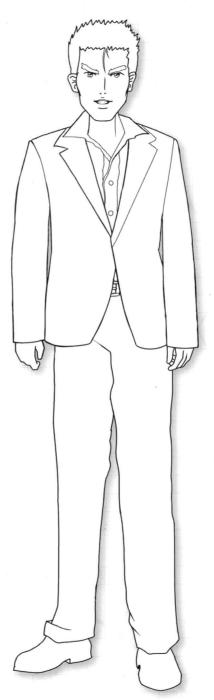

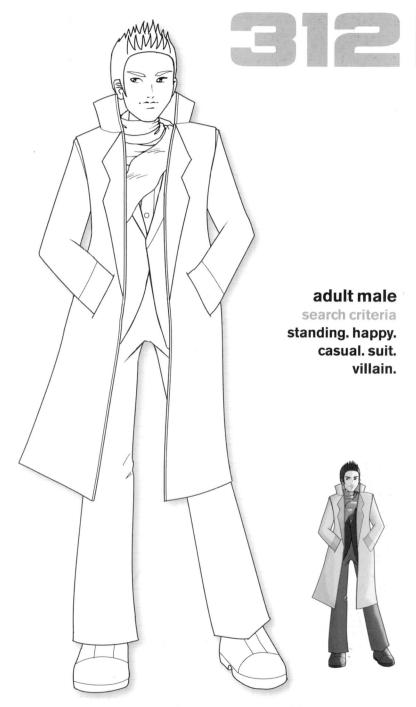

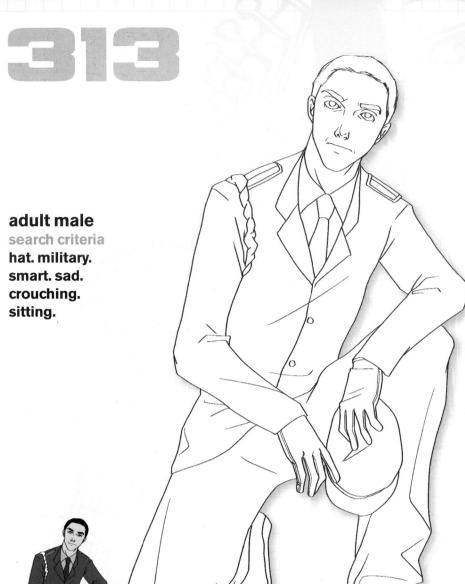

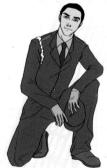

adult male

search criteria

angry. casual. martial arts. sport. action. fighting. standing.

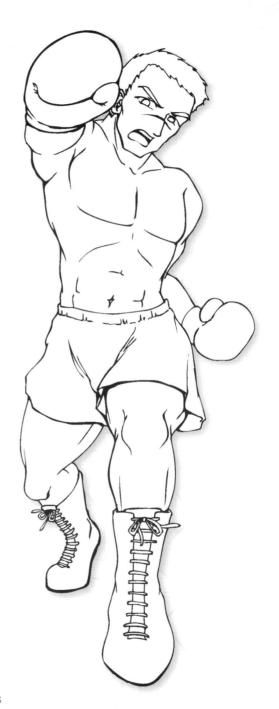

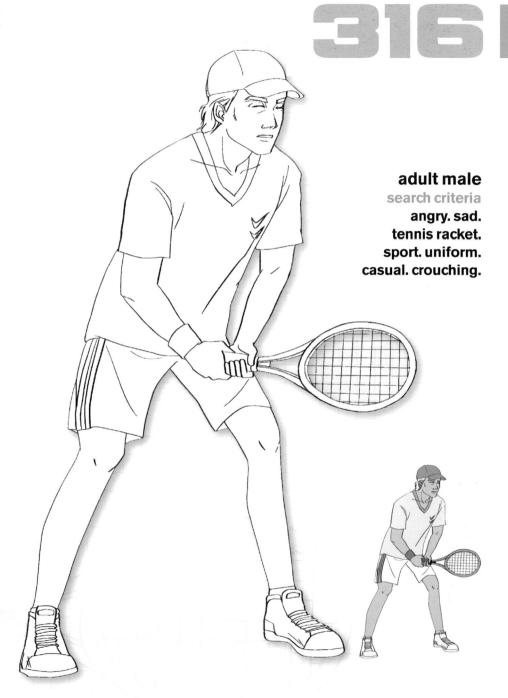

search criteria

sad. angry. smart. wedding. uniform. suit. standing.

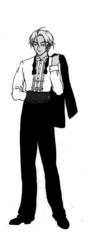

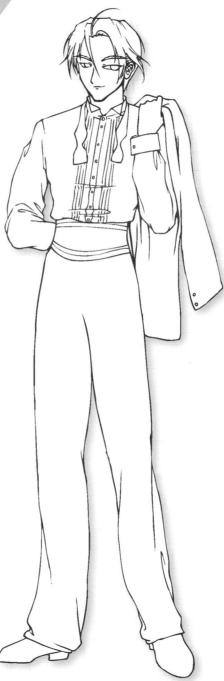

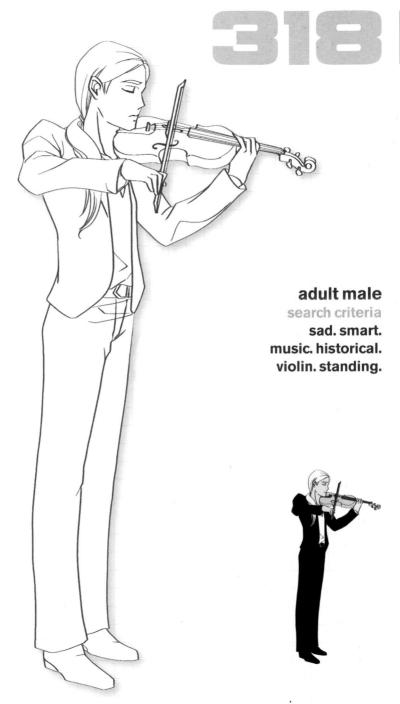

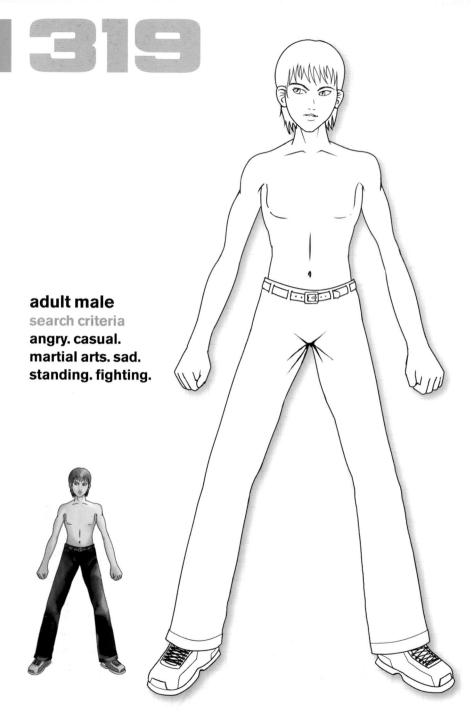

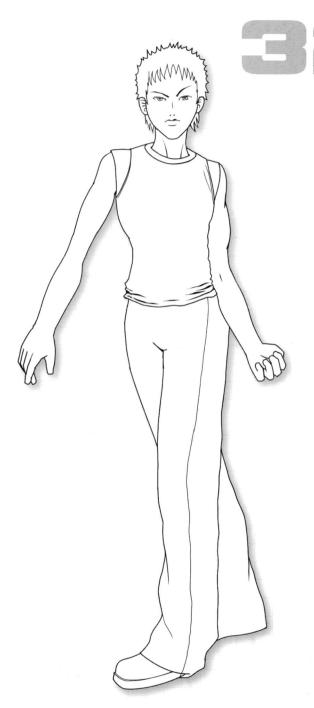

search criteria

standing. angry. sad. casual. action. martial arts. walking. fighting.

search criteria

happy. smart. wedding. suit. standing. sad.

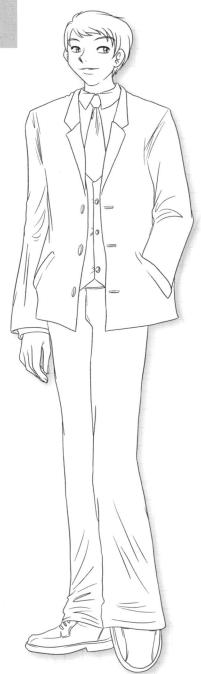

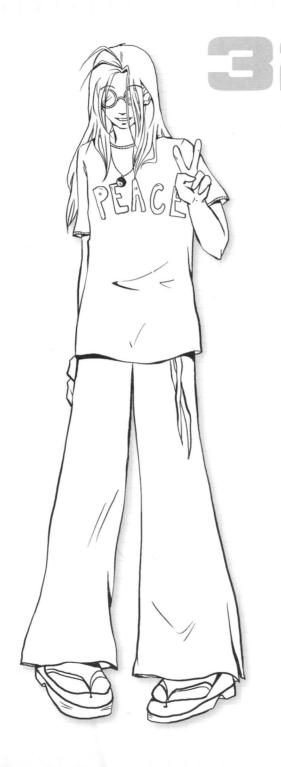

search criteria

happy. casual. glasses. waving. standing.

adult male search criteria weapon. sword. action. casual. martial arts. tattoo. angry. fighting. standing.

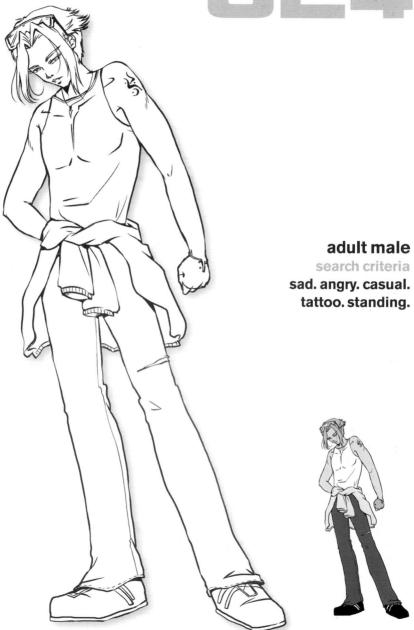

search criteria

chibi. happy. casual. smart. future. walking. standing.

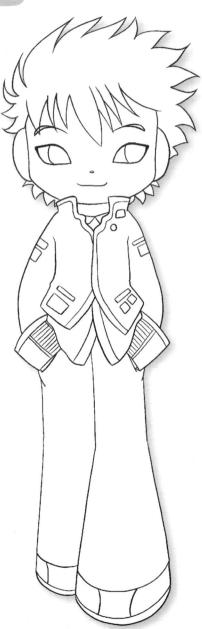

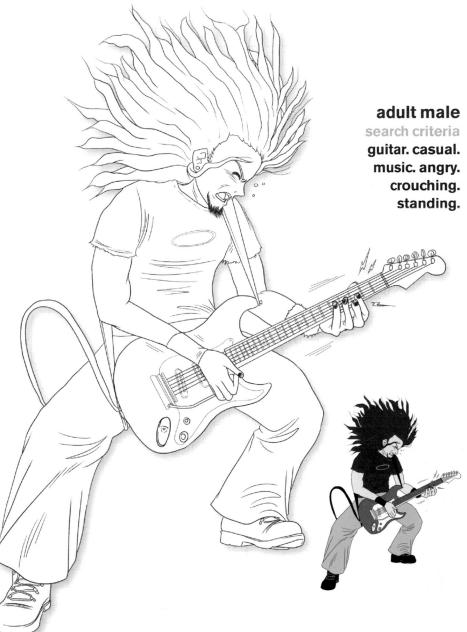

search criteria

hat. tattoo. historical. casual. villain. smart. angry. standing. suit.

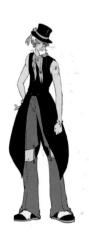

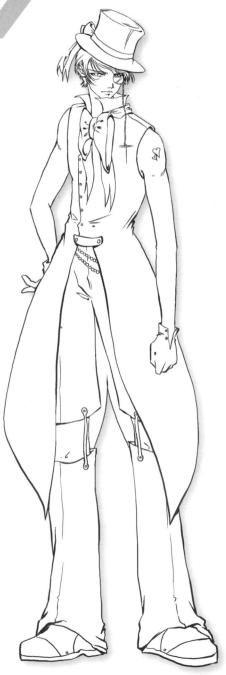

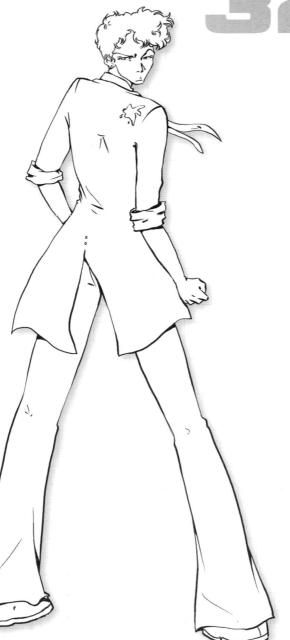

adult male

search criteria

angry. sad. casual. smart. villain. standing.

adult male search criteria happy. glasses. book. watch. casual. sitting.

search criteria

bag. hat. casual. sport. angry. sad. standing.

adult male

search criteria

book. angry. sad. smart. uniform. standing.

search criteria

glasses. sad. angry. wedding. smart. standing.

search criteria

hat. historical. smart. suit. happy. walking. standing.

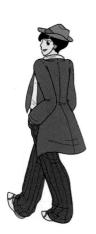

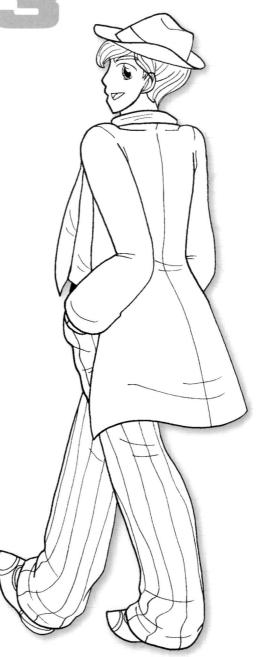

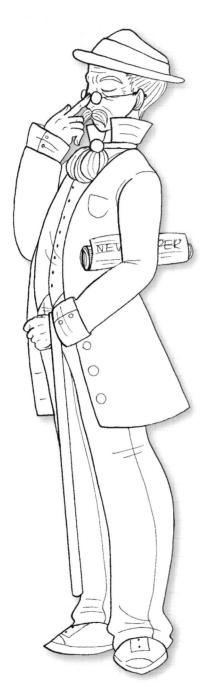

adult male search criteria

hat. newspaper. glasses. sad. smart. suit. historical. standing.

adult male

search criteria

gun. weapon. happy. casual. warrior. action. standing. fighting.

search criteria

angry. sad. casual. future. villain. standing.

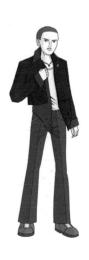

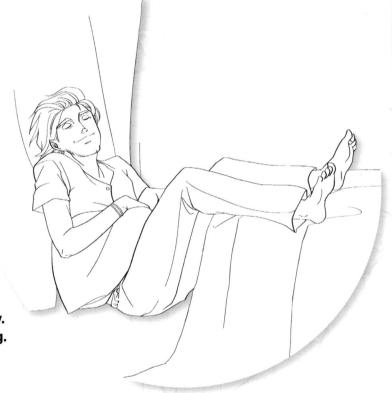

adult male

search criteria pillow. casual. pajamas. happy. sitting. sleeping.

adult male search criteria sad. casual. wink. watch. sitting.

III.

adult male search criteria standing. sad. happy. casual. future. action.

villain. walking.

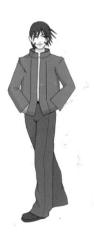

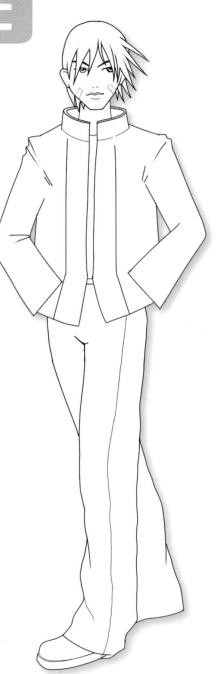

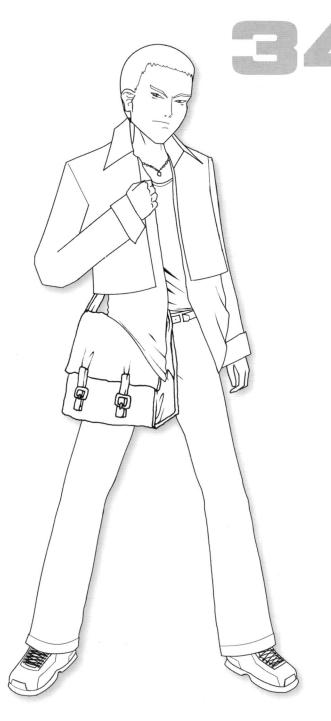

search criteria

standing. bag. angry. casual. future. villain.

search criteria

book. sad. angry. casual. walking. standing.

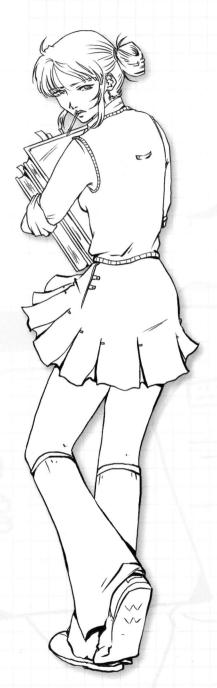

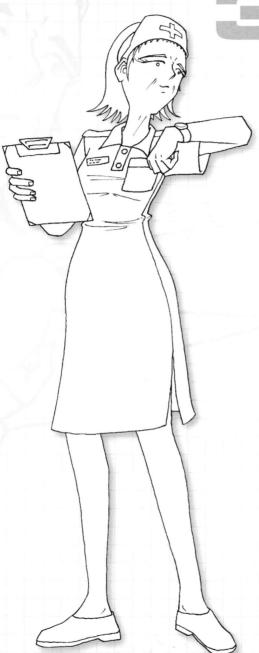

search criteria

hat. clipboard. watch. sad. smart. uniform. standing.

search criteria

phone. bag. glasses. sad. standing. smart.

adult female search criteria pen. sad. angry. smart. standing. waving. suit. clipboard.

E 4.5

adult female

search criteria

bag. happy. casual. standing. waving. smart.

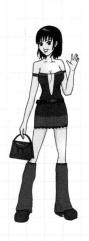

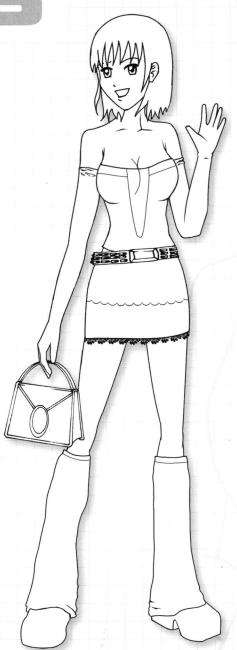

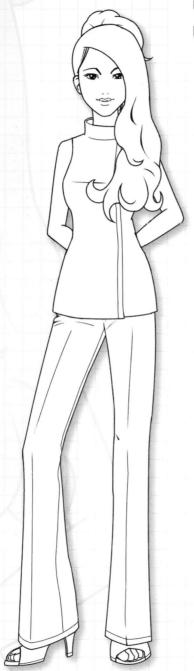

adult female

search criteria

happy. smart. uniform. future. casual. standing.

adult female

search criteria

happy. bunny ears. casual. dance. hat. standing.

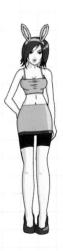

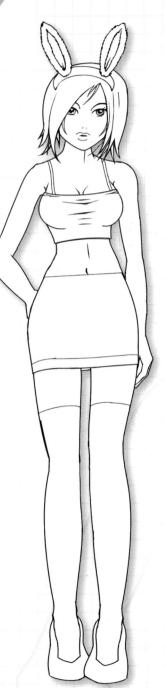

search criteria

chibi. happy. smart. dance. casual. standing.

34.9

adult female search criteria chibi. glasses. happy. smart. casual. standing.

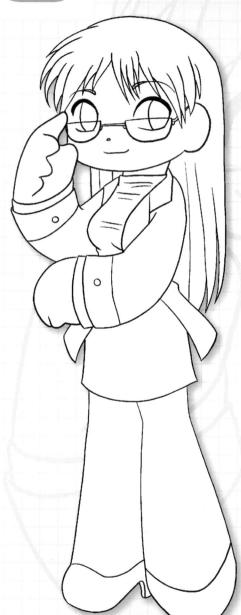

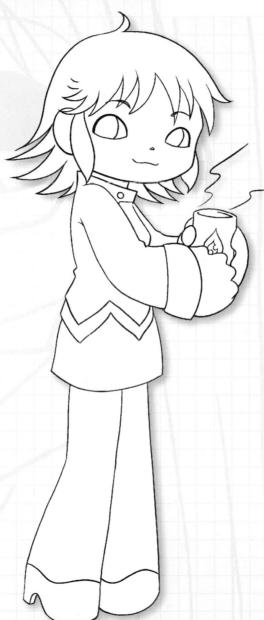

search criteria

chibi. food. happy. casual. cup. standing.

adult female

search criteria

happy. smart. casual. standing.

adult female

search criteria

happy. casual. dance. standing.

adult female

search criteria

glasses. hat. happy. sad. casual. swimwear. standing.

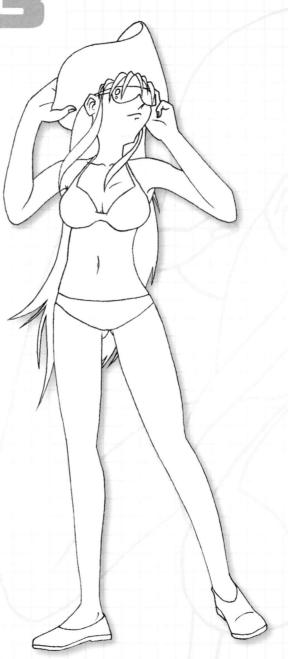

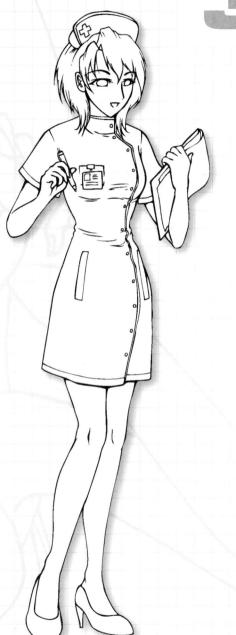

search criteria

happy. hat. pen. clipboard. smart. uniform. standing.

search criteria

food. plate. uniform. smart. bow. happy. walking.

search criteria

bag. dog. casual. smart. tattoo. happy. sad. standing. walking.

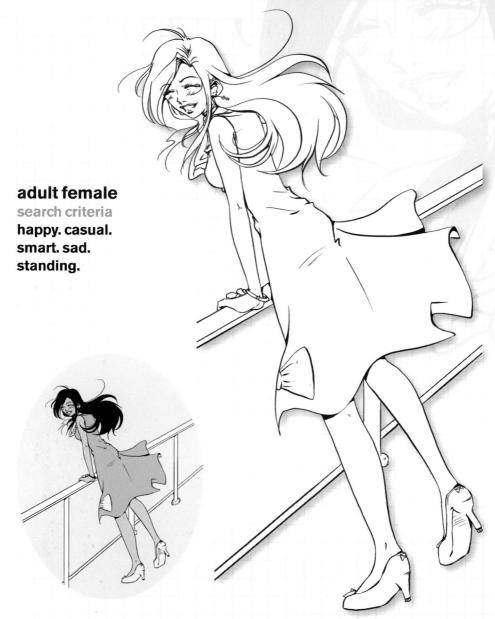

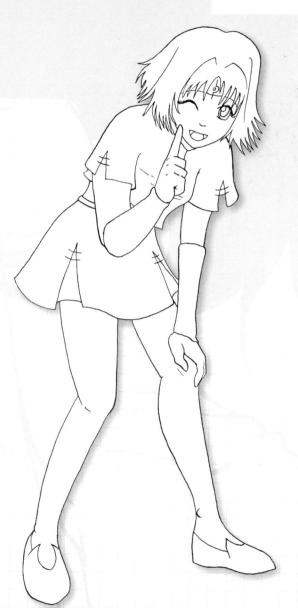

adult female

search criteria

happy. casual. dance. sport. historical. crouching. standing. wink.

search criteria

bag. glasses. sad. casual. smart. standing.

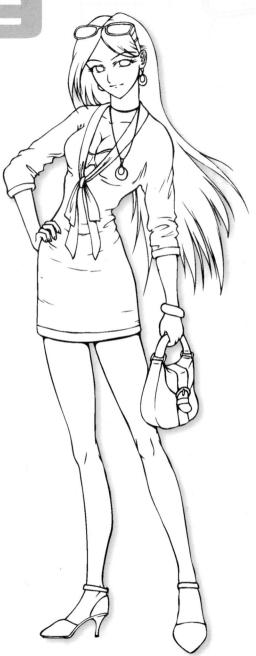

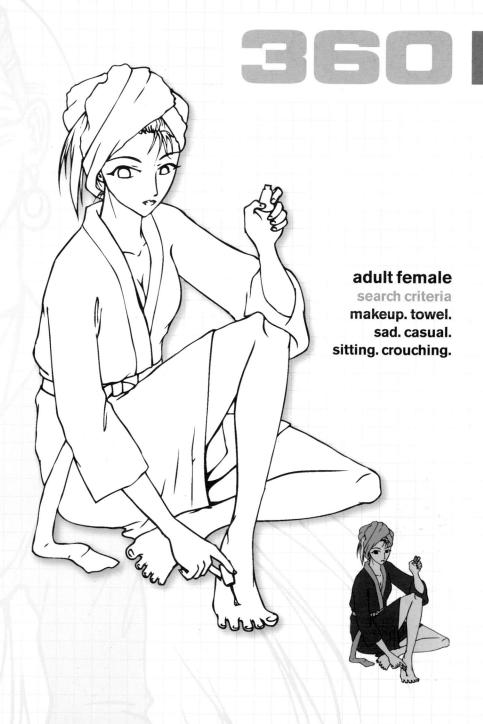

search criteria

hat. walking. angry. smart. standing. bag. suit. sad.

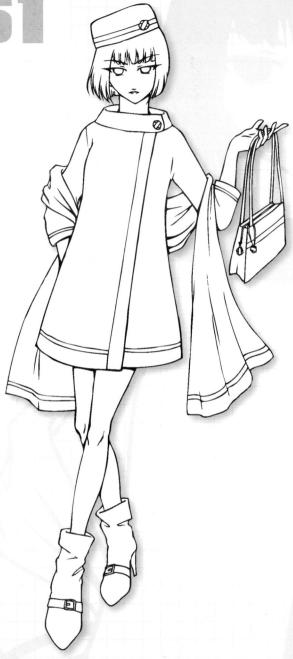

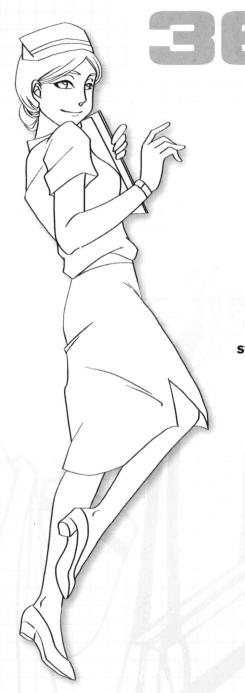

search criteria

hat. paper. happy. uniform. smart. watch. standing. running.

search criteria

bag. glasses. happy. smart. standing. walking.

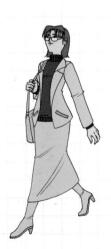

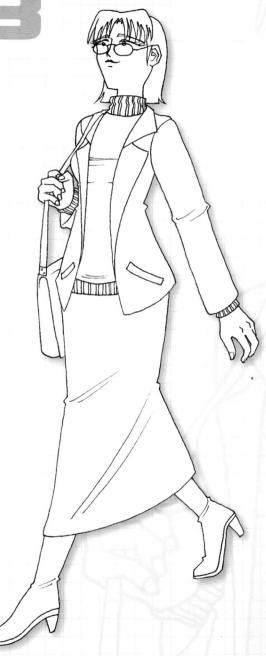

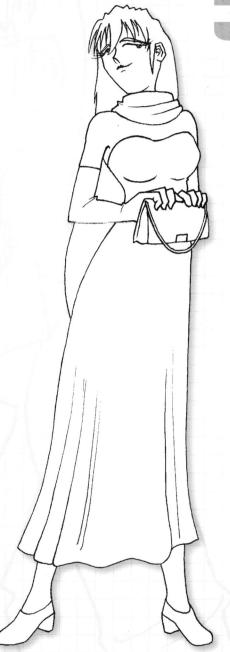

adult female search criteria

bag. happy. smart. casual. wedding. standing.

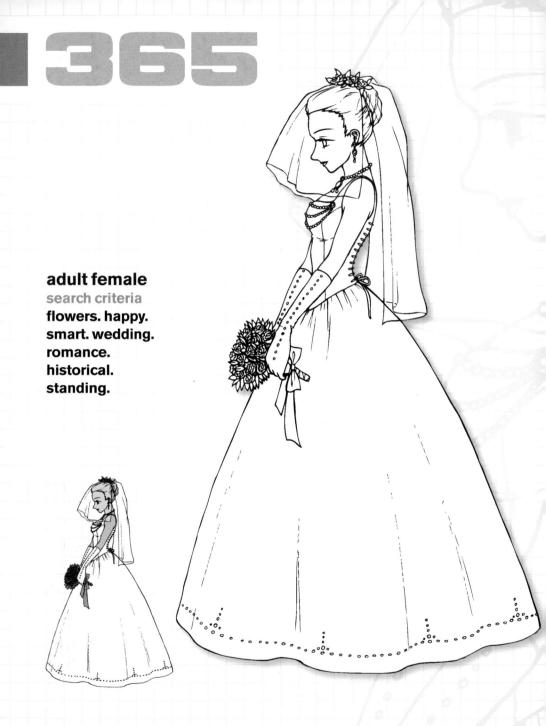

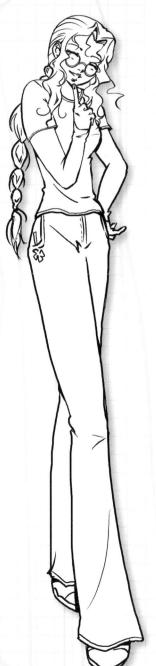

adult female search criteria glasses. happy. casual. smart. standing. walking.

adult female

search criteria

microphone. music. happy. smart. standing. waving. singing.

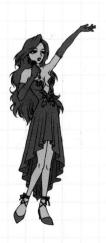

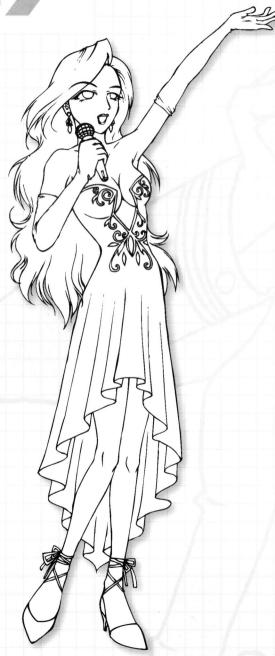

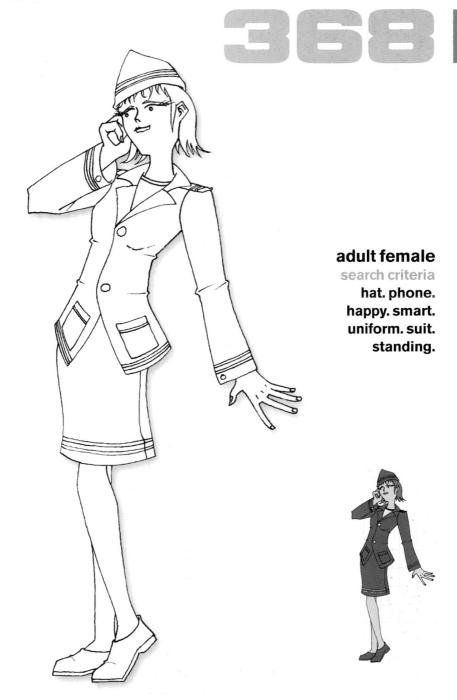

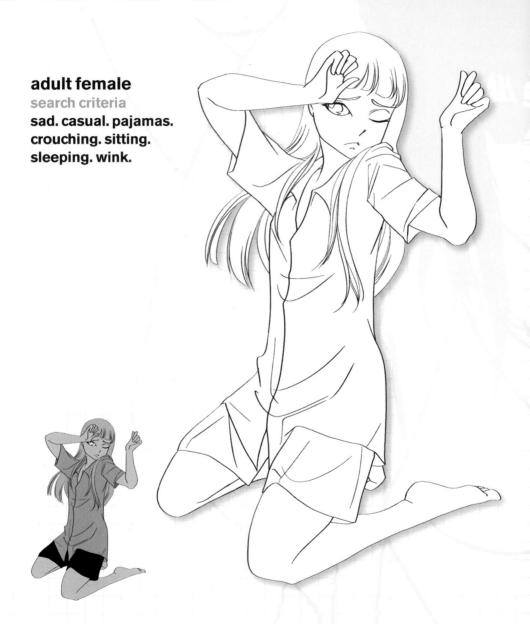

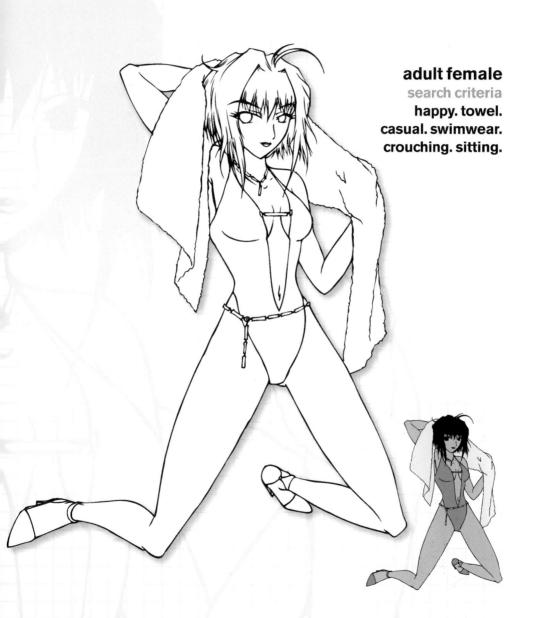

E371

chibi male

search criteria

cat ears. happy. teenage. casual. tail. standing.

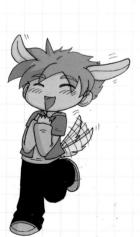

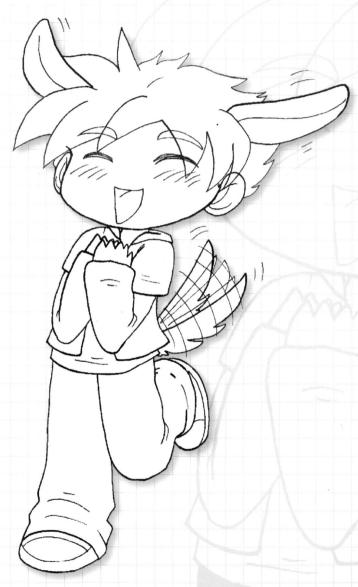

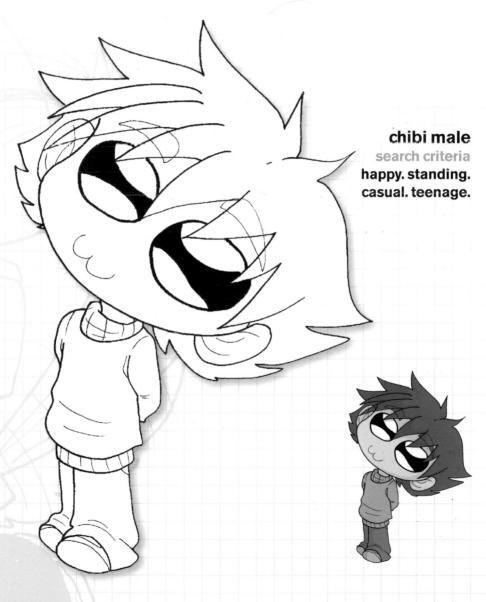

chibi male

search criteria

mirror. teenage. happy. smart. casual. standing.

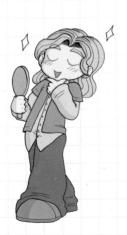

37/5

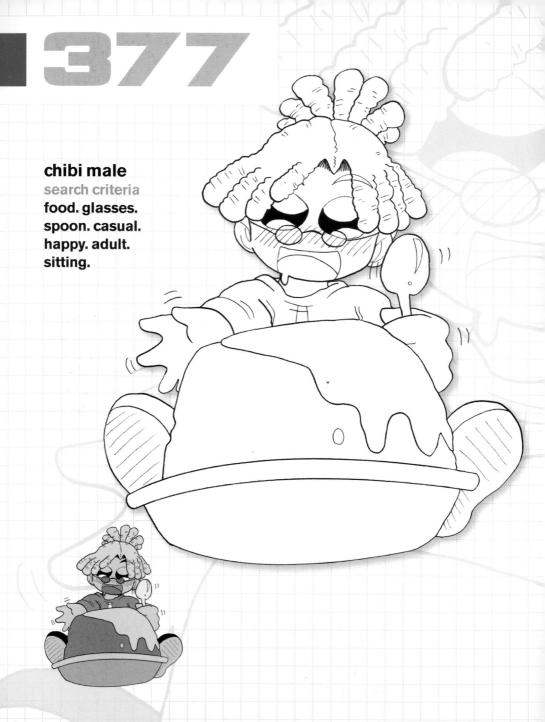

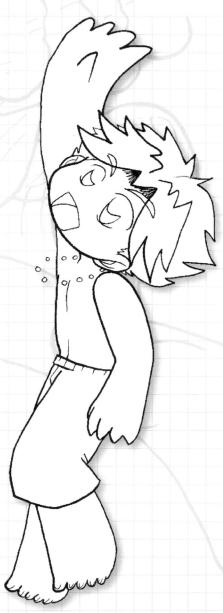

chibi male

search criteria

teenage. happy. casual. dance. standing. waving. jumping.

37/5

chibi male

search criteria

hat. headphones. teenage. sad. casual. music. standing.

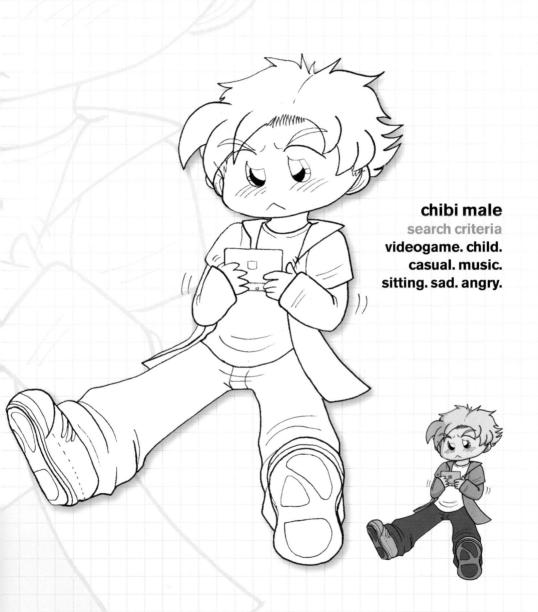

E E 1

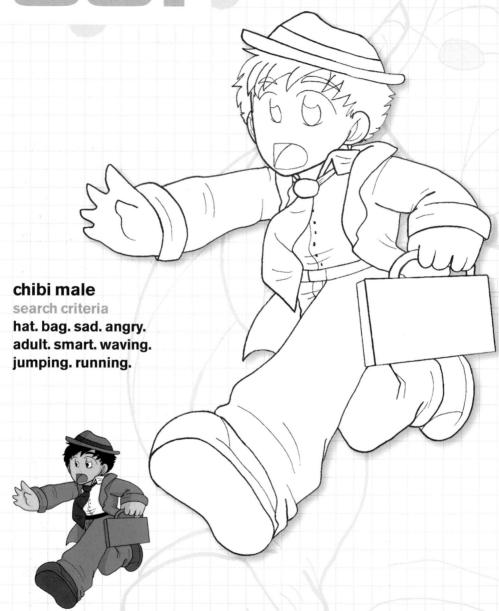

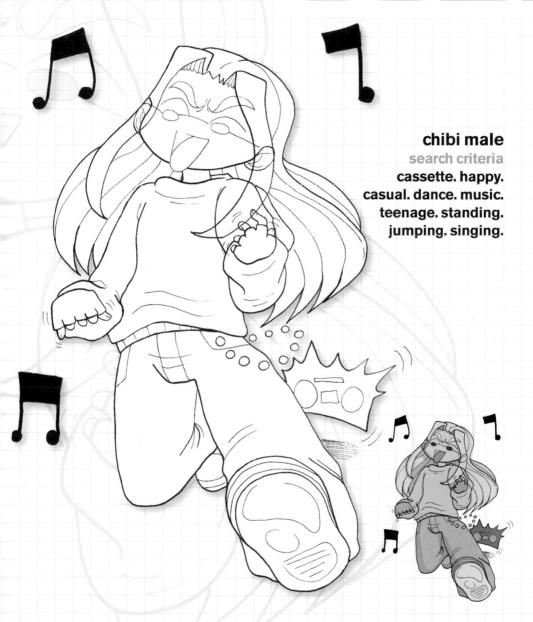

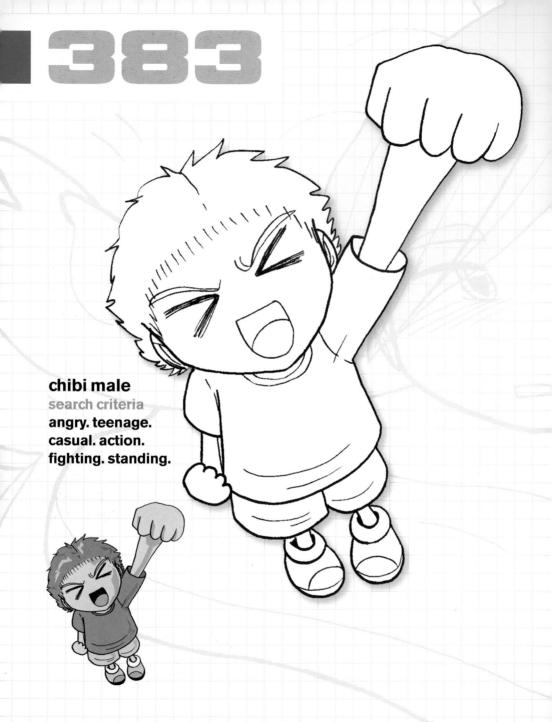

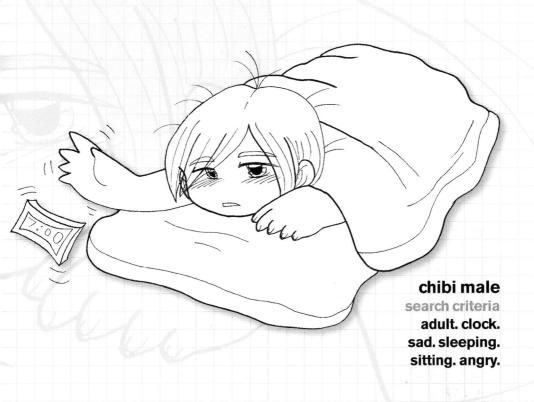

E E 5

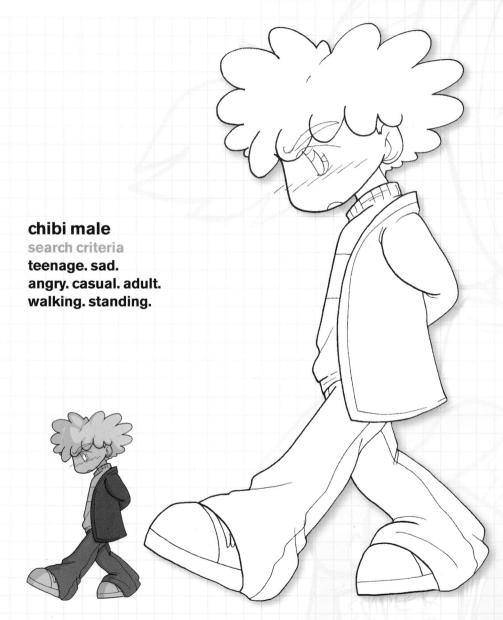

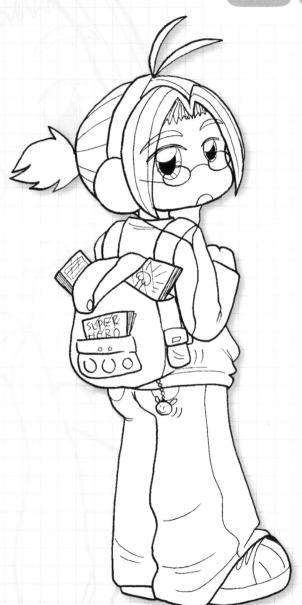

chibi male

search criteria

bag. glasses. hat. sad. casual. teenage. standing

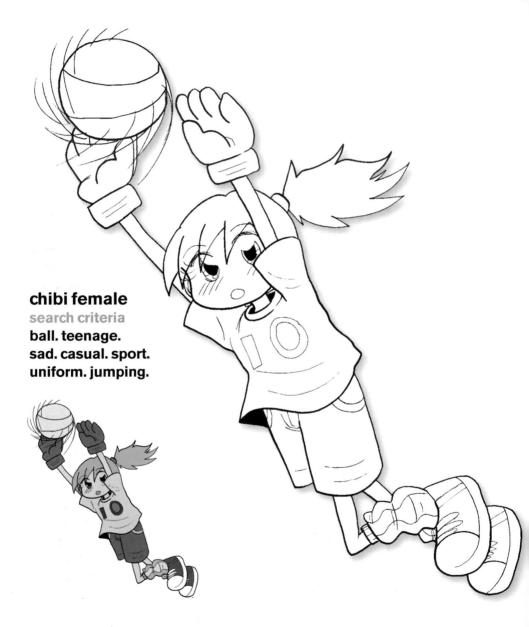

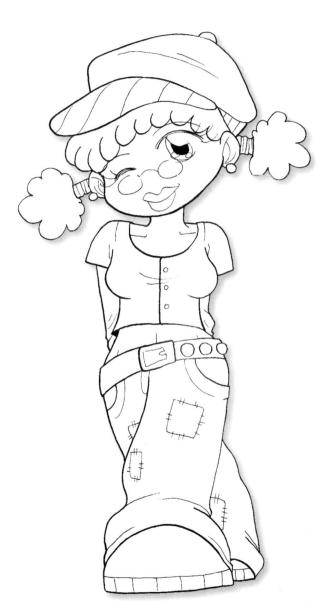

chibi female

search criteria

teenage. glasses. hat. happy. wink. casual. walking. standing.

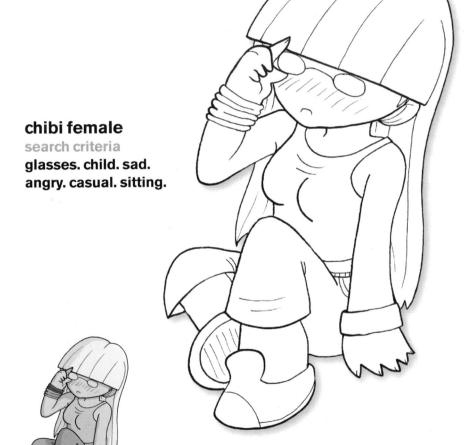

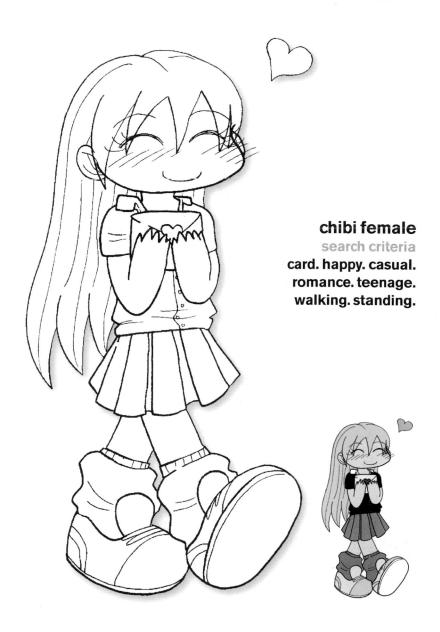

chibi female

search criteria

traditional. asian. dance. smart. happy. standing.

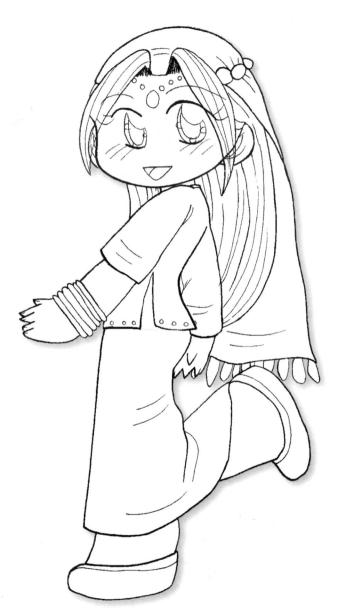

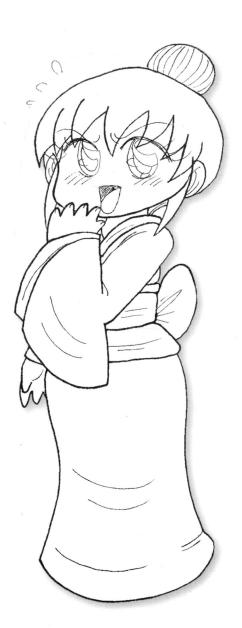

chibi female search criteria traditional. asian.

traditional. asian. kimono. sad. standing. adult.

chibi female search criteria angry. teenage. villain. casual. sad. standing.

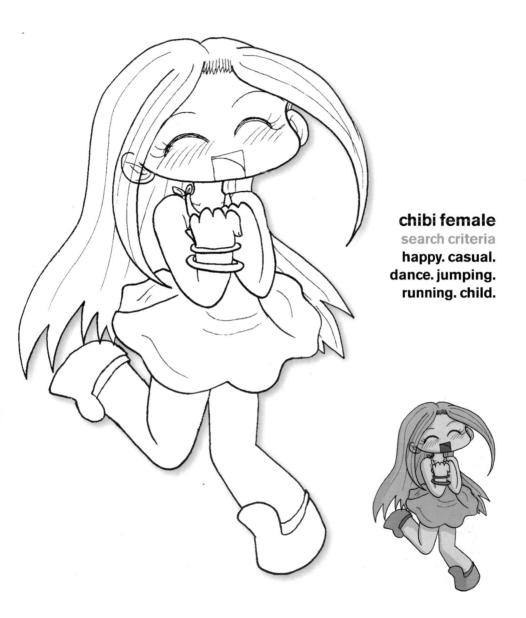

chibi female

search criteria

teenage. angry. sad. casual. standing.

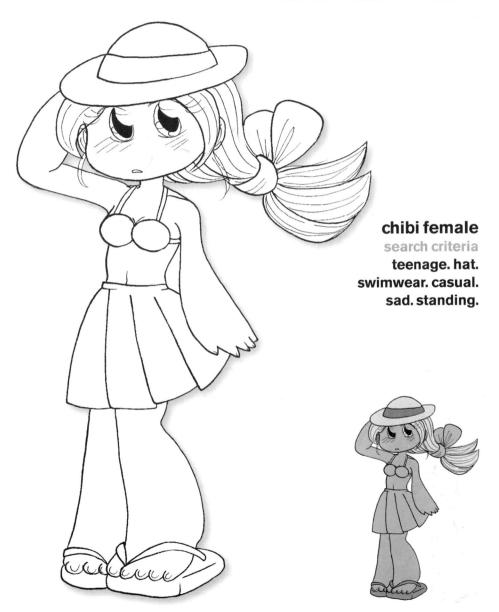

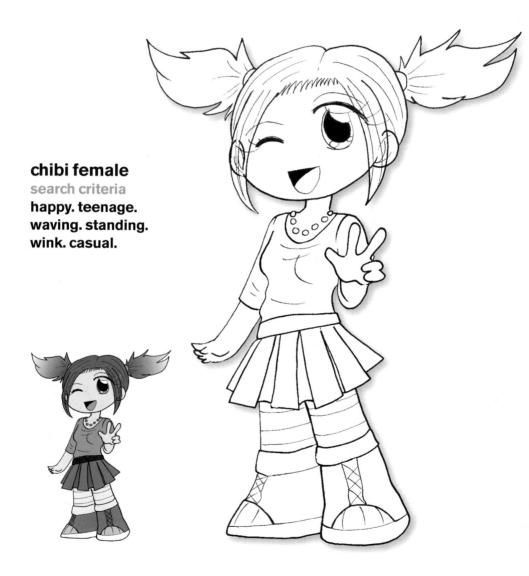

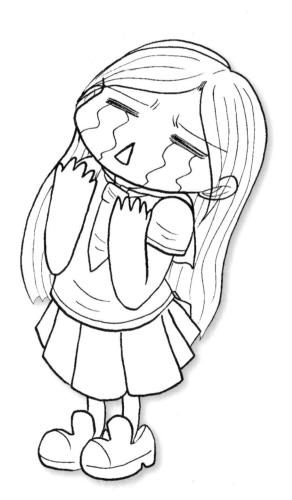

chibi female search criteria sad. smart. uniform. child. standing.

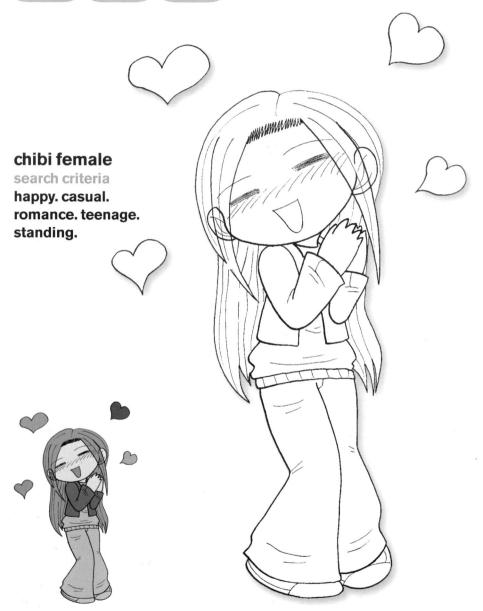

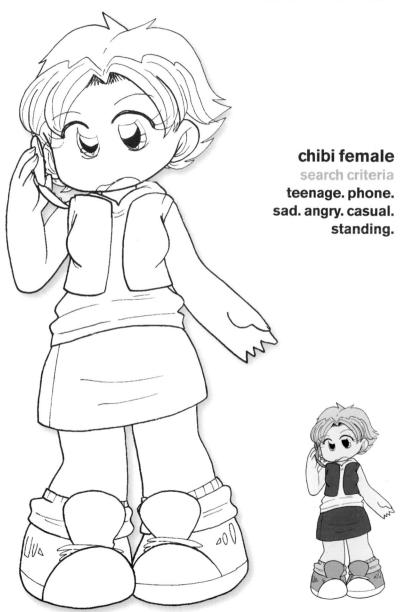

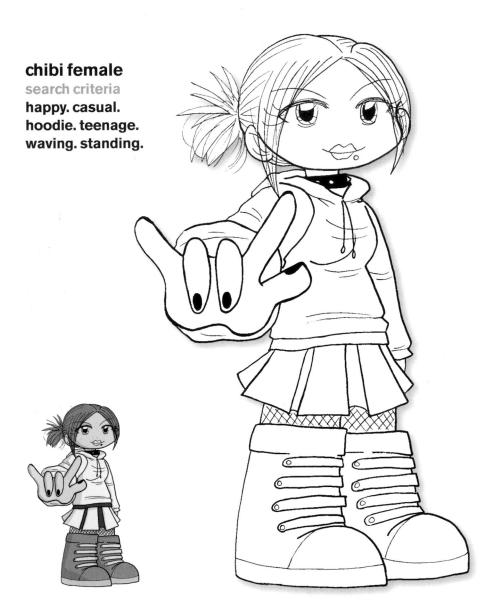

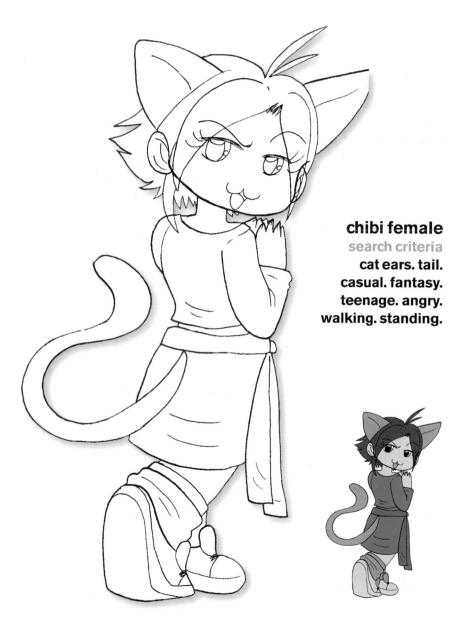

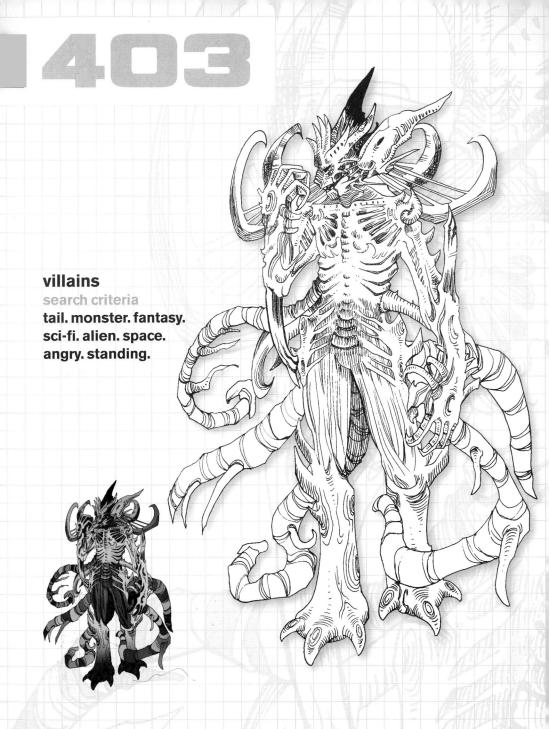

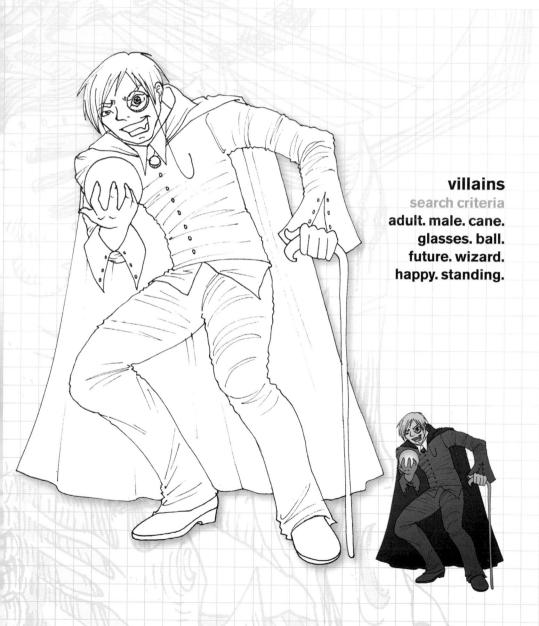

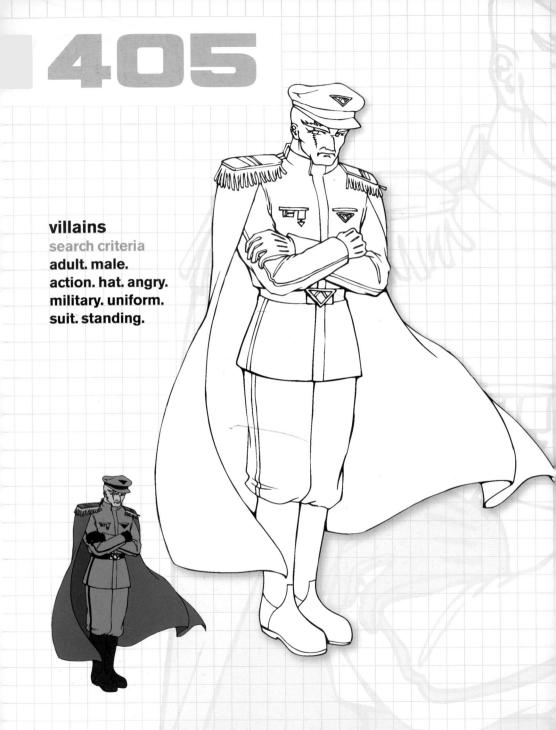

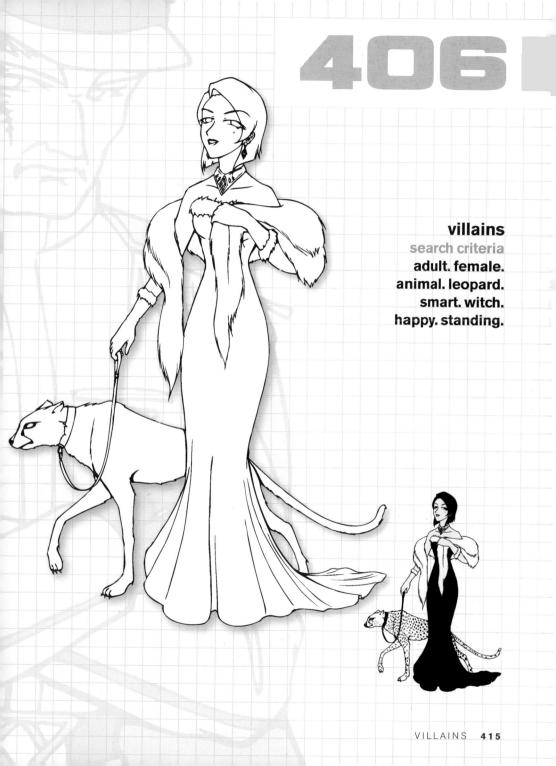

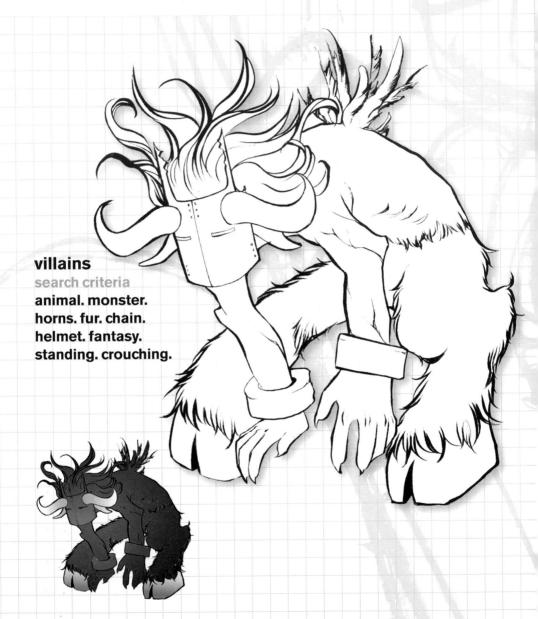

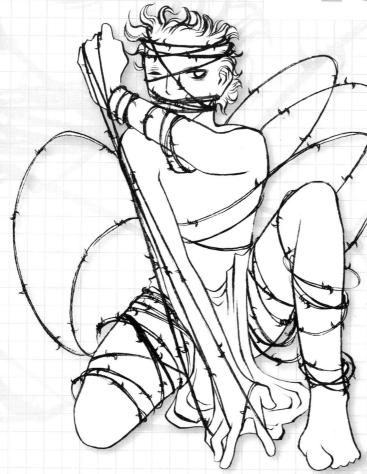

villains

search criteria

chain. barbed wire. fantasy. teenage. male. warrior. sad. crouching. sitting.

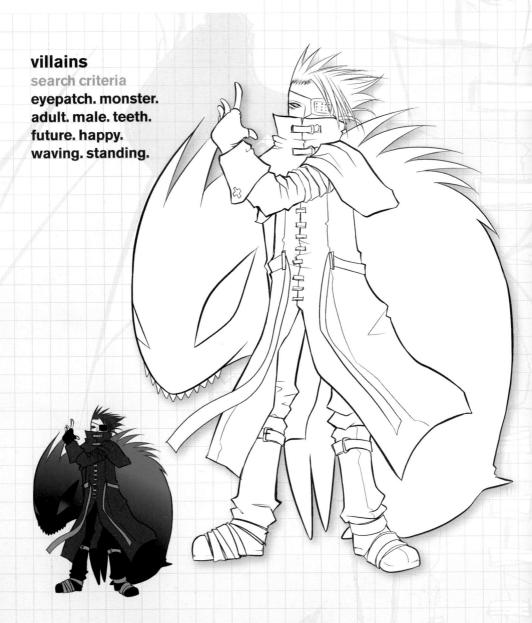

villains

search criteria

monster. ghoul. walking. happy. male. standing.

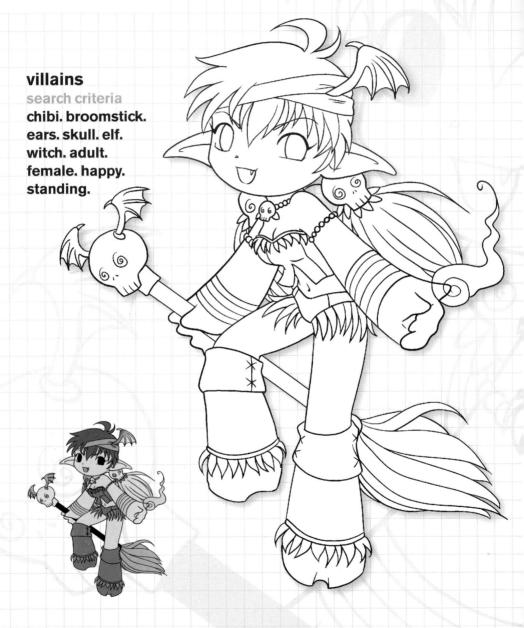

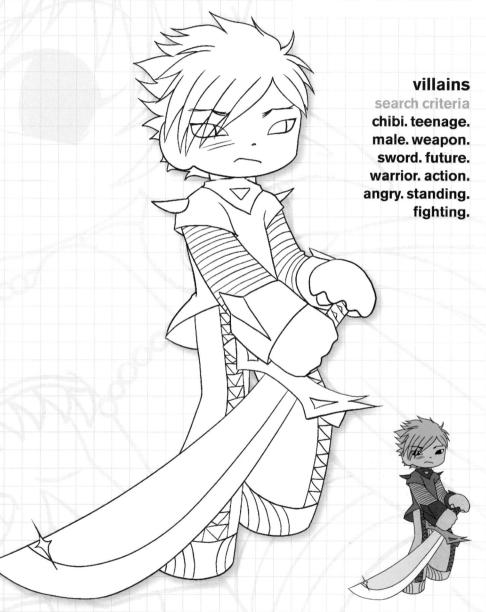

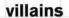

search criteria

chibi. female.
monster. fantasy.
witch. teeth. tail.
ears. happy.
dragon. horns.
sitting. flying.
crouching.

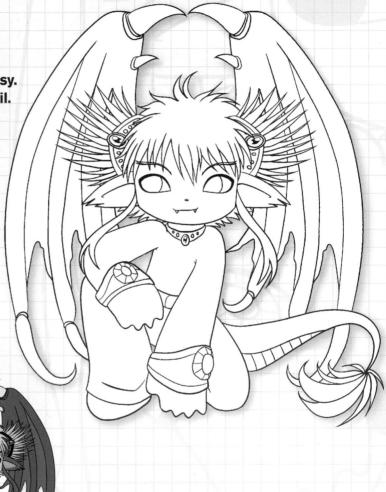

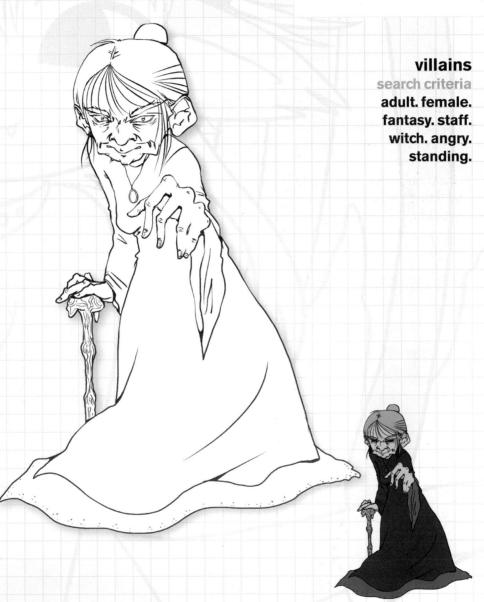

villains

search criteria

hat. rope. historical. male. smart. suit. sad. hanging. sitting.

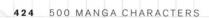

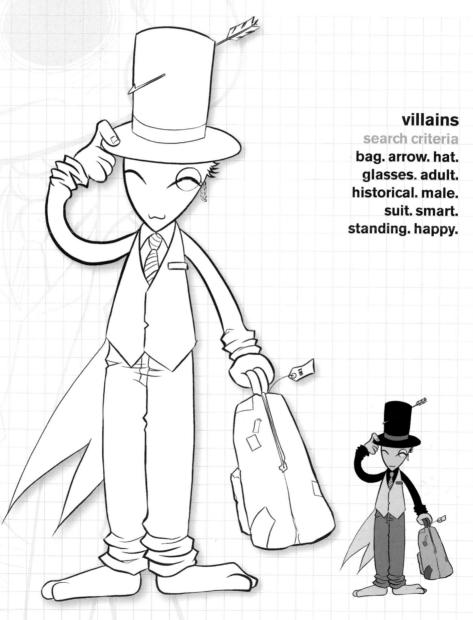

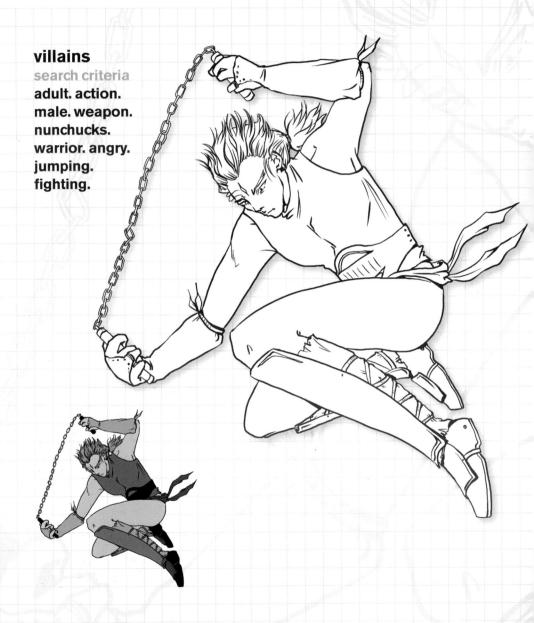

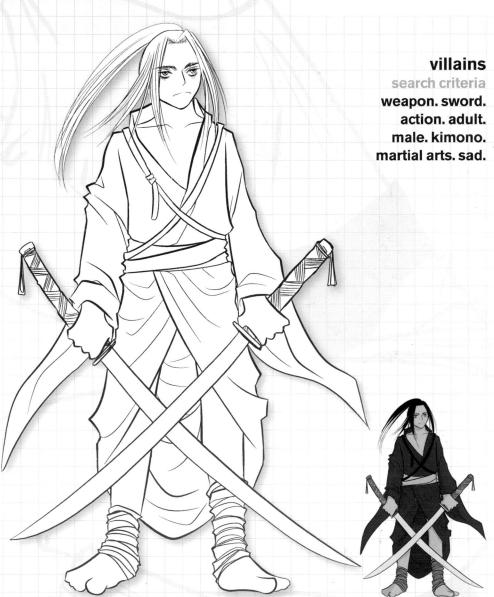

villains search criteria

teenage. male. action. casual. standing. fighting. angry.

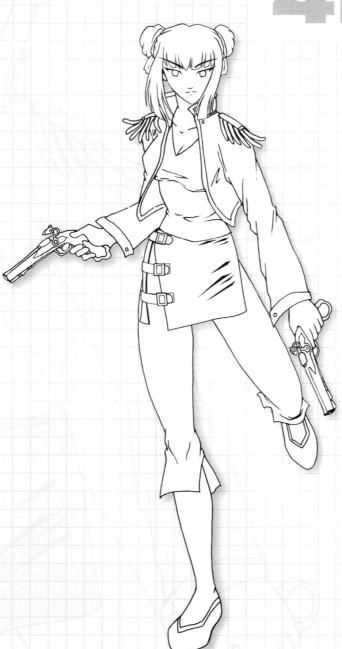

villains

search criteria

adult. female. action. weapon. gun. warrior. happy. running. standing.

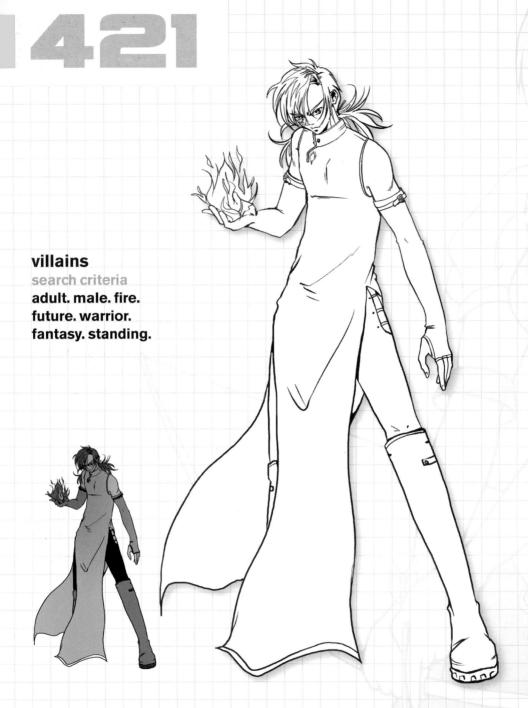

villains search criteria

weapon. arrow. bow. historical. action. teenage. female. warrior. sad. standing.

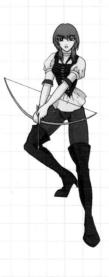

villains

search criteria

male. monster. book. horns. sad. standing.

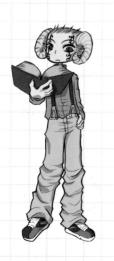

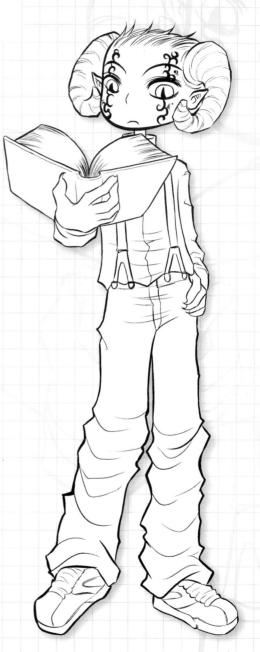

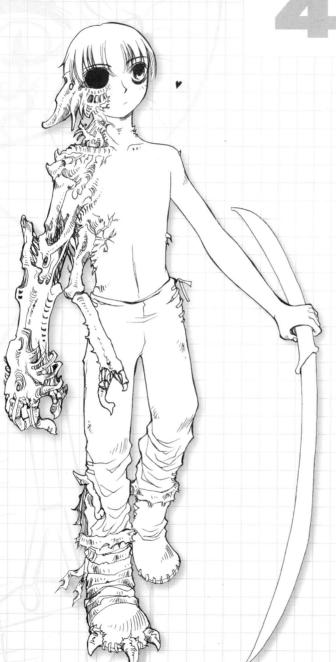

villains search criteria

weapon. sword. warrior. vampire. ghoul. monster. male. sad. walking. standing.

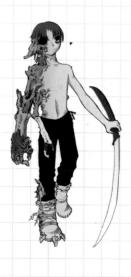

villains search criteria

weapon. sword. adult. male. action. casual. warrior. standing. fighting. angry.

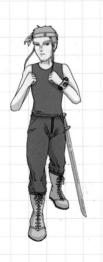

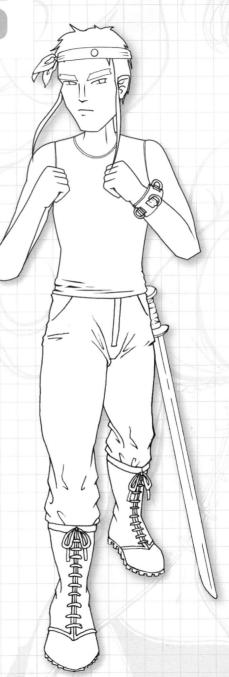

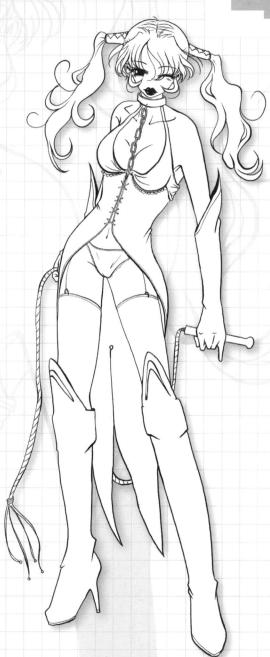

villains search criteria

adult. female. weapon. whip. future. standing. wink. happy.

villains

search criteria

female. monster. horns. teeth. witch. vampire. angry. standing. walking.

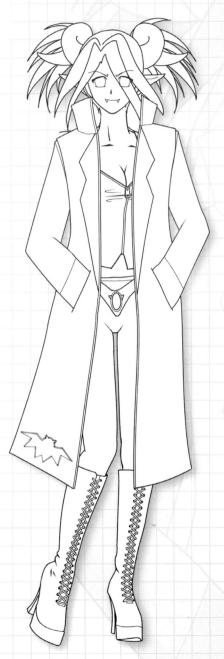

4.28

search criteria

chains. horns. skull. monster. fantasy. vampire. standing. sad.

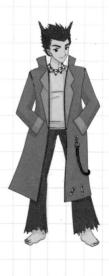

villains search criteria

female. teenage. weapon. gun. action. warrior. angry. standing. fighting.

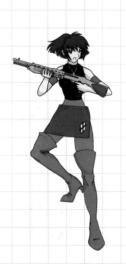

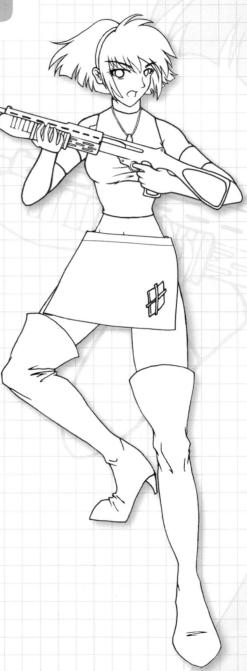

villains search criteria

angry. casual. sport. martial arts. action. male. teenage. fighting. standing.

00000 (000) 00000

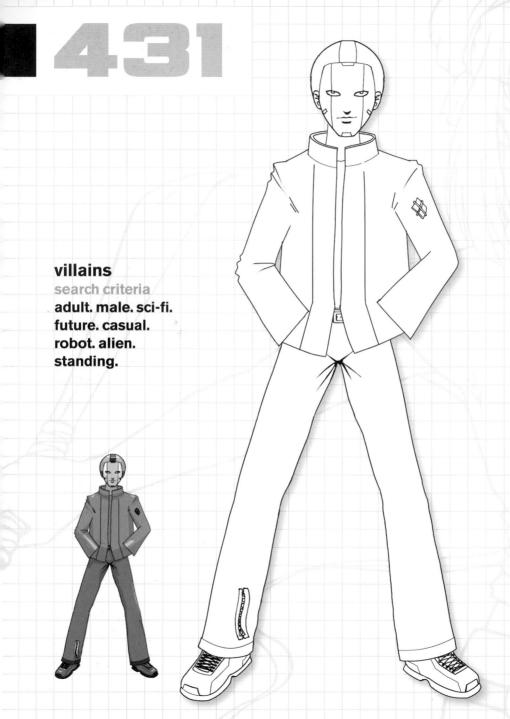

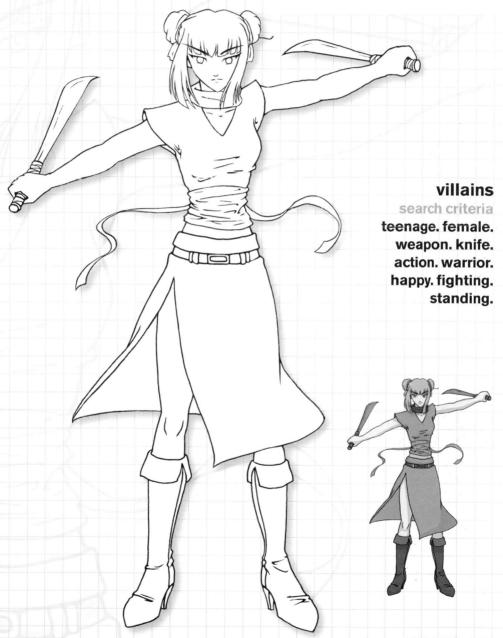

mecha

search criteria

robot. future. sci-fi. standing. gun. weapon. mobile suit. helmet.

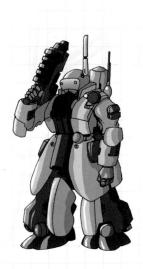

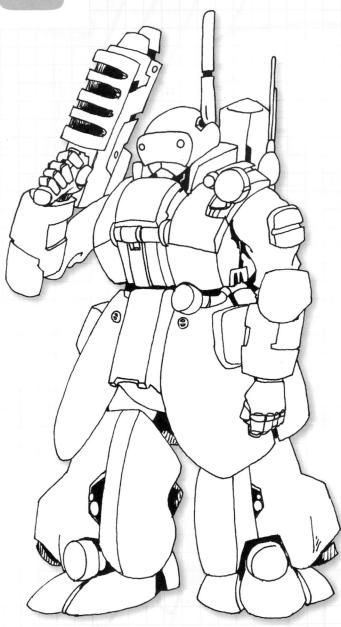

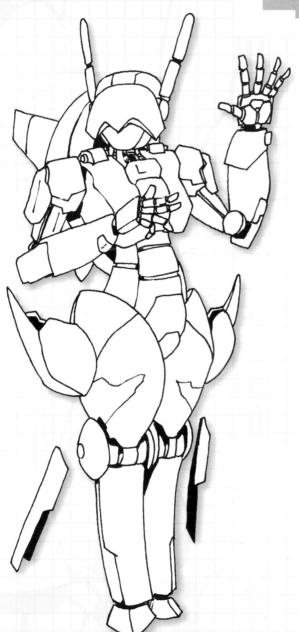

mecha search criteria

robot. future. sci-fi. standing. mobile suit. waving. helmet.

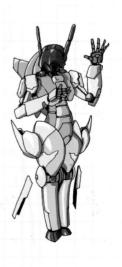

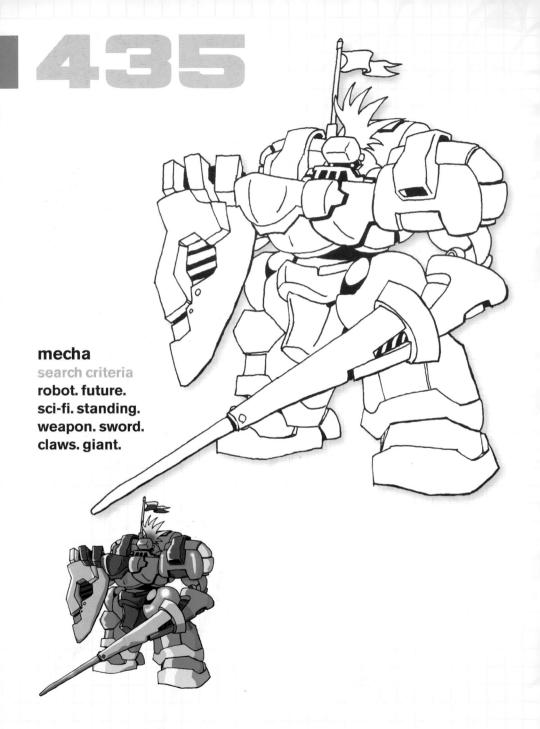

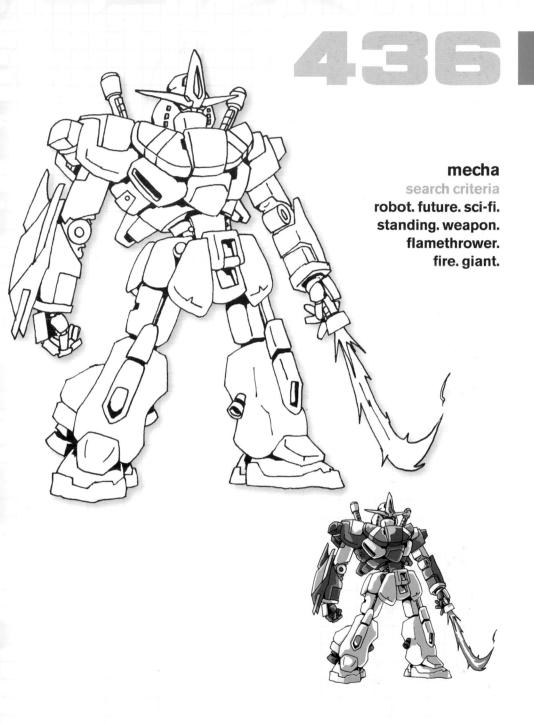

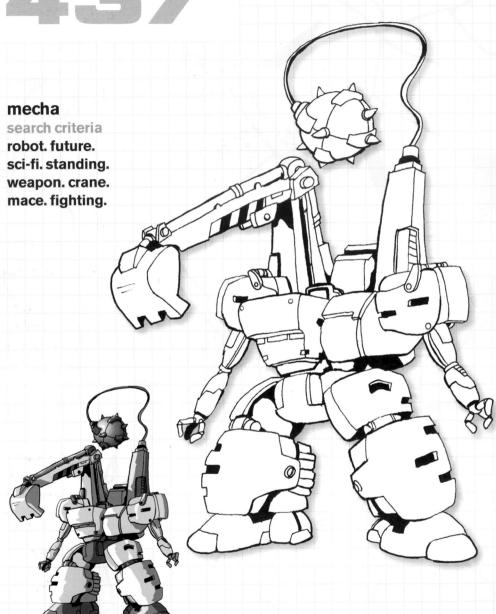

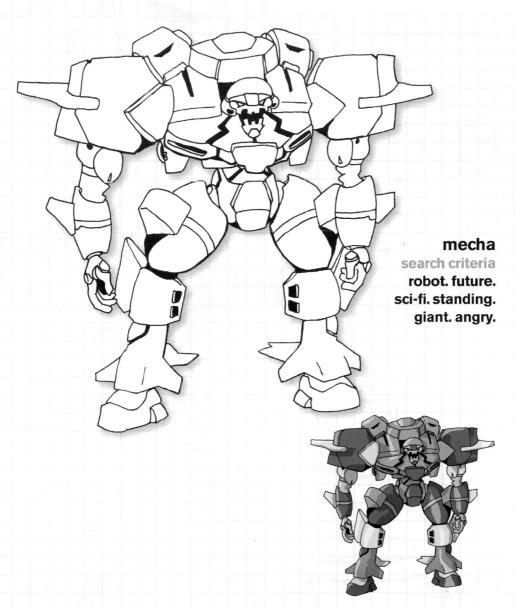

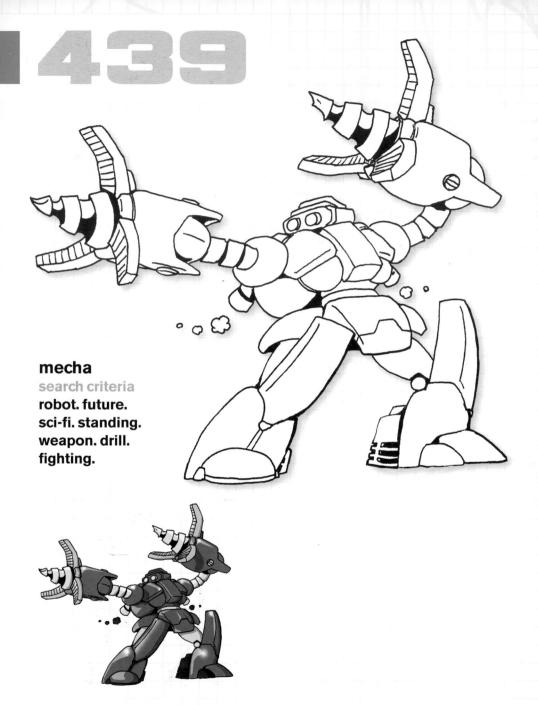

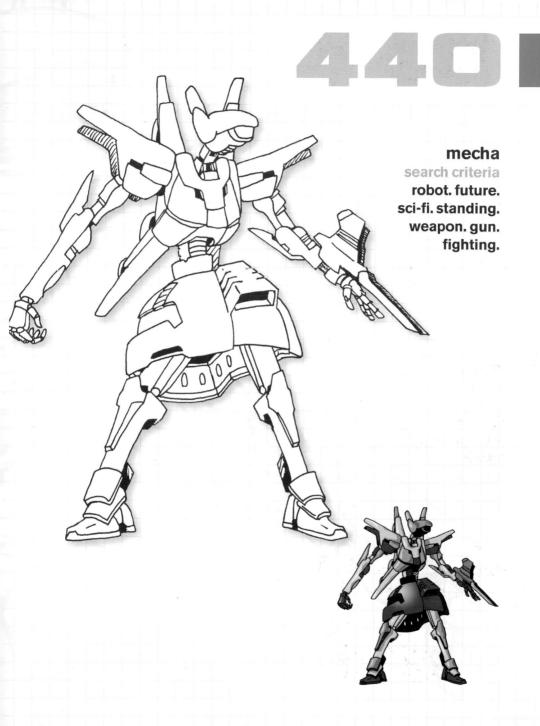

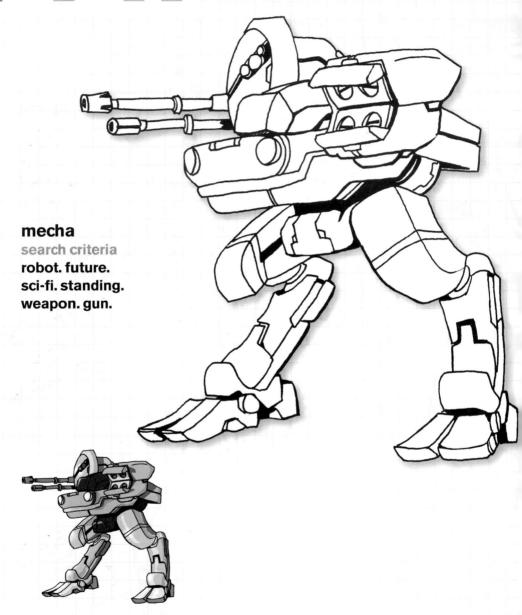

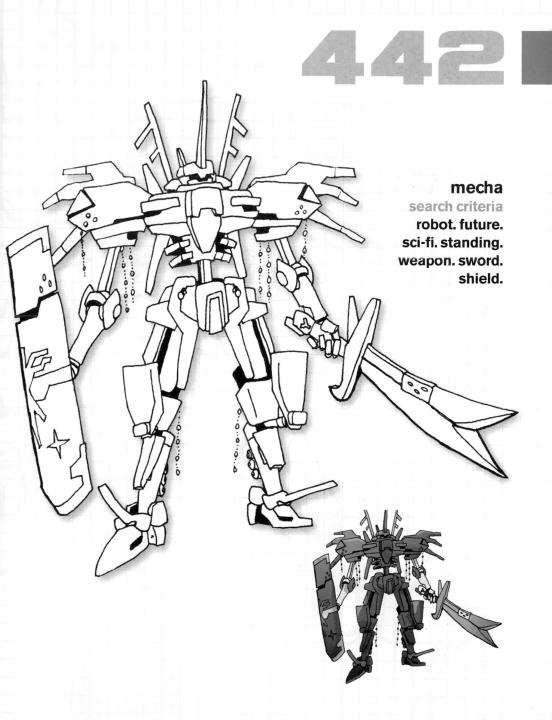

mecha

search criteria

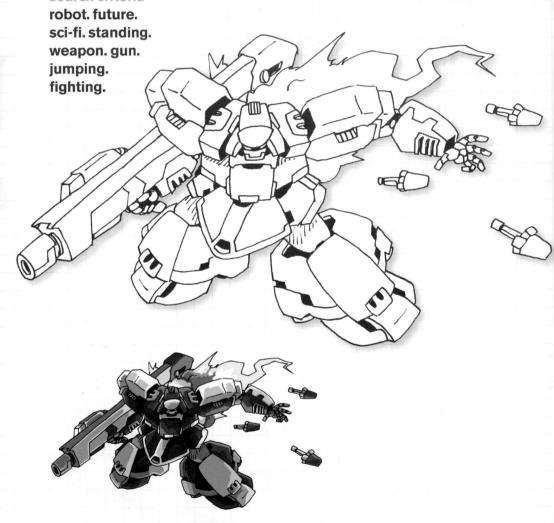

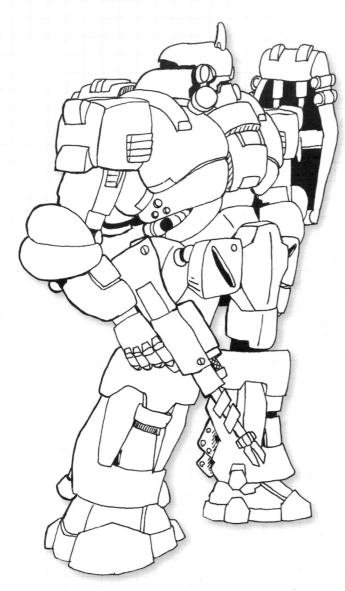

mecha search criteria

robot. future. sci-fi. standing. weapon. shield. gun. giant.

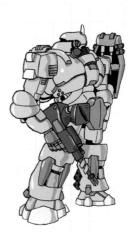

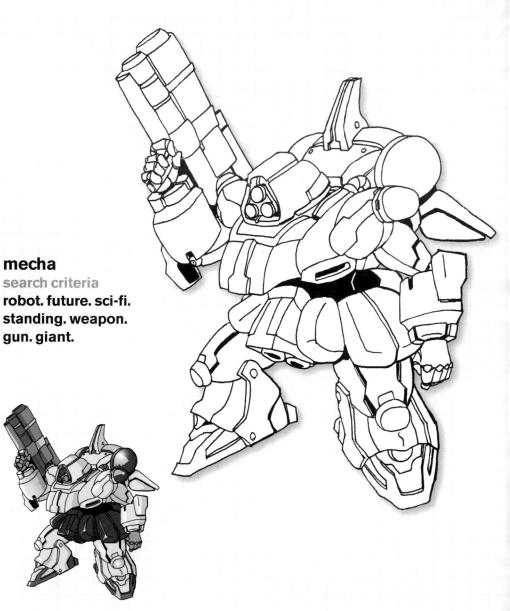

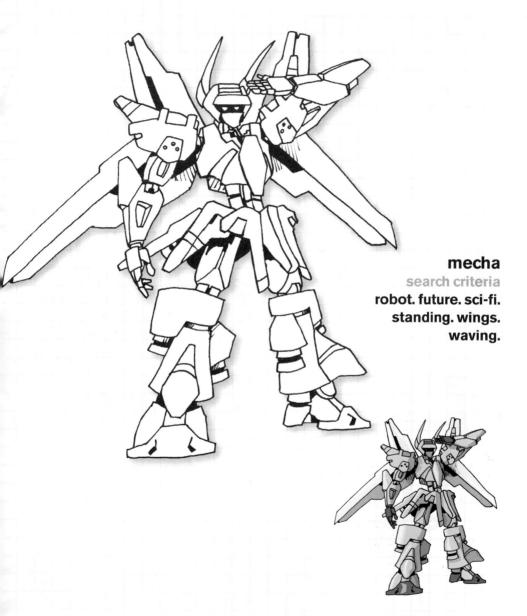

mecha

search criteria

robot. future. sci-fi. standing. weapon. sword. mobile suit.

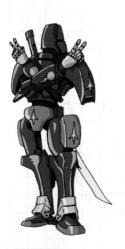

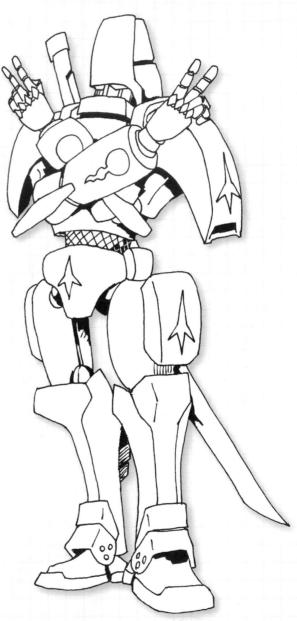

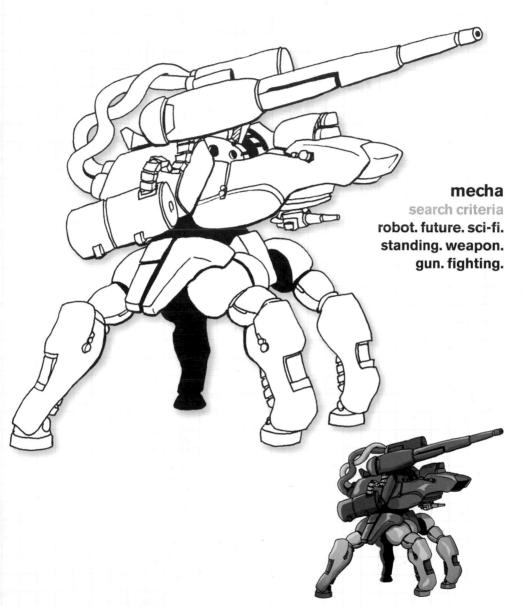

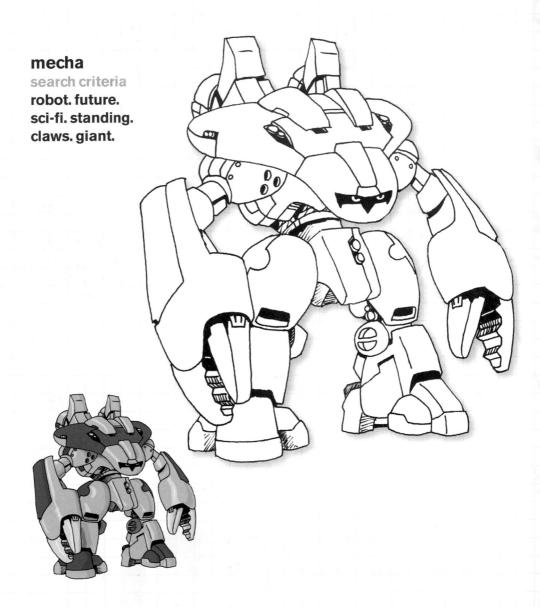

4.50

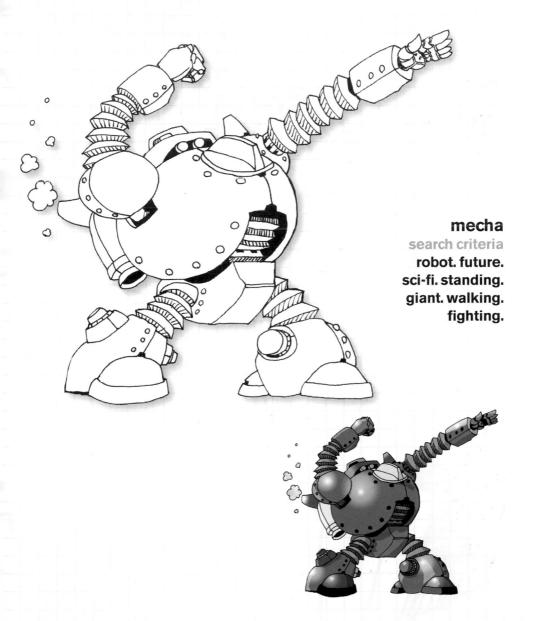

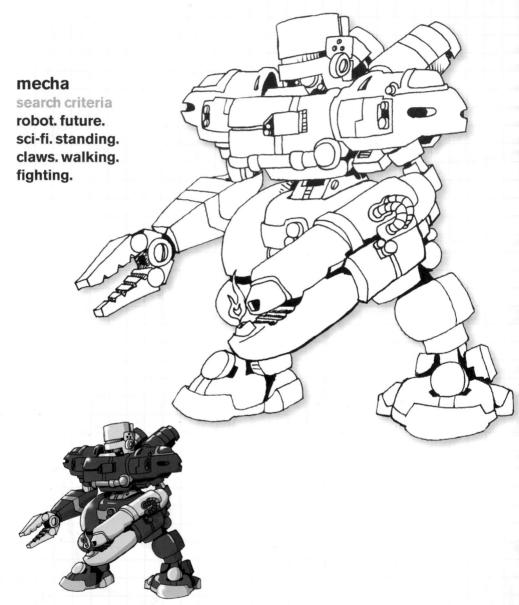

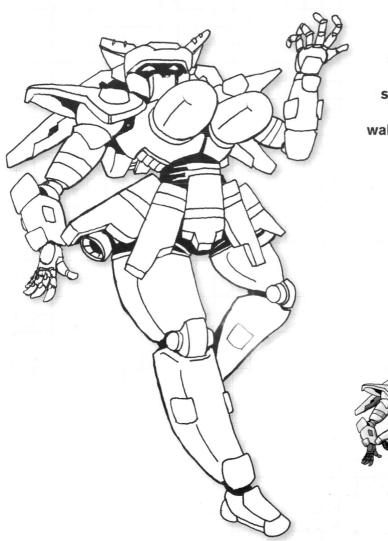

mecha search criteria

robot. future. sci-fi. standing. mobile suit. walking. running.

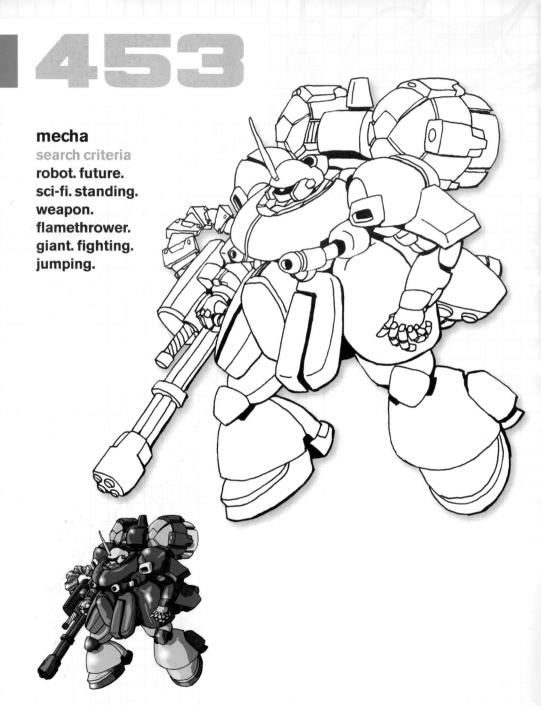

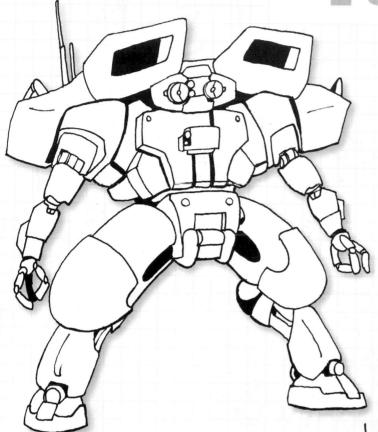

mecha

search criteria

robot. future. sci-fi. standing. giant.

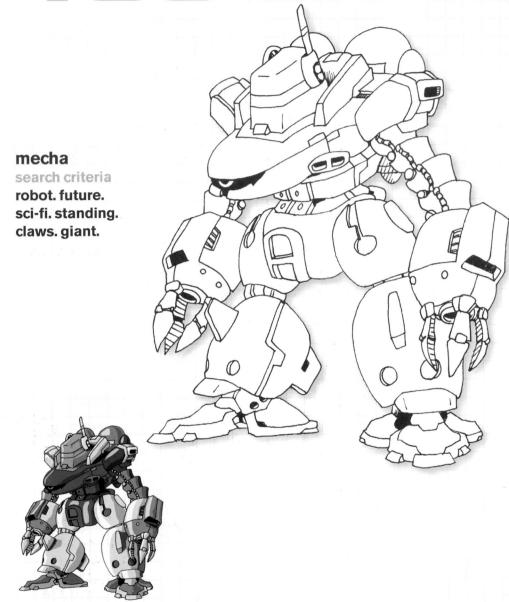

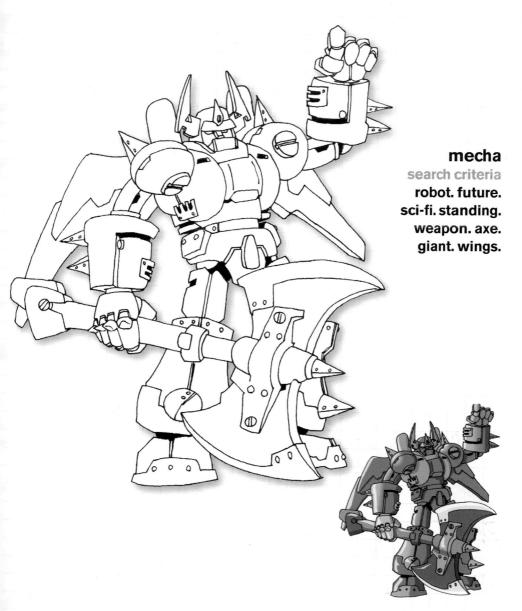

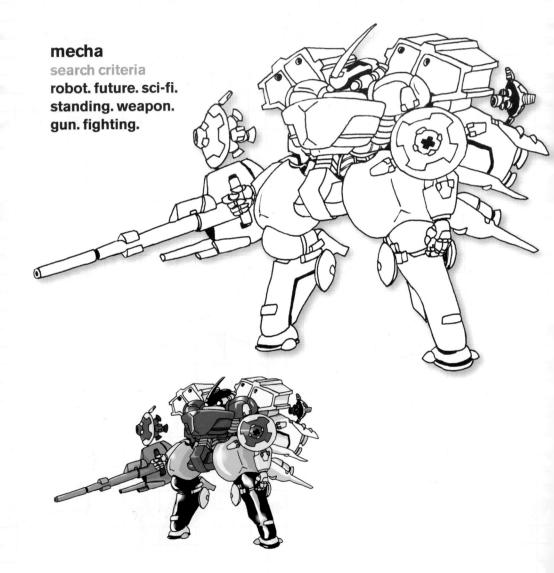

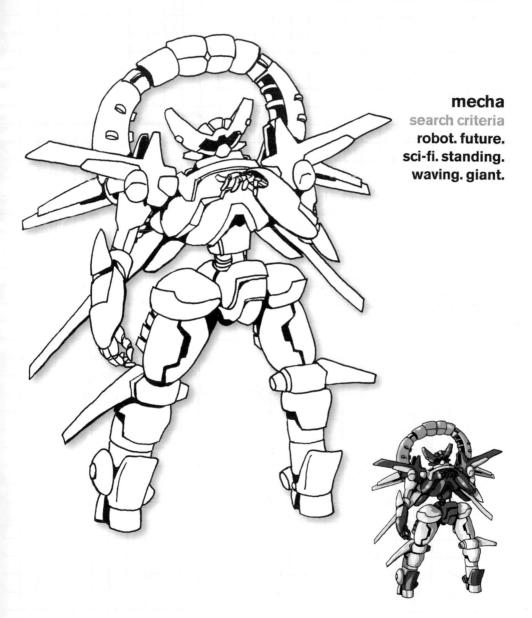

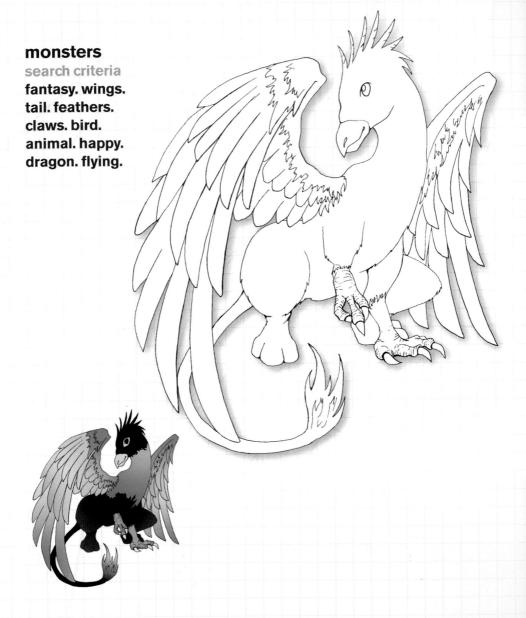

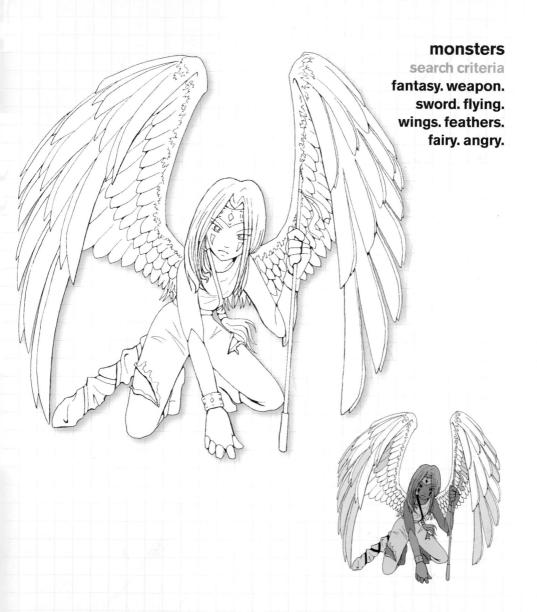

monsters

search criteria

fantasy. horns. tail. fur. satyr. happy. standing. male.

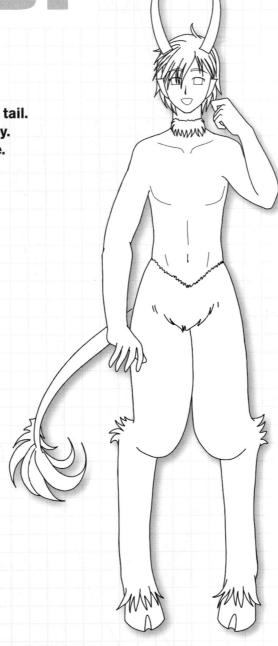

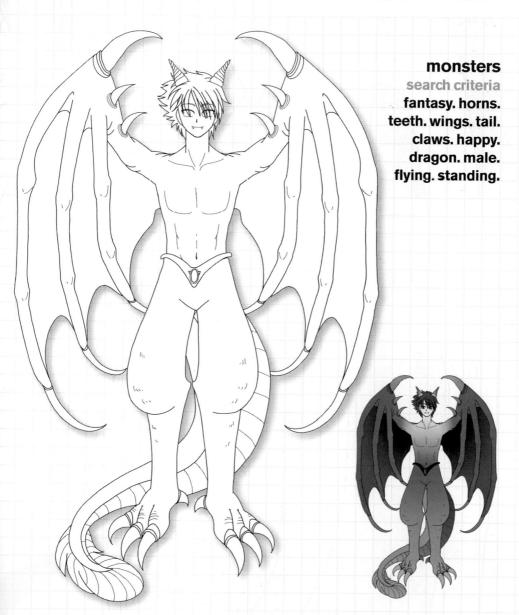

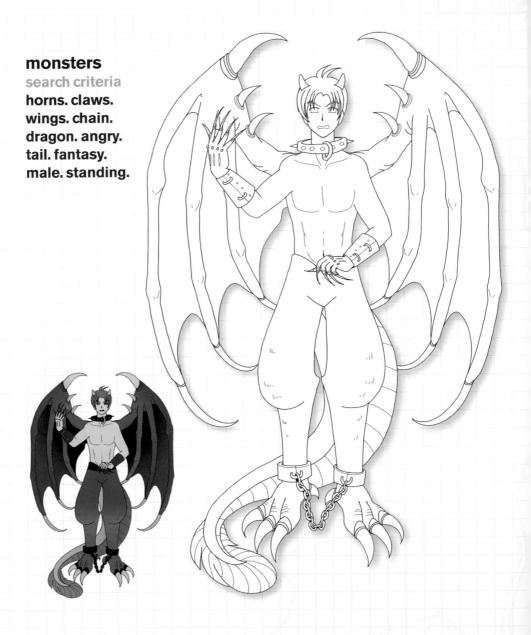

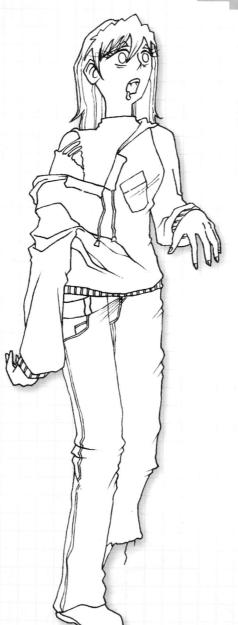

monsters

search criteria

sad. vampire. ghoul. standing. walking. female.

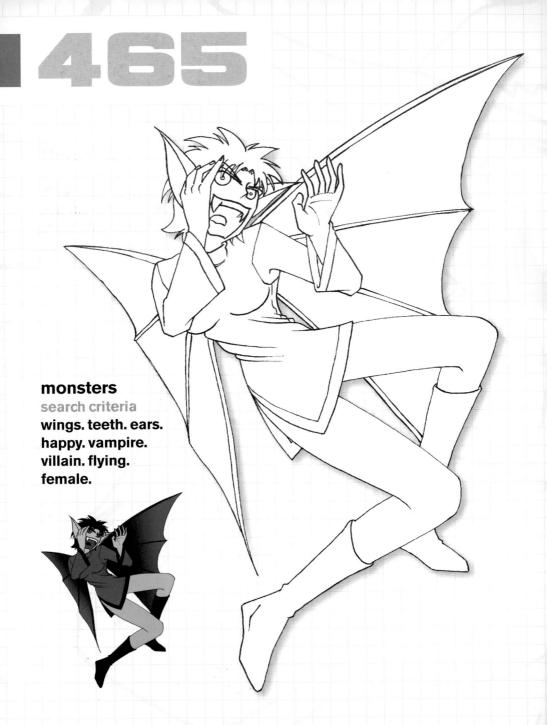

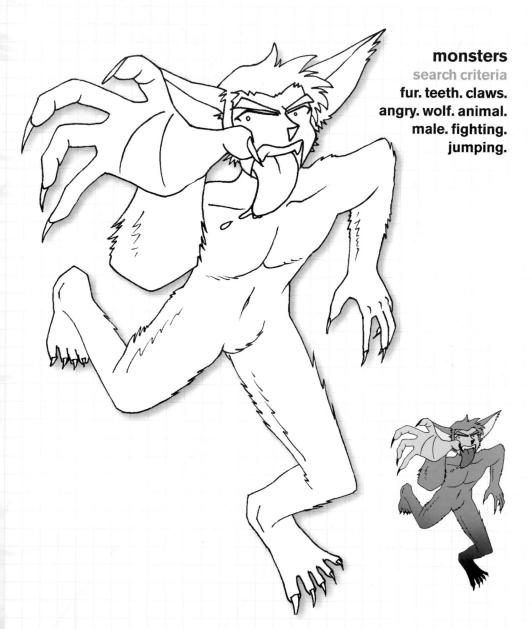

monsters

search criteria

horns. tail. sad. fantasy. female. witch. standing.

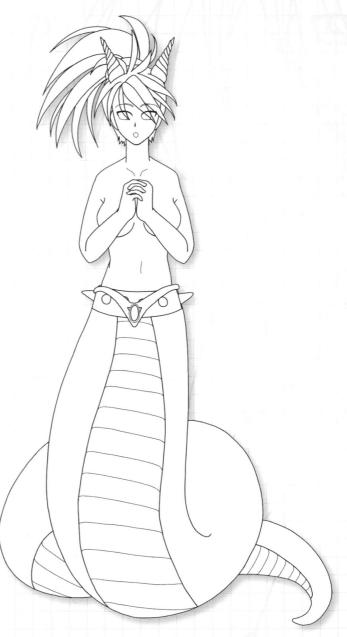

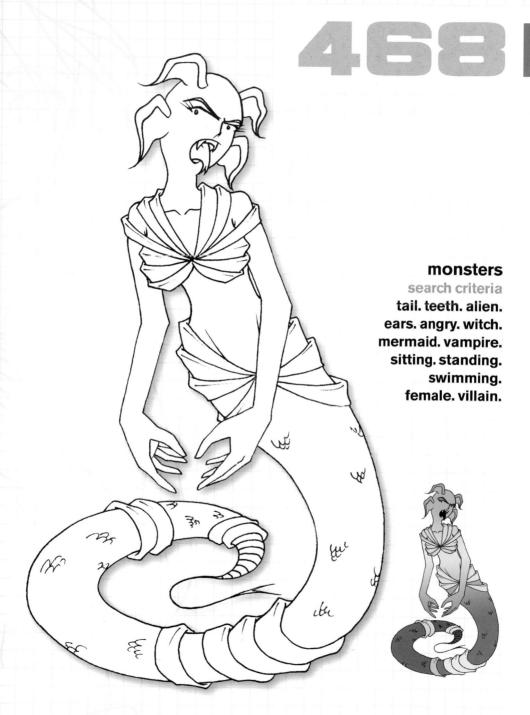

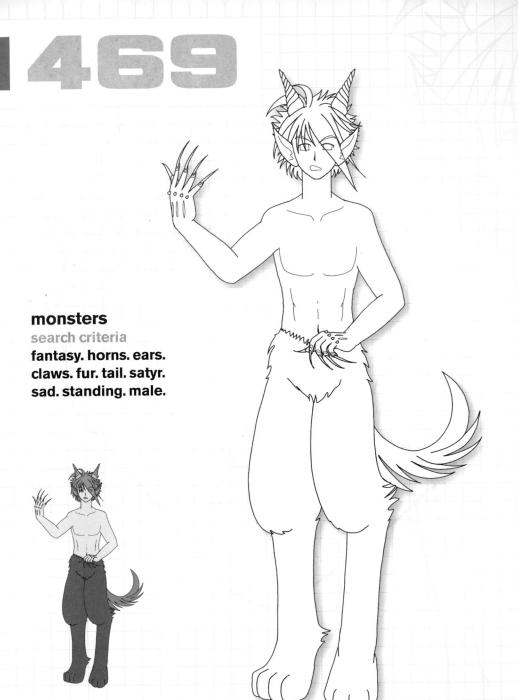

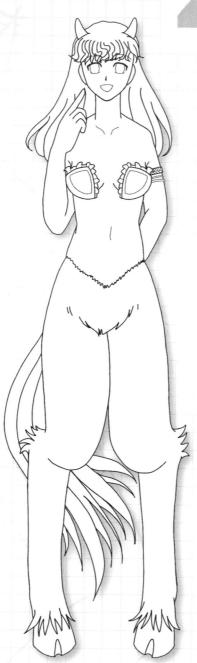

monsters

search criteria

fantasy. fur. tail. horns. satyr. happy. standing. female.

monsters

search criteria

feathers. wings. fur. halo. sad. satyr. angel. fantasy. female. standing.

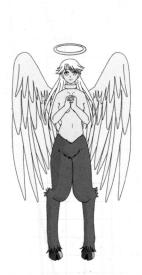

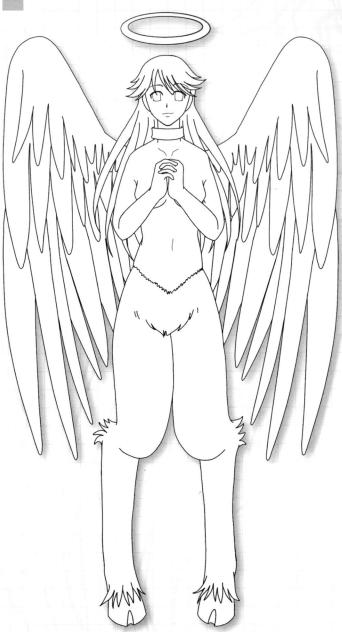

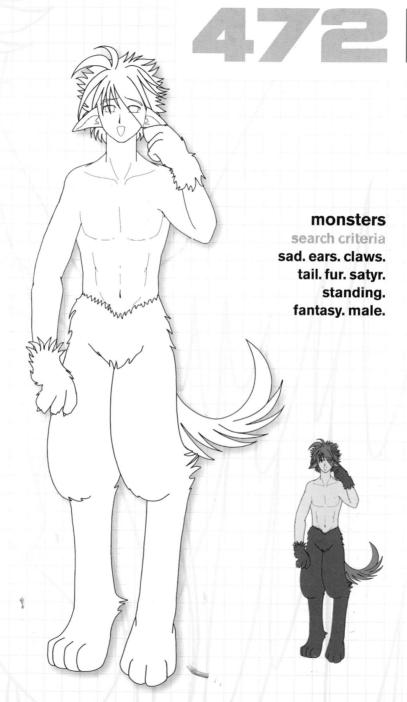

monsters search criteria fantasy. horns. tail. teeth. claws. fur. happy. female. lion. standing.

monsters

search criteria

fantasy. horns. tail. fur. angry. standing. male. claws. lion.

monsters

search criteria

feathers. fantasy. wings. sad. swimming. tail. sea creature. fins. male. merman.

monsters

search criteria

feathers. wings. fantasy. female. fins. mermaid. tail. angel. sea creature. sad. swimming.

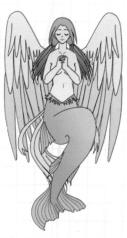

monsters

female.

search criteria fantasy. tail. fins. sad. mermaid. sea creature. swimmimng.

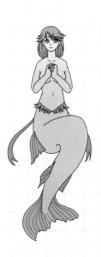

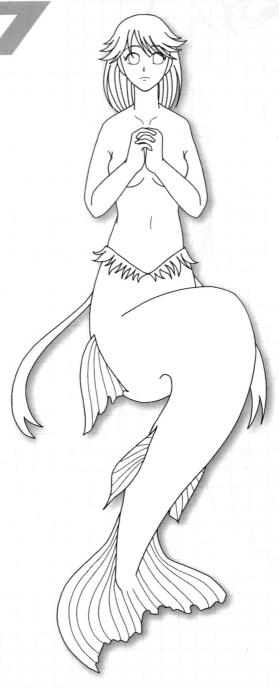

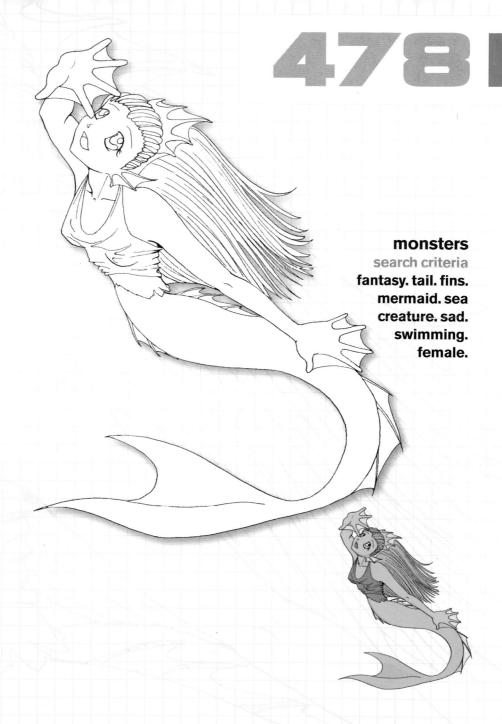

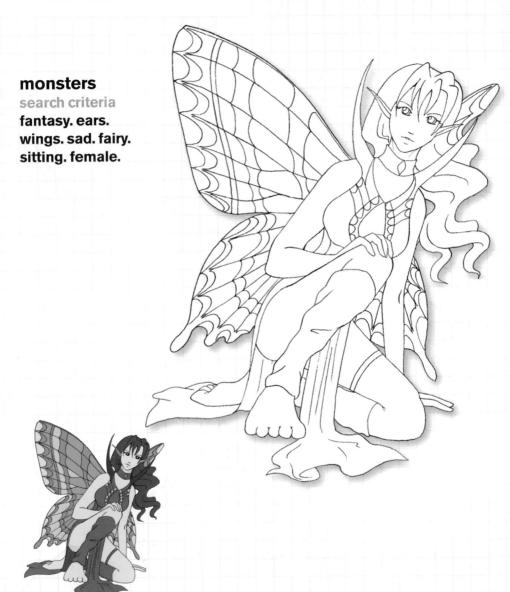

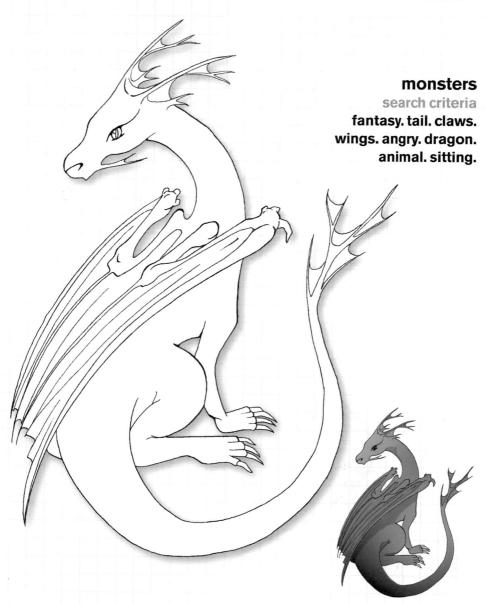

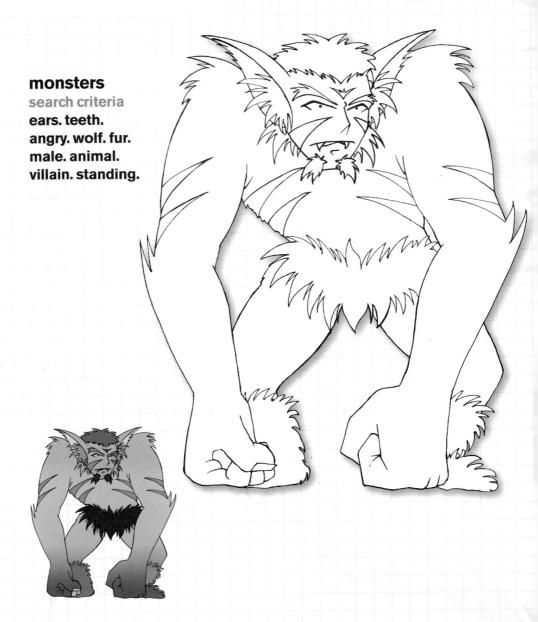

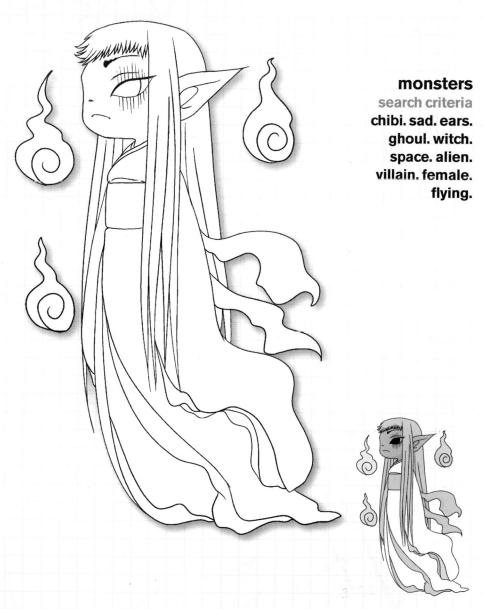

monsters

search criteria

chibi. mask. tail. teeth. claws. angry. child. male. fantasy. standing.

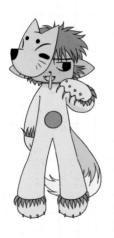

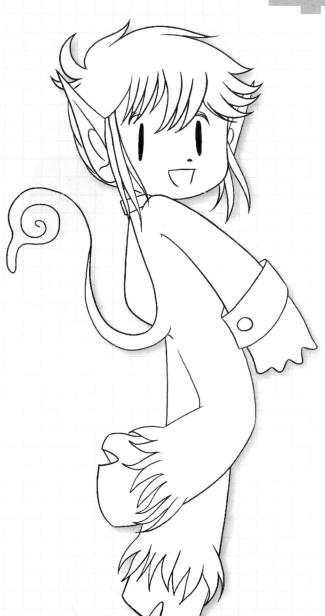

monsters

search criteria

chibi. ears. tail. happy. fantasy. male. child. satyr. walking. standing.

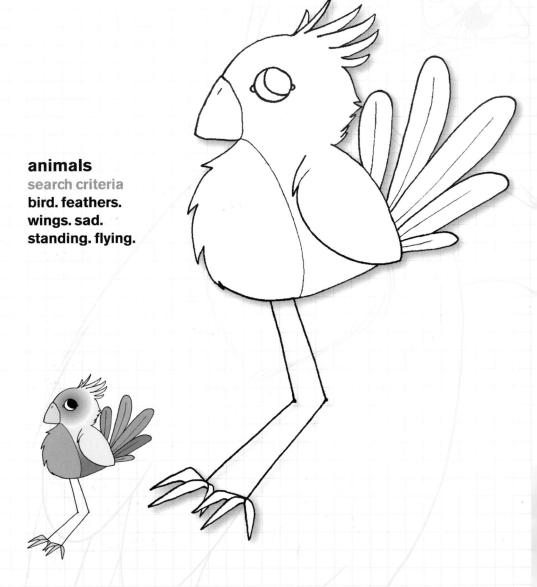

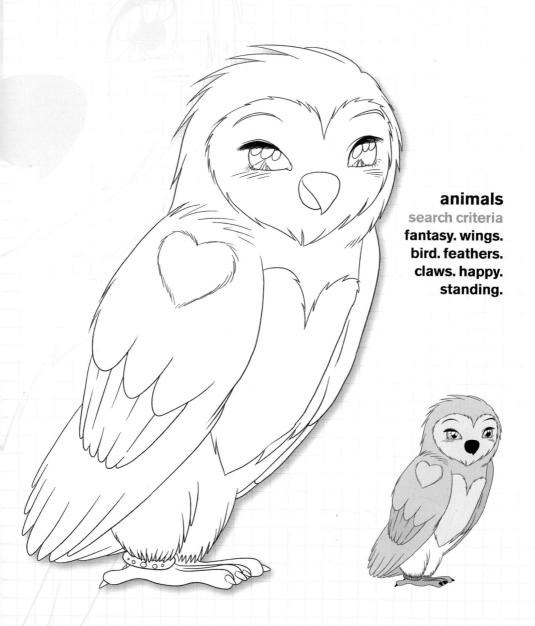

animals

search criteria

monkey. tail. fur. happy. waving. standing. jumping.

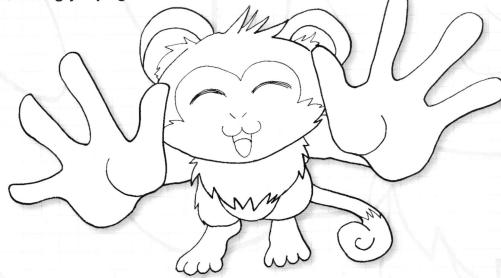

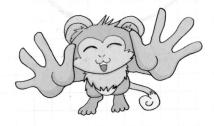

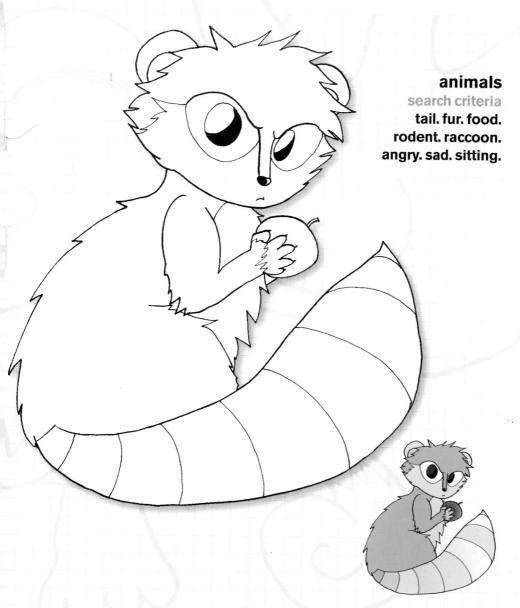

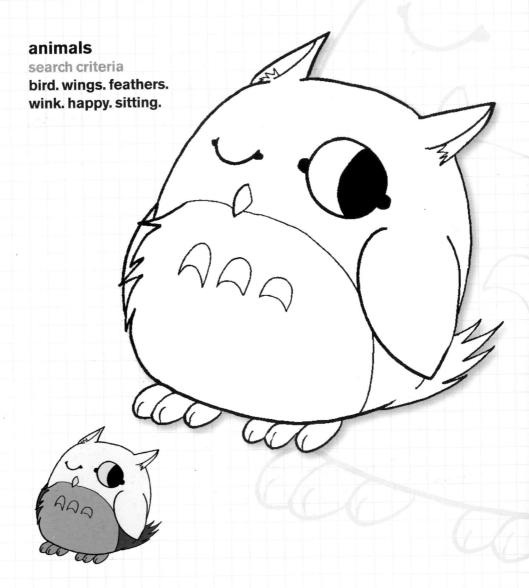

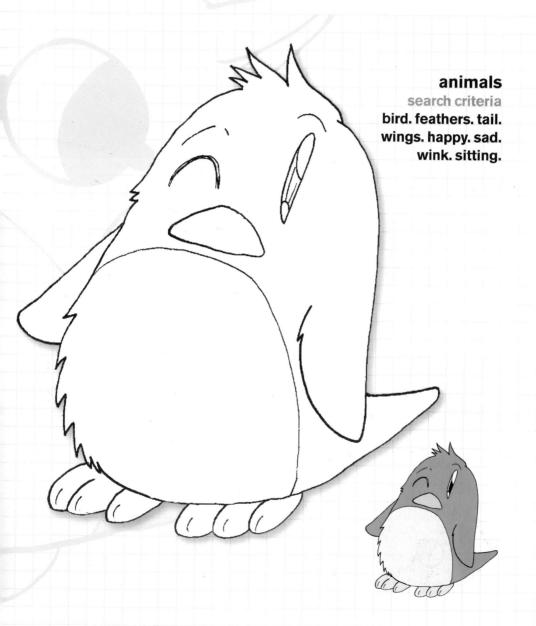

4.91

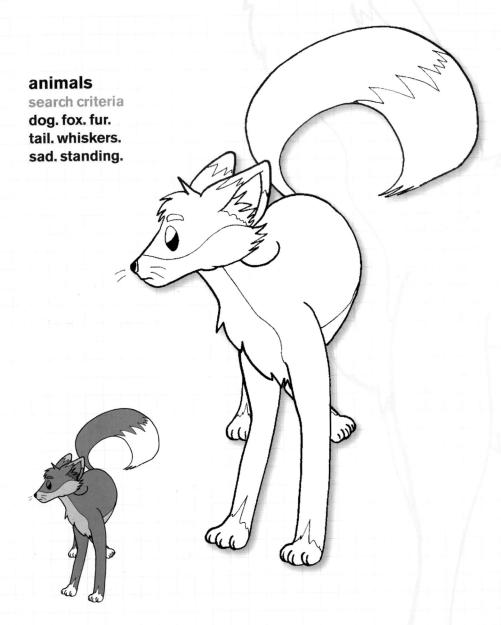

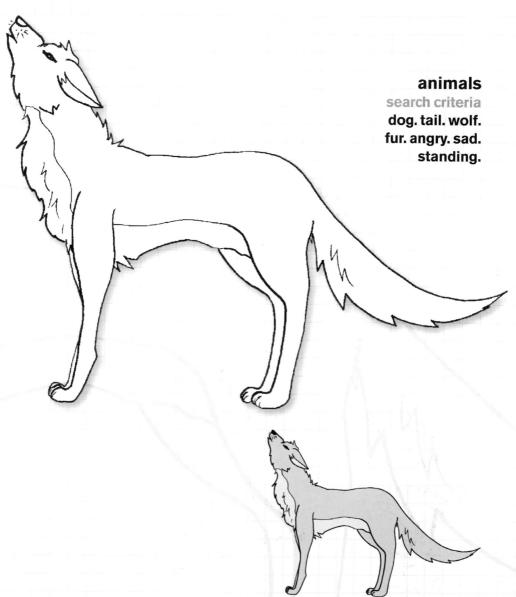

animals

search criteria

rodent. guinea pig. fur. sad. rúnning. jumping.

4.94

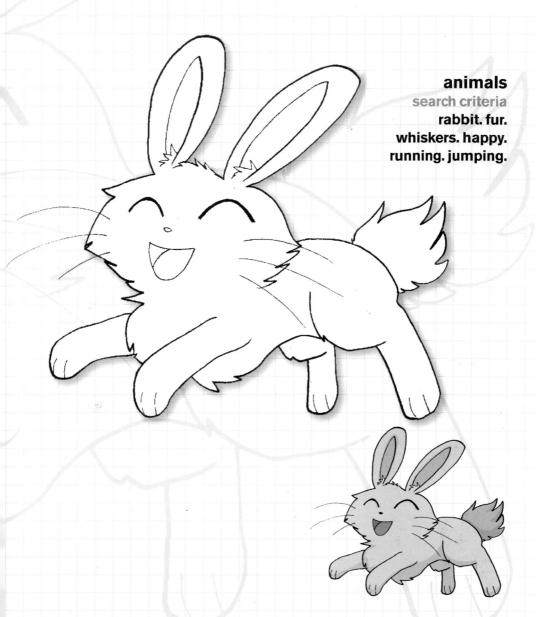

4.95

animals

search criteria

cat. fur. tail. whiskers. sad. standing.

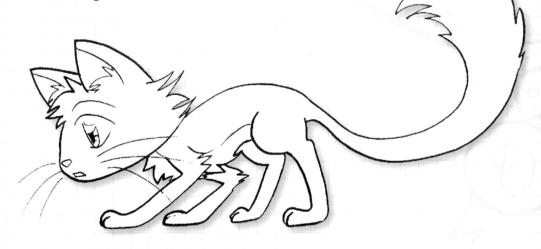

4.96

animals search criteria

dog. fur. tail. collar. happy. sitting.

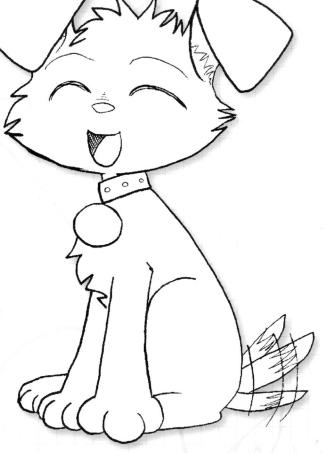

4.97

animals

search criteria

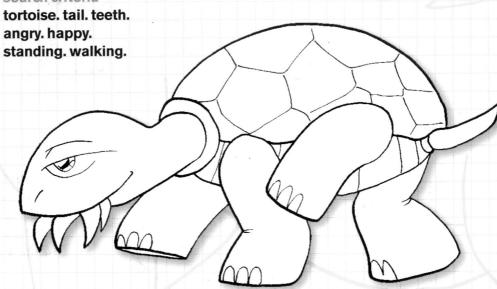

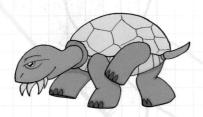

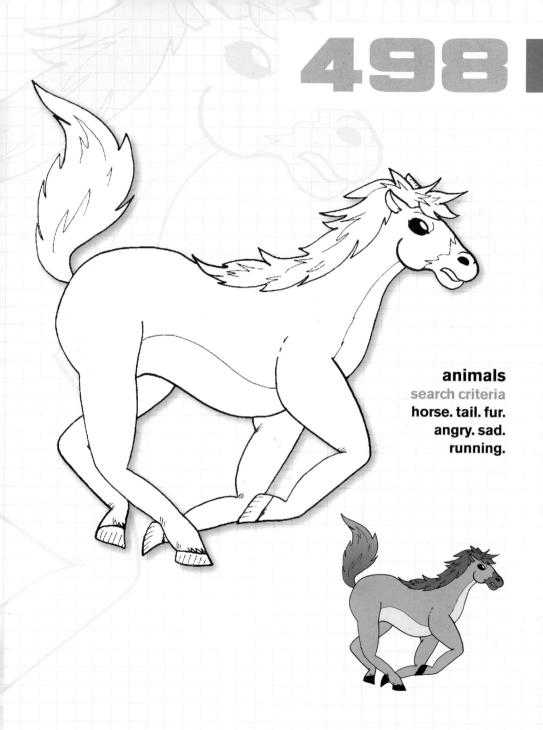

4.55

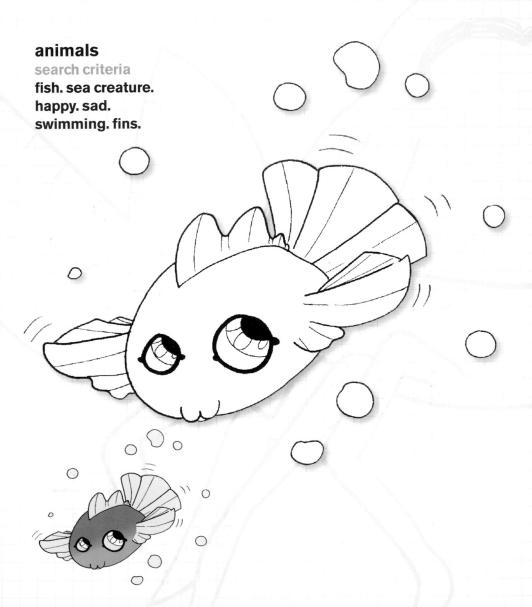

animals

search criteria

crab. claws. happy. sitting. wink. sea creature.

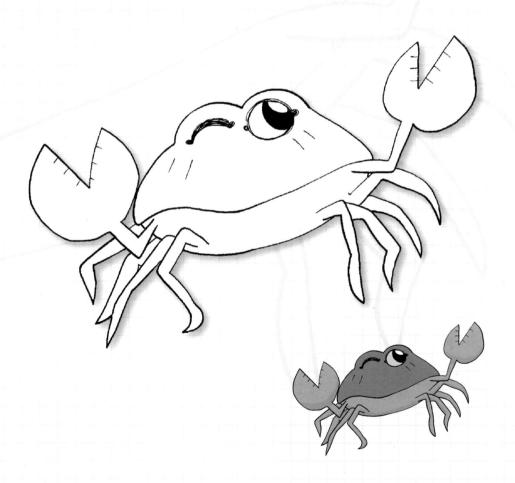

hardware

The use of computers in the production of artwork has completely revolutionized the industry, introducing a vast array of visual opportunities to artists at all levels of experience. Computers can be used solely to complement artwork produced on paper, but they can also be used as a replacement for the paper itself. Every step of the creative process can now be digitized, allowing an infinite amount of flexibility and freedom to experiment and create the best piece of artwork possible. By using your computer with some specialized image-editing software, such as Adobe Photoshop, you'll be able to capture the perfect look for the image that you are constructing. You can create artwork with just about any computer setup, but to make your life easier, you should think carefully about the hardware you choose.

Monitor

There are two common types of computer display. The traditional type is CRT (cathode ray tube). These are the large, bulky displays of a similar design to an old-fashioned TV. The pixels are less sharp on a CRT display, but sometimes the colors can be more precise. The more modern type of display is a flatscreen type known as LCD TFT (liquid crystal display—thin film transistor). These displays are generally sharper, but are sometimes less effective for fast-moving visuals. Also, LCD displays are usually more comfortable to work on for long periods of time because of the absence of screen flicker.

The type of monitor you use doesn't make a huge amount of difference to your work, but it's worth realizing that colors may appear slightly differently on other people's screens. You can never be completely certain of other people's computer setup, so try to avoid your image relying on very subtle color differences. For example, if you add a lot of detail in a very similar color to the background or surface color, this difference might not be visible. This problem is especially noticeable with certain laptop displays.

Mouse

Every computer uses a pointing device of some sort, but it's helpful to use a decent-quality mouse if you're hoping to use it to produce artwork. You should ideally be using a modern laser or LED-based mouse, which are now quite common, as opposed to a traditional ball-based mouse (check the bottom of your mouse if you're uncertain). LED and laser mice are much more precise than their ball-based brethren, and don't jam or slow down. The only problem with them is that they sometimes become unresponsive on reflective or transparent surfaces, but this is generally not difficult to overcome.

hardware

Graphics Tablet

The graphics tablet is an extraordinarily versatile input device and is virtually essential if you are to make full and extensive use of the Airbrush tool. Graphics tablets come in a variety of sizes and different price points. Most tablets also have transparent overlays that you can use to trace over previously drawn artwork if you don't have a scanner.

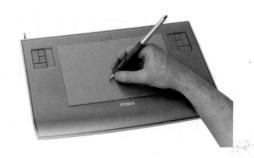

Inkjet Printer

These offer the easiest solution for printing high-quality color images. Inkjet printers are incredibly affordable, compact in size, and available to buy from a wide variety of outlets. The colors on inkjet printers can be enhanced even more with the use of specific photographic paper that enables the printer to produce finer lines and better details. It's important to realize that certain colors that are visible on screen will not be accurate when printed on paper because of the limitations of mixing the standard four inks to create the colors, though some printers offer six-color printing to increase the color fidelity. Bright purples, yellows, and certain other colors will be difficult to reproduce on paper.

Laser Printer

Although color laser printers are still prohibitively expensive, black-and-white laser printers are the best option for printing monochrome images or documents because they are often capable of printing much finer lines than inkjets. Also, the toner they use is often waterproof and alcohol resistant. This is useful for things such as comic pages (fingers can easily smudge inkjet prints), and great for printing images that you intend to color by hand with alcohol-based markers.

software

Photoshop has become the standard software for digital art production and photo editing. It is used by professionals and home users alike to create artwork in a wide range of styles. The software is available for both Apple Macintosh and Windows PC machines, with only superficial differences between the two platforms, and it is available in various bundles depending upon the needs of the user.

Photoshop is also available in two different versions: The classic edition (which is now part of Adobe's Creative Suite range of software), and Photoshop Elements, a cut-down version intended for home use. The functionality removed from Photoshop Elements is quite specialized and thankfully doesn't impede the creation of manga or anime-style artwork.

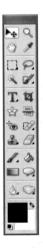

Toolbox

All versions of Photoshop feature the Toolbox, which is placed by default on the left side of the screen. In Photoshop Elements the Toolbox is docked to the left side of the window as a long single column by default, but it can be undocked and placed wherever you wish within the workspace.

The Toolbox allows you to choose tools, as well as selecting foreground and background colors. Some of the tool icons have a small additional arrow in the bottom-right corner that indicates the presence of additional tools with related functions that will become available if you hold the mouse button down on that tool icon.

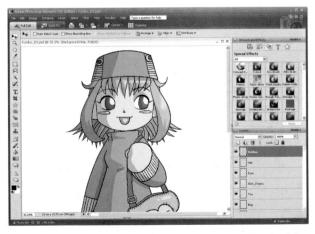

This is the standard Photoshop Elements default workspace. Although palettes are docked in a pull-out "bin" on the right side of the workspace, they can be undocked and freely placed within the work area.

software

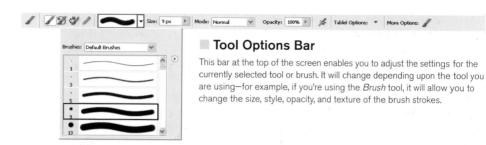

Palettes

Photoshop Elements features a number of palette windows. By default some of these are in the *Palette Bin*, located on the right side of the workspace, that can be pulled open or left closed. It's possible to drag palettes from the bin into their own windows, and to combine these individual windows into one large multi-tab palette. This flexibility is useful for setting up the palettes in the most convenient layout. You can save your palette layout in the *Window* menu, or choose to reset the palettes to their default layout.

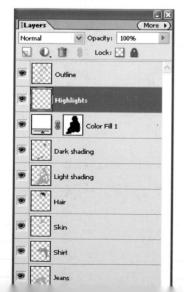

Layers Palette

The most commonly used palette is the *Layers* palette. Layers act like transparent sheets of plastic stacked on top of one another, enabling you to work on different parts of the artwork independently. In this way you can apply color and shading without risk of damaging the original line-art.

Context-sensitive menus

Like many pieces of software, Photoshop will bring up a contextsensitive menu when you right-click the mouse (Ctrl+click on a Mac). This menu will differ depending upon the currently selected tool, or whether a selection has been applied, but will always present you with useful options. Try the context-sensitive menu when performing different tasks to see the options that are available.

basic tools

Most image-editing programs have a broadly similar selection of tools. Here we will use Photoshop Elements as an example to outline their basic functions.

Navigation Tools

Move Hold the mouse button down to drag the currently selected layer around, or to move the content of the current selection box.

Zoom This enables you to enlarge or reduce the image on screen. This is useful when you want to see an overview of the entire artwork, or zoom in close to work on the details. Holding Ctrl/Cmd and pressing the + and - keys will allow you to zoom in quickly using the keyboard.

Hand The Hand tool is designed to move the viewable area of the image around the screen when you are zoomed in. When you have another tool selected, holding down the Space bar on the keyboard will switch to the Hand tool temporarily so you can navigate your document easily.

Eyedropper This tool is used to select colors from the existing image and set them as your current paint color. Set it to Point Sample in the Tool Options bar to get more accurate color selection. When using the paint tools, you can hold the Alt/Option key to temporarily select the Eyedropper.

Selection Tools

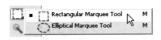

Marquee The Marquee tools are the simplest selection tools, enabling you to click and drag a rectangular or elliptical area of the image. Holding Shift will constrain these tools into perfect square or circle shapes respectively.

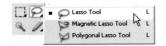

Lasso These tools allow you much greater control over the area of image you want to select. The Freehand Lasso allows you to draw around the area you want to select, but it can be tricky to control precisely. The Polygonal Lasso lets you plot a series of points to define the selection area.

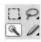

Magic Wand This tool uses the shapes and colors of the image to work out which areas of the image you wish to select. By changing the Threshold value, it's possible to change how much contrast the tool will use to define different areas.

basic tools

Paint Tools

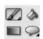

Paintbrush The standard painting tool in Photoshop, this is useful for applying color with soft edges and smooth lines. This is a great tool for applying color to an image, and the effect of brushstrokes can vary widely depending upon the chosen brush and Tool Options settings.

Pencil The pencil is an ultra-precise variation of the *Brush* tool, allowing pixel-perfect (or "aliased") brushstrokes. The tool sits under the *Brush* tool in the Tools palette, so you need to hold the mouse button down on it, then select the tool from the drop-down menu to switch between them. The *Pencil* tool is useful for cel-style coloring and making sure that colors are kept precise, but it can appear "jaggod" when used on a low resolution image.

Paint Bucket The Paint Bucket works in a very similar way to the Magic Wand tool, but instead of selecting an area, it fills it with the current foreground color. Remember to select All Layers in the Tool Options bar if you're applying color to a different layer.

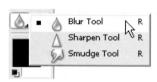

Blur

Smudge

Blur, Sharpen, and Smudge These tools adjust the colors already present in the image. *Blur* and *Sharpen* adjust the nearby contrast for the area to make the image more pronounced or fuzzy. *Smudge* allows you to move the colors around depending upon the direction you draw with the tool.

Bur

Sponge, Dodge, and Burn These tools behave like brushes, but are actually used to adjust the existing color in different ways. The *Sponge* tool is used to remove color from the image and make the image grayscale. *Dodge* fades the current color, while *Burn* makes the color darker and richer. These can be used to apply shading and highlights, but most artists prefer to use layers and other methods of shading to ensure greater control over the results.

brush tools

When coloring your manga-style artwork you will inevitably be using the Brush and Pencil tool for a significant part of the procedure because they represent the most direct method of applying colors to the image. The Brush tools enable you to paint directly onto the image using freehand strokes similar to a real pencil, pen, or paintbrush. You can apply color to be opaque like paint or translucent like ink, or even remove color as you would with an eraser. Your strokes can be wide like chalk, fine like pencil, or even change width dynamically like a nib pen or paintbrush. Learning how to adjust these settings will help you to achieve the best results.

Brush Toolbar

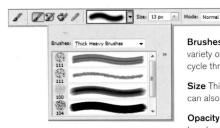

Brushes From the drop-down menu you can choose from a wide variety of preset brush types. Use the up and down arrow keys to cycle through the brushes.

Size This allows you to set the size of the currently chosen brush. You can also use the [and] keys to adjust the brush size in set increments.

▼ Opacity: 100% ► Tablet Options: ▼ More Options:

Opacity The opacity represents how transparent the paint or ink will be when placed on the page. 0% is completely transparent, 50% is half-visible, and 100% is completely solid. If you want to mix colors on the page, this is an easy way to do it.

Airbrush This changes the behavior of the brush, so that holding down the brush produces a constant flow. Although this can be useful, it's generally much easier to use a brush with soft edges instead.

Brush Spacing

The Spacing setting in the Tool Options bar (found under More Options in Elements, and in the Brushes palette under Brush Tip Shape in Photoshop) and can make a big difference to the quality of your brush strokes, but can also slow down your computer. By reducing the Spacing, the space between each "dot" of the stroke is reduced, creating a more realistic flow of paint. Adjust the setting to suit your needs.

Pastel brush set to 1% spacing

Pastel brush set to 50% spacing

Pastel brush set to 200% spacing

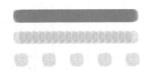

brush tools

Brush Shapes

Hard brushes These brushes give a solid line where the color stops clearly at the edge of the brush stroke. They are ideal for applying base colors to an image, and defining lines and shapes.

Brushes: Default Brushes

5

9

13

Soft brushes These brushes produce lines that fade toward the edge of the stroke. They tend to be best for applying soft, airbrush-style shading and coloring.

Natural brushes Photoshop Elements offers a range of irregular brush shapes to help recreate natural media techniques such as pastel, charcoal, or chalk. These can be useful for introducing texture into your image.

■ Graphics Tablet Pressure Settings

A graphics tablet allows a much greater degree of control over your digital brushes. Not only will it help you to draw precise brush strokes, but you will also be able to control the opacity or size of the brush directly depending upon the pressure of the pen against the tablet, because the pen nib is pressure sensitive. This can help you to achieve a much more natural-looking result.

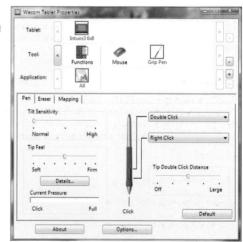

blocking in colors

With every image, whether simple or complex, it's useful to lay down basic colors before proceeding with more complicated shading. When you've mastered your basic coloring technique, you may even find that, in some cases, additional shading is unnecessary.

■ Start by opening an image from the CD. Change the image mode from grayscale to RGB (*Image* > *Mode* > *RGB Color*). This will enable you to add color to the image.

Next, create a new layer containing just the outline. To do this, duplicate the original Layer 0 (*Layer* > *Duplicate Layer*) and name the duplicate "Outline."

With the Outline layer active, select the Magic Wand tool and set the Tolerance to 32. Make sure that Anti-alias and Contiguous are unchecked in the Tool Options bar—with Contiguous unchecked, the tool will select all instances of the color you click on.

Click in any of the white image areas, and all the white will become selected. Press Delete. Deselect (Ctrl/Cmd+D) and you will be left with just the outline.

Rather than filling in all your colors on the original Layer 0, it is much better to create a new layer for each group of colors. This will give you much greater control over the final look of the image. To make new layers, click on the *Create a New Layer* icon at the top of the *Layers* palette, and name them appropriately by double-clicking on its name in the *Layers* palette.

On complex images, you may find that you build up a large number of layers, and it may be best to group associated colors, such as skin, together on the same layer.

Now we can start blocking the basic image with flat color. Click on Layer 0 to make it active, and start selecting areas that you want to be the same color within the image. Use the *Magic Wand* tool again, but this time make sure that *Contiguous* is checked. Hold the Shift key while selecting so that you add to the previously selected areas. When all of the areas that you want to be a particular color are selected, click on your new color layer to make it active (the marching ants will remain, selecting the chosen areas).

To choose the color that you want to fill the area with, click once on the foreground color icon in the Toolbox and

the *Color Picker* dialog will open. From here, pick a suitable color and click *OK*—this color will now be your foreground color.

blocking in colors

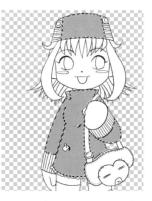

To fill your selection, use the Paint Bucket (make sure Contiguous is unchecked in the Tool Options bar). Clicking the Paint Bucket tool in any of the selected areas will fill them all with the foreground color. Alt/Opt+Backspace will also fill all of the selected areas with the foreground color.

Soom in to your image when making small selections, to make sure that you only select the required areas. You can also use the *Pencil* tool to fill in very small areas, or areas that are not defined by lines (such as around the eyes in this example).

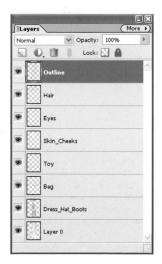

Press Ctrl/Cmd+D to deselect. Click on Layer 0 to make it active again, and continue to work selecting and coloring on new layers. How you name the layers is up to you, but try to stick with logical names that will be easy to understand next time you come back to the file.

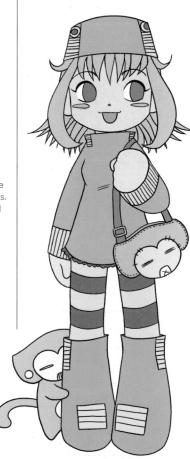

Hon you've finished, you will have a flat-colored figure that you can either use as is, or take to the next stage and introduce more complex lighting and shading.

light and shade

The application of shading is one of the most distinctive aspects of anime-style artwork. The method of defining tone with a few solid stages of color developed a distinctive and iconic visual appearance that has become synonymous with Japanese anime. Shading is represented by large areas of darkened tone, while highlights are picked out with bright white glints. By paying attention to the direction of light and considering the shape and volume of the body, it's easy to introduce effective shading into your artwork.

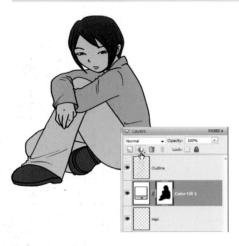

■ Start with an image that you have already blocked in with flat colors, as described on pages 518–519. It is useful to create a mask around the image to help keep the shadow color brushstrokes within the image outline. This is easy to do because our image still has the transparent Layer 0. Simply click the *Magic Wand* tool (with *Contiguous* unchecked) in the transparent (checkerboard) area of the layer to select it all.

Make a new Solid Color layer (Layer > New Fill Layer > Solid Color, or by clicking on the Create Adjustment Layer icon in the Layers palette), and fill it with white (it fills with the foreground color). Move this layer beneath the Outline layer created in the blocking stage. Make another new layer below this mask layer, and call it "Light Shading." Set its blending mode to Multiply by clicking on the drop-down list at the top of the Layers palette.

Choose the color you want to use for your shadows. Although you can use gray to add shading, it can result in a very dull image. It's better to use a color such as dull orange or a faded purple. Experiment with different colors to see what suits the image and its existing colors. You can create paler shadows by choosing lighter tones of the same color.

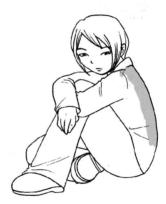

All Make sure the Light Shading layer is active by clicking on it in the *Layers* palette. Choose a soft round brush and start painting in the shadows in your image. You can erase mistakes on the shadow layer with the *Eraser*. Try to block out all of the shadows roughly at first to get an idea of the overall look of the image, and to make sure that the light is cast evenly.

It's often helpful to hide the color layers when working on shading. You can do this by clicking the eye icons next to the color layer names in the *Layers* palette.

light and shade

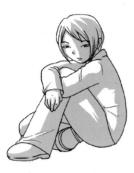

4 Continue to block in the shadow color, using different-sized brushes to fill the shadow area until you are satisfied with it. Remember that painting with white will not show up when the blending mode is set to Multiply, so you can use it to tidy up areas of shadow.

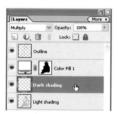

Make another new laver, name it "Dark Shading," and place it above the Light Shading layer. Draw with a darker color in the areas that are heavily cast in shadow, or on shiny, reflective materials. Using this darker shadow tone sparingly has a greater impact and helps to define the shape of the character.

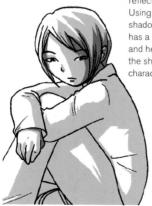

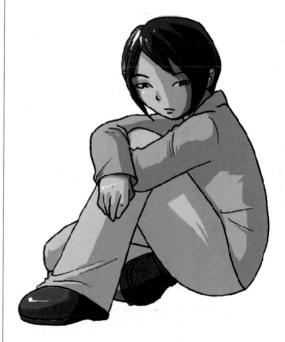

For the highlights, be sure to turn the color layers back on. Create a new layer with the blending mode set to Normal and place it at the top of the layer stack. You shouldn't need to make a layer mask for this layer because you'll only be creating a small number of highlights. Paint the glints of highlight in places where the main light source falls. This is best when applied only to shiny surfaces such as leather, metal, and plastic, and also hair and skin.

airbrush & beyond

While the traditional flat shading or "cel-coloring" style is especially iconic and commonly associated with manga and anime, it is by no means the only way in which color can be applied. With a variety of methods and styles available, it's possible to extend the cel style with airbrushing, or to completely ignore hard shading and try for something much more subtle. Depending upon the mood you want to create and the overall look of your image, you can apply any number of brush styles. When working digitally, it's possible to experiment with styles by saving multiple versions of your work, so that there's always room to try out new ideas and improve your techniques. Here are just a few examples.

Airbrush Style

The airbrush style refers to the use of gradient colors to achieve a look similar to a traditionally airbrushed image. This style can either be used to add softness to an image already painted in cel colors, or to completely replace the shading with softer lighting and gradual shading.

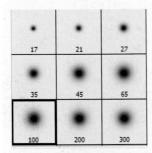

For airbrush technique the use of soft brushes is crucial. These are represented in Photoshop as circles which become lighter toward the edge of the circle. The larger the brush is, the softer the gradient will be.

One of the simplest and most effective ways to introduce airbrush work into your artwork is to make the shading lighter beyond the initial area of contrast. This "falloff" effect helps to emulate ambient lighting and generally manages to maintain the feel of cel shading while adding a softer, more natural look.

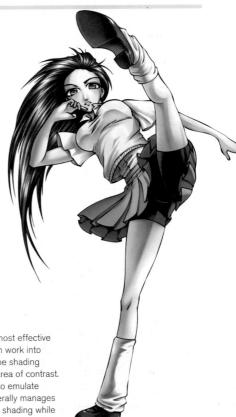

airbrush & beyond

Airbrushed Highlights

Simple but natural-looking highlights can be easily created using the airbrush—just apply dabs of white in the appropriate places using the airbrush tool. Experiment with the settings, but it is essential to always use a very soft brush. When combined with the basic shadows and highlights used in block shading, the results can be very effective.

Natural Media Style

There are a number of different ways to achieve a natural media look using modern software. The natural media brushes available in Photoshop offer irregular shapes that give the impression of the tools used on canvas and paper, especially when the brush settings are handled well. By using settings like the *Multiply* blending mode, you can ensure that colors overlap and intensify in a manner similar to working with ink, while other settings can emulate paints, pencils, or even bleach. When working with these sorts of brushes, it is always advisable to set the brush to a low opacity—between 5 and 40%. This helps to achleve the desirable layered look of "real" tools, and also helps to build up color with increasingly confident lines. If you are working with opaque paint-like brushes, it's still worth setting the opacity to 80–90%, so that the faintest trace of the color beneath shows through.

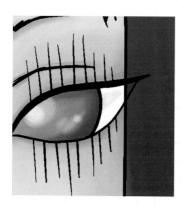

This otherworldly ghost figure has been colored by using a variety of natural media brushes. The enlargement of the eye area shows how different brush types, strokes, colors, and opacity have been used to create a particular look, somewhat similar to pastel crayons.

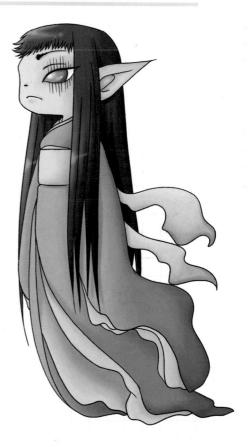

artists

Hayden Scott-Baron www.deadpanda.com

Hayden, otherwise known as Dock, is a professional videogames artist, focusing on character design and 3D graphics. He has produced artwork and scripts for several manga graphic novels and has created character illustrations for books, games, magazines, and advertisements. He is the co-founder of Sweatdrop Studios, a group of artists producing manga-style comics.

Emma Vieceli

http://emma.sweatdrop.com

Emma Vieceli is a key member of the U.K. manga group, Sweatdrop Studios. A winner of Tokyopop's Rising Stars of Manga and *Neo* magazine's manga competition, she also recently completed work on a 200-page graphic novel adaptation of *Hamlet*.

Michael Stearns

www.starquail.com

Michael Stearns is an illustrator who likes giant robots too much. While some might consider his collection of unfinished Gundam models proof enough, Michael feels that true mecha comes from within, and only by opening one's heart to the majestic angles and curves forming a giant robot can it truly be appreciated. His first (finished) videogame, SkyPuppy, is available now!

Wing Yun Man
http://ciel-art.com

Wing Yun Man is a freelance artist specializing in manga-style illustrations, character design, and sequential art. As well as being featured in various books and magazines, her work also won an award at the prestigious International Manga & Anime Festival in 2004.

Rebecca Burgess

http://bex.elvenblade.co.uk/

Rebecca Burgess began drawing at around the age of four, and has not stopped since! It was at the age of 12 that Rebecca discovered anime and manga, and since then she has created several manga comics, which can be found on her website. Rebecca is currently studying at art college.

artists

Natcha Prapatpornkul www.sweatdrop.com

Natcha was born in 1981. Twelve years later the fortune-teller said to her mother, "This girl was not supposed to be born." Without asking why, she has grown up and become an illustrator and comicker anyway. Luckily, her uncle said she has a good nose, which can lead to a wealthy life in the future, and the lines on her palm show that she will have a peaceful life in the end.

Shari Chankhamma

http://sharii.com

Shari has been a sequential artist since high school, and has been serialized in *Thaicomic* and *Rina* magazine in Thailand. 2007 saw her first graphic novel release in the U.S., entitled *The Clarence Principle*. Shari is currently striving to obtain wealth and a male harem.

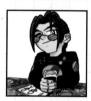

Sam Brown

www.revolutionbaby.com

Sam Brown, AKA Subi, is a founder member of Sweatdrop Studios, where he is chiefly responsible (and that is the word) for the satirical small-press manga *Revolution Baby*. He divides his remaining time between coding MP3 players, feeding his neighbor's cat, and not putting up shelves for his vast comic collection.

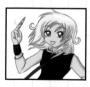

Laura Watton

www.laurawatton.co.uk

Laura is a professional 2D games artist and freelance manga-style illustrator. She has been self-publishing since 1994, and is one of the founding members of Sweatdrop Studios. She recently won a place in the 2006 Neo Manga Competition.

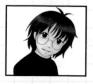

Morag Lewis

www.toothycat.net

Morag is a molecular biologist by profession, and started drawing in the manga style while at university. She joined Sweatdrop Studios in 2004. She now has two books published through Sweatdrop, and is working on the third. She placed first in the character brief competition at the 2006 International Manga and Anime Festival.

artists

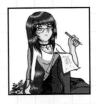

Sonia Leong www.fyredrake.net

Sonia is a freelance artist and illustrator specializing in the anime/manga style and comic artwork. She is a member of Sweatdrop Studios. Her artwork has made several professional appearances in manga-related publications and at manga events in the U.K. and abroad. She frequently participates in industry panels, presentations, and workshops on the manga artform. Sonia works in a variety of natural media, and with software.

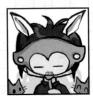

Selina Dean www.noddingcat.net

Selina Dean is a freelance illustrator, specializing in manga-style illustrations for books, magazines, and comics. She produced her first commissioned art for promotional fliers when she was 15, and decided drawing and getting paid for it was pretty good. She is a founding member of Sweatdrop Studios. Her own comics include long-running drama series Fantastic Cat, the surreal fantasy comic Fantasma, and a variety of short stories.

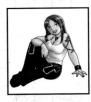

Yapi Santiago

www.yapipie.com

Yapi graduated from the University of the Philippines College of Fine Arts with a Bachelor's Degree in Visual Communications in May 2005. Two months later she entered the world of advertising as an Art Director for Campaigns & Grey, a Philippine partner of the international advertising agency, Grey Worldwide. After 18 months in advertising, Yapi left her career to pursue her passion for illustration. She now works as a freelance illustrator.

Michiru Morikawa

http://photos.yahoo.com/michirumorikawa

Michiru is an illustrator and cartoonist who has seen her career blossom since moving from Japan to Birmingham, England, where she now studies and draws. Her work, inspired by the style of British children's books, picked up the coveted International Manga and Anime Festival (IMAF) grand prize in 2005 for her unique style. She has been described as "a very rare talent."

Artists' Credits

Note: Listed by page number, not character number.

Sam Brown

74, 78, 79, 81, 99, 170, 171, 172, 173, 176, 182, 182, 186, 188, 194, 202, 203, 214, 215, 218, 219, 222, 223, 226, 227, 351, 362, 372, 373, 377, 473, 474, 475, 477, 490

Rebecca Burgess

46, 47, 48, 49, 50, 51, 56, 57, 58, 59, 60, 62, 63, 68, 70, 108, 110, 111, 112, 114, 118, 119, 120, 121, 129, 130, 131, 133, 134, 137, 153, 228, 229, 230, 231, 232, 233, 234, 235, 236, 237, 238, 239, 240, 241, 242, 243, 244, 246, 247, 248, 249, 250, 342, 343, 380, 381, 382, 383, 384, 385, 486, 487, 488, 489, 390, 391, 392, 393, 394, 395, 396, 397, 398, 399, 400, 401, 402, 403, 404, 405, 406, 407, 408, 409, 410, 411, 494, 496, 497, 498, 499, 500, 501, 502, 503, 504, 505, 506, 507, 508, 509

Shari Chankhamma

254, 255, 258, 259, 262, 263, 264, 265, 267, 268, 272, 284, 289, 290, 293, 412, 416, 417, 418, 419, 424, 425, 427, 432, 433

Selina Dean

22, 23, 24, 25, 67, 82, 83, 104, 105, 122, 123, 124, 125, 126, 127, 200, 276, 319, 334, 357, 358, 359, 420, 421, 422, 489, 492, 493

Sonia Leong

10, 15, 26, 31, 41, 42, 43, 52, 54, 61, 69, 71, 72, 73, 113, 116, 117, 132, 141, 164, 168, 169, 174, 175, 177, 178, 180, 181, 184, 185, 187, 190, 191, 192, 193, 195, 196, 197, 251, 252, 253, 256, 257, 260, 261, 266, 269, 270, 271, 298, 299, 302, 303, 306, 307, 310, 311, 314, 315, 323, 324, 326, 332, 344, 352, 363, 364, 364, 369, 370, 374, 376, 379, 414, 415, 429, 431

Morag Lewis

179, 189, 278, 279, 285, 367, 468, 469, 487, 488, 489

Michiru Morikawa

291

Natcha Prapatpornkul

18, 21, 30, 32, 90, 97, 98, 102, 142, 145, 149, 158, 161, 245, 322, 325, 327, 338, 339, 340, 346, 347, 365, 371, 378

Yapi Santiago

275, 277, 280, 281, 282, 283, 296, 287, 288, 292, 300, 301, 304, 305, 308, 309, 312, 313, 316, 318, 413

Hayden Scott-Baron

14, 16, 20, 27, 28, 29, 34, 36, 37, 38, 39, 40, 52, 54, 61, 71, 75, 84, 85, 86, 88, 89, 93, 94, 95, 100, 101, 103, 113, 116, 117, 132, 147, 148, 150, 151, 192, 204, 205, 209, 212, 213, 220, 221, 224, 225, 274, 294, 295, 296, 297, 317, 320, 321, 328, 329, 345, 348, 349, 354, 355, 356, 360, 361, 428, 434, 436, 437, 438, 439, 440, 441, 470, 471, 472, 476, 478, 479, 480, 481, 482, 483, 484, 485, 486

Michael Stearns

138, 139, 140, 144, 146, 154, 155, 156, 157, 160, 162, 163, 165, 166, 167, 198, 199, 201, 206, 207, 208, 210, 211, 216, 217, 442, 443, 444, 445, 446, 447, 448, 449, 450, 451, 452, 453, 454, 455, 456, 457, 458, 459, 460, 461, 462, 463, 464, 465, 466, 467

Emma Vieceli

143, 159, 273, 331, 333, 336, 337, 341, 350, 366, 375, 423, 426, 430, 435

Laura Watton

11, 12, 13, 17, 19, 33, 35, 44, 45, 53, 55, 64, 65, 66, 76, 77, 80, 87, 91, 92, 96, 106, 107, 109, 115, 128, 135, 136, 152, 330, 335, 353, 495

Wing Yun Man

274, 294, 295, 296, 297, 317

Image Gallery: 500 Manga Characters License Agreement

The 500 Manga Characters image gallery of digitized images ("The Images") on this CD-ROM disc ("The Disc") is licensed for use under the following Terms and Conditions, which define what You may do with the product. Please read them carefully. Use of The Images on The Disc implies that You have read and accepted these terms and conditions in full. If You do not agree to the terms and conditions of this agreement, do not use or copy The Images and return the complete package to The Ilex Press Ltd. with proof of purchase within 15 days for a full refund.

Terms and Conditions of Use

You agree to use The Images under the following Terms and Conditions:

Agreement

1. These Terms and Conditions constitute a legal Agreement between the purchaser ("You" or "Your") and The Ilex Press Ltd. ("Ilex").

2. License

You are granted a non-exclusive, non-transferable license to use, modify, reproduce, publish, and display The Images provided that You comply with the Terms and Conditions of this Agreement.

3. You may, subject to the Terms and Conditions of this Agreement:

- a) Use, modify, and enhance The Images (provided that You do not violate the rights of any third party) as a design element in commercial or internal publishing, for advertising or promotional materials, corporate identity, newsletters, video, film, and television broadcasts except as noted in paragraph 4 below.
- b) Use, modify, and enhance the images as a design element on a web site, computer game, video game, or multimedia product (but not in connection with any web site template, database, or software product for distribution by others) except as noted in paragraph 4 below.
- c) Use one copy of The Disc on a single workstation only.

destroyed at the end of the production cycle.

d) Copy the images to Your hard drive. e) Make a temporary copy of The Images, if You intend to output the images by means of an output device owned or operated by a third party, such as a service bureau image setter. Such copies must be

4. You may not:

- a) Distribute, copy, transfer, assign, rent, lease, resell, give away, or barter the images, electronically or in hard copy, except as expressly permitted under paragraph 3 above.
- b) Distribute or incorporate the images into another photo or image library or any similar product, or otherwise make available The Images for use or distribution separately or detached from a product or web page, either by copying or electronically downloading in any form.
- c) Use the The Images to represent any living person.
- d) Modify and use The Images in connection with pornographic, libellous, obscene, immoral, defamatory, or otherwise illegal material.
- e) Use The Images as part of any trademark whether registered or not. f) Transfer possession of The Images to another person across a network,
- on a CD, or by any other method now known or hereafter invented.

5. Termination.

This license is in force until terminated. If You do not comply with the terms and conditions above, the license automatically terminates. At termination, the product must be destroyed or returned to llex.

6. Warranties.

- a) llex warrants that the media on which The Images are supplied will be free from defects in material and workmanship under normal use for 90 days. Any media found to be defective will be replaced free of charge by returning the media to our offices with a copy of Your receipt. If llex cannot replace the media, it will refund the full purchase price.
- b) The Images are provided "as is," "as available," and "with all faults," without warranty of any kind, either expressed or implied, including but not limited to the implied warranties or merchantability and fitness for a particular purpose. The entire risk as to quality, accuracy, and performance of The Images is with You. In no event will llex, its employees, directors, officers, or its agents or dealers or anyone else associated with llex be liable to You for any damages, including any lost profit, lost savings, or any other consequential damages arising from the use of or inability to use The Images even if Ilex, its employees, directors, officers, or its agent or authorized dealer or anyone else associated with llex has been advised of the possibility of such damages or for any claim by any other party. Our maximum liability to You shall not exceed the amount paid for the product.
- c) You warrant that You do not reside in any country to which export of USA products is prohibited or restricted or that Your use of The Images will not violate any applicable law or regulation of any country, state, or other governmental entity.
- d) You warrant that You will not use The Images in any way that is not permitted by this Agreement.

7 General

- a) The Disc, The Images, and its accompanying documentation is copyrighted. You may digitally manipulate, add other graphic elements to, or otherwise modify The Images in full realization that they remain copyrighted in such modification.
- b) The Images are protected by the United States Copyright laws, international treaty provisions and other applicable laws. No title to or intellectual property rights to The Images or The Disc are transferred
- c) You acknowledge that You have read this agreement, understand it, and agree to be bound by its terms and conditions. You agree that it supersedes any proposal or prior agreement, oral or written, and that it may not be changed except by a signed written agreement.